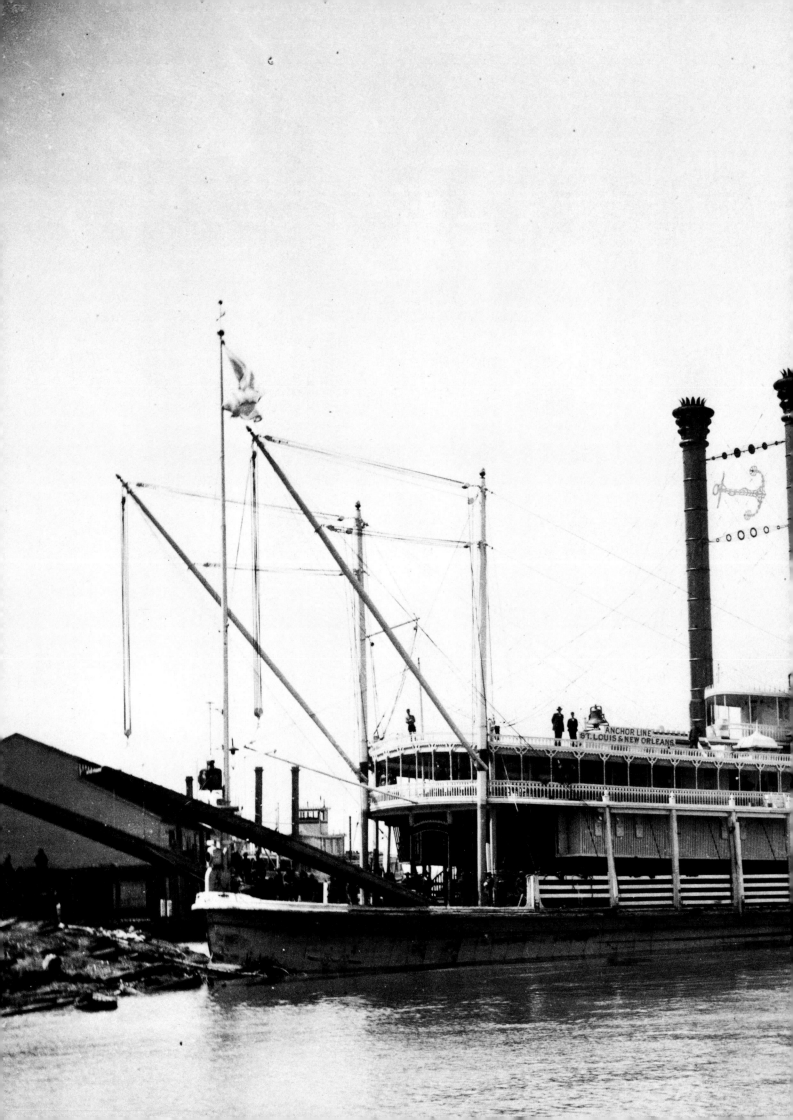

The Mississippi Steamboat Era in Historic Photographs

NATCHEZ TO NEW ORLEANS
1870–1920

❧

Joan W. Gandy and
Thomas H. Gandy

❧

DOVER PUBLICATIONS, INC.
NEW YORK

Published in Canada by General Publishing Company, Ltd., 30 Lesmill Road, Don Mills, Toronto, Ontario.
Published in the United Kingdom by Constable and Company, Ltd.

The Mississippi Steamboat Era in Historic Photographs: Natchez to New Orleans, 1870–1920 is a new work, first published by Dover Publications, Inc., in 1987.

Book design by Carol Belanger Grafton
Manufactured in the United States of America
Dover Publications, Inc., 31 East 2nd Street, Mineola, N.Y. 11501

Library of Congress Cataloging-in-Publication Data

Gandy, Joan W.
 The Mississippi steamboat era in historic photographs.

 Bibliography: p.
 1. Steamboats—Mississippi—Natchez Region—History—Pictorial works. 2. Steamboats—Mississippi River—History—Pictorial works. 3. Mississippi River—Navigation—History—Pictorial works. 4. Navigation—Mississippi—Natchez Region—History—Pictorial works. 5. Natchez Region (Miss.)—History—Pictorial works. I. Gandy, Thomas H. II. Title.
VK24.M7G36 1987 386′.22436′0977 86-24354
ISBN 0-486-25260-4

Preface

In 1870, the year of the famous steamboat race between the *Natchez* and the *Robert E. Lee*, a young man named Henry C. Norman boarded a boat in Louisville, Kentucky, and traveled down the Mississippi River to Natchez, Mississippi, where he disembarked at the landing known as Natchez Under-the-Hill. Norman was 20 years old at the time. He left a mother and a younger brother in Louisville, where they had moved just a few years before from their home in Newnan, Georgia, perhaps because of the death of Norman's father.

Why Henry Norman chose to settle in Natchez is not known, but it may have been that the reputation of the town as a bustling little commercial center attracted him. Indeed, Natchez had become widely known for its wealthy citizens, beautiful mansions and gardens and thriving businesses as the cotton trade reached its peak in the mid-1800s. Moreover, Natchez was virtually untouched by the Civil War and therefore in an excellent position to make a comeback in the years following it.

Young Norman went to work for a photographer named Henry Gurney soon after he arrived in Natchez. Gurney had been in and out of Natchez for almost 20 years by then, having started out there as a daguerreotypist in 1851, when Natchez was said to have had more millionaires than any other town in the country besides New York. Gurney was therefore firmly established in Natchez when Norman became the studio "operator," learning the techniques of both camera and darkroom. For several years Norman worked in Gurney's studio, and it became clear that the young operator was gifted as a photographer.

By 1876, Norman had opened his own studio. It appears that Gurney may have withdrawn from the business to travel, or perhaps he retired. In the early 1880s, he was living in Minnesota and occasionally disembarking in Natchez to visit old friends when he made trips to New Orleans by steamboat. When he gave up the photography business, Gurney left Norman many—if not all—of his negatives and, it may be assumed, his equipment.

During the next 30 years, Henry Norman became the best-known photographer in the Natchez region. People from miles around came to his studio for portraits, and he was called upon to photograph the most significant social and cultural events. Norman demonstrated skill and artistry as a photographer but, more important, he showed a love for his work that is evident in the great number of photographs he seems to have made for his own pleasure, a truly remarkable record of his little town.

Norman traveled around Natchez with his camera. He photographed the streets, buildings, people. He went into the countryside and photographed rural scenes. And of course, he traveled to the river landing and photographed boats, people at work and play and scenes that today tell the story of late nineteenth-century life on the lower Mississippi River—the photographs that appear in this book.

In 1874, Norman married a Natchez woman, Clara Field.

They had three sons and a daughter. All three sons became photographers, but only the youngest, Earl, born in 1888, remained in Natchez to work with his father. When Henry Norman died in 1913, Earl inherited the studio and continued to work as a photographer in Natchez until his own death in 1951. Earl, like his father, became widely known for his photographic skills and left images of his town in the 1920s and '30s equal in significance to those of an earlier time left by his father.

Following Earl Norman's death, his widow, Mary Kate, found herself in possession of dozens of boxes of old photographic negatives in addition to those she knew to be her husband's. For ten years, she held on to them, moving the boxes from the old studio to the patio of her house. Although not a photographer, she had worked closely with Earl in the studio retouching and hand-coloring photographs. Realizing that the exposure to the weather would eventually destroy the negatives, if it had not indeed already done so, Mrs. Norman finally agreed in 1961 to sell the entire lot, including Earl's work and some of the old equipment they had inherited from his father, to Thomas H. Gandy, a Natchez physician.

"If I find just eight or ten photographs of steamboats or Natchez Under-the-Hill in good shape, I'll be happy," Dr. Gandy said at the time. Since he had not examined the negatives before buying them, he had no way of knowing how many, if any, were undamaged. He knew little about photography but was vitally interested in Natchez history, particularly the history of the Mississippi River there. When he took possession of the negatives and began to sort, clean, categorize and catalog them, he found to his astonishment that he had thousands of negatives, perhaps 30,000 or more glass plates and the same number of celluloid negatives, extending over a period of nearly a hundred years and representing the work of three photographers: Henry Gurney, Henry C. Norman and Earl Norman.

In 1978, Gandy and his wife Joan saw their first book based on the photographic collection published, *Norman's Natchez: An Early Photographer and His Town* (University Press of Mississippi), and in 1981, the second, *Natchez Victorian Children: Photographic Portraits, 1865–1915* (Myrtle Bank Press).

Henry Norman's photographs of the Mississippi River and the vessels that plied that famous stream in the years following the Civil War are among the finest made by any photographer during that time, according to river historians. Many of his most beautiful photographs were known before Norman was identified as the photographer. Not until the collection of negatives passed to Thomas Gandy and he began to print and publish them did Henry Norman begin to enjoy once again the fame that he had had a hundred years before among riverboat enthusiasts. *The Mississippi Steamboat Era in Historic Photographs: Natchez to New Orleans, 1870–1920* brings together for the first time the best Norman photographs of the river. Like other categories of Norman's work, these reveal not only his skill and artistry, but also his deep interest in people and the times.

The Photographs

Most of the photographs appearing in this book are prints made by Thomas H. Gandy from the original glass or celluloid negatives of photographers Henry C. Norman and his son Earl. A few photographs were made from negatives in the Gandys' collection that are from other sources. In addition, a few photographs are used with the permission of Ralph DuPae and the University of Wisconsin at La Crosse, as they are from that collection. The University of Wisconsin photographs are Nos. 15, 82, 86, 155, 164 and 165, and the Gandys wish to thank the University for the use of them.

Contents

The Mississippi Steamboat Era in Historic Photographs

NATCHEZ TO NEW ORLEANS
1870–1920

The Mississippi River:
A Brief Sketch

A weary, tattered Hernando de Soto and his decimated band of Spanish soldiers hacked their way through dense and tangled brush in the lush river land where they marched in search of gold and riches. They found instead disaster, death and disappointment. Their travels took them to the great river that cuts and winds through the continent over nearly 3,000 miles before emptying into the Gulf of Mexico—the Mississippi. They were the first white men known for certain to have reached its banks* but were unaware of their place in history. In 1542 de Soto died and was buried in the mile-wide river.

Other explorers, trappers, voyagers and, finally, settlers followed the Spaniards into the rich river valley over the next 200 years. In 1682, La Salle descended nearly the entire length of the Mississippi to the mouth, where he claimed all lands drained by the river for his native France. In 1699, the Frenchman d'Iberville led a party from the mouth of the river up into Natchez Indian territory and in 1716, the French established Fort Rosalie, the first permanent white settlement on the river and today the site of Natchez, Mississippi. New Orleans was founded two years later.

Navigation of the river developed rapidly during the eighteenth century. New Orleans, located near the mouth, became an international port as valuable furs and other goods floated down the river to be shipped to European countries. The settlement at Natchez grew as a result of land rich for agriculture and its protected location on the high bluffs. Flimsy rafts and flatboats made the long and often treacherous trip downstream where, at their destination in Natchez or New Orleans, they were taken apart and their wood sold for lumber.

During the late 1700s, the westward-moving nation came to depend more and more on the Mississippi River for the transportation not only of goods, but also of people. The need for a boat that could return up the river was crucial to increasing profits as well as to giving travelers an alternative to such thief-infested land routes as the Natchez Trace. These needs led to the development of the keelboat. Sturdy and skillfully proportioned to carry dozens of tons of freight in its rounded bottom, the keelboat was equipped with poles by which a hardy crew of men propelled it forward against the current. Some keelboats had sails to aid in navigation; in some situations the crew hauled the boat upstream by a rope from the riverbank; and other times they simply rowed.

Returning north by river instead of land did not assure passengers' safety, however. Hostile Indians, river pirates and the river itself with its unpredictable current, snags and sandbars made the journey a gamble. The keelboatmen were a

rough, tough breed, suited to the rigors of the life they had chosen. Mark Twain described them in *Life on the Mississippi* as:

> rough and hardy men; rude, uneducated, brave, suffering terrific hardships with sailor-like stoicism; heavy drinkers, coarse frolickers in moral sites like the Natchez-under-the-hill of that day, heavy fighters, reckless fellows, every one, elephantinely jolly, foul-witted, profane . . . yet, in the main, honest, trustworthy, faithful to promises and duty, and often picturesquely magnanimous.

Many of the most raucous river tales grew out of the days when keelboats ruled the Mississippi and the boatmen stopped at landings in Memphis, New Orleans and Natchez (known then as Natchez Under-the-Hill) to carouse. They fought, gambled, hustled prostitutes and often destroyed property. Legend has it that Natchez was the favorite stopover, offering the best brothels and bars. This colorful breed of river man survived for several generations, even into the days of the steam-driven boats.

Steam came to the Mississippi in 1811. The *New Orleans*, designed by Robert Fulton, carried three passengers: Nicholas Roosevelt, his pregnant wife and their dog. The crew included a captain, an engineer, six deck hands, a cook and three servants. Though some in Pittsburgh, where the journey began, considered it scandalous for Roosevelt to take his pregnant wife on the risky journey, for Mrs. Roosevelt it was, in her words, "jolly." She had, after all, spent her honeymoon in 1809 on a flatboat trip from Pittsburgh to New Orleans.

The *New Orleans* arrived in the city for which it was named in January 1812, having survived hostile Indians, a fire on board, the New Madrid earthquake and the birth of Mrs. Roosevelt's baby. Before New Orleans, however, was Natchez, where the entire town had gathered at the Natchez Under-the-Hill landing to greet the boat. As the captain had allowed his fires to slow and his steam to diminish, he found the boat drifting too far downstream with the swift current. The boat slipped past Natchez as the onlookers' anticipation turned to dejection. Additional fuel and a new surge of steam set the boat on course again, however, and it turned back up the crowd-filled shore. When it left town, the *New Orleans* carried a load of cotton, the first ever to be shipped by steamboat from Natchez.

For all its success in going down the river, the *New Orleans* proved to be poorly designed for travel any farther north than Natchez. Fulton's boat resembled his Hudson River steamboats, which had hulls too deep for the Mississippi's snags, sandbars and swift currents. It took a Mississippi River man to understand the application of steam there. That man was Henry Shreve, who had navigated pirogues, flatboats and keelboats for several years by the time the *New Orleans* made its

*There is some speculation (based on a map in the Royal Library at Madrid) that Columbus viewed the mouth of the river on one of his voyages.

maiden voyage. Shreve knew that a Mississippi River steamboat should have a shallow hull, and that it in fact should be very similar to a keelboat in design. In 1816 he designed such a boat, the *Washington*, which traveled up from New Orleans to Louisville in 24 days, a trip that might have taken a keelboat six months. Shreve's design opened the river to steam navigation, and all Mississippi River steamboats in the following years copied the basic design of the *Washington*.

The *Washington* measured 136 feet in length and 28 feet in width. Because of its shallow hull, the machinery was placed on the deck. To add space, a second deck was built and atop that, a little house for the pilot. Though strange and clumsy in appearance compared to the graceful boats designed by Fulton, the Shreve boat worked: it glided across the swift Mississippi waters. Shreve placed an engine on each side for the wheels so that maneuvering in and out of small places along the river was virtually effortless.

During the late eighteenth century more and more settlers moved into the rich lands of the lower Mississippi. The cotton gin was perfected, and large numbers of slaves were brought into the area. This coming together of productive people, rich land, the cotton gin, slave labor and the steamboat produced great opportunities for landowners, who took advantage of them to amass great fortunes. Mansions appeared along the lower riverbanks and high on the bluffs at Natchez and Vicksburg. Steamboats brought fine furnishings for the mansions, as well as fashionable clothing, expensive food items, books and entertainers to satisfy the growing sophistication of the people in towns such as Natchez and New Orleans. Steamboating and cotton, then, embarked on a journey together in the early nineteenth century that lasted a hundred years.

The wealthy population during this time looked to steamboats for transportation, too, and the boats became more and more luxurious as well as faster as the middle of the nineteenth century approached. The trip by steamboat from Louisville to New Orleans that had taken 20 days in 1820 took only six by 1838. The demands for smaller boats grew—boats that could travel the small tributaries and bayous to carry mail and supplies to plantations and pick up small shipments of cotton, pork and other produce.

The phenomenal growth of steamboat traffic on the Mississippi came to an abrupt halt as the Civil War began. Southern boats pulled up into shadowy estuaries to escape destruction and, in some cases, remained in those boggy hiding places through the war, lost forever, rotted and ruined beyond repair. Some, including Mark Twain, said steamboating was gone forever.

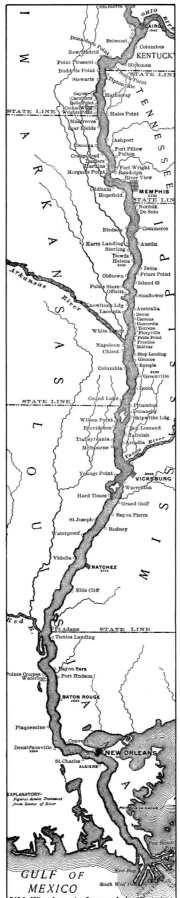

Fortunately, those prophets were wrong. Steamboat building, other than some packets ordered for troop transportation by the North, did come to a halt during the war, and many routine steamboat schedules ceased. But when the war was over, river men were swift to pick up where they had left off. Steamboat builders joined forces to form pools of boats, such as the great Anchor Line and the Southern Transportation Line.

During the 1870s and early 1880s, some of the grandest boats ever seen on the Mississippi were built. The luxurious boats of the 1850s faded in comparison to the *J. M. White*, for example. Built in 1878, the *White* was unequaled in luxury and grandeur. A river reporter, after seeing the boat, wrote this poem:

> Aladdin built a palace,
> He built it in a night;
> And Captain Tobin bought it
> And named it *J. M. White*.

Capt. John Tobin, who built the *White*, was one of several steamboat captains who ran successful palatial boats in the postwar years. Two others were John W. Cannon and Thomas P. Leathers, who were the rival captains on the *Robert E. Lee* and the *Natchez* for the great race in 1870.

Steamboatmen knew, however, that theirs was not an easy task—to keep steamboat trade alive despite the spreading networks of railroads over the nation. Trains gradually proved to be too much competition, as steamboats battled many other handicaps during the last few years of the nineteenth century. High water on the river interrupted navigation as landings were flooded; low water prohibited navigation by big boats, which feared grounding on sandbars or banks; yellow-fever epidemics in New Orleans and other places on the lower Mississippi halted river trade altogether every few years for as long as two to three months. Despite some Federal assistance, river improvements, such as dredging and harbor work, were slow.

The pace of the entire country was quickening, and trains were fast. They were becoming more economical; even cotton planters were finding rail transportation convenient. Trains were also becoming more comfortable for travelers.

As the twentieth century was born, steamboating began to die. It was not a sudden death: many steamboats continued to travel the Mississippi into the 1920s and '30s. By that time, however, powerful diesel boats had begun to dominate river transportation. The second coming of steamboats to the Mississippi was a brief moment in the history of the river but for that short time, the steamboatmen reigned with style.

A Second Chance

Steamboats whistled and puffed along some 9,000 miles of waters in the heart of nineteenth-century America. They steamed down from Pittsburgh, where the Monongahela joins the Allegheny, into the Ohio River to the queen city of Cincinnati, then south to the Mississippi; down from St. Paul past island forests and on to the Illinois grasslands, steaming from the clear Mississippi of the North to the muddy waters of the South; out of the wide Missouri from 2,000 miles west; out of the Tennessee and Cumberland Rivers from the East and out of the White, the Yazoo, the Ouachita, the Big Black and the Atchafalaya in the lush lands of the South.

Indian villages, trappers' settlements, trading posts and small farms had served the early adventurers floating down the river in search of new lands. By the first half of the nineteenth century, there were villages, towns and cities—sprawling commercial centers such as St. Louis, Memphis and New Orleans on the lower river and, between them, smaller but thriving cities and towns such as Helena, Arkansas; Greenville, Vicksburg and Natchez, Mississippi, and Bayou Sara and Baton Rouge, Louisiana.

Interrupted by the Civil War, steamboating on the Mississippi made a brief but strong comeback for a quarter of a century in the postwar years. The formation of steamboat companies resulted in greater efficiency, as groups of individual boat owners combined their capital and experience to rescue the steamboat industry from its near-ruined state and launch the finest, most luxurious boats ever to run the Western waters. Efficiency, comfort and luxury were their only hope, for railroads competed ruthlessly for steamboat business. Even in small cities like Natchez, river men formed packet companies consisting of perhaps two or three boats. These small local traders traveled to other small towns and plantation landings a distance of a hundred miles or so and back several times a week. And as cotton again flourished, so did the need to distribute great quantities of other goods to the lands along the nation's greatest water system. It was a second chance for steamboating that grew slowly in the 1870s—especially in the South, where the restrictions of Reconstruction continued to thwart economic recovery—but one that grew rapidly and thrived in the two decades that followed.

ঌ 1. A big "O" Line boat, traveling between Cincinnati and New Orleans, stopped at Natchez Under-the-Hill on this day sometime in the late 1870s. The "O" (for Ohio) Line was the popular name for the Southern Transportation Company, one of the successful pools of boats formed during the years after the Civil War. This company began its operations on the river in 1877 and went out of business in 1893.

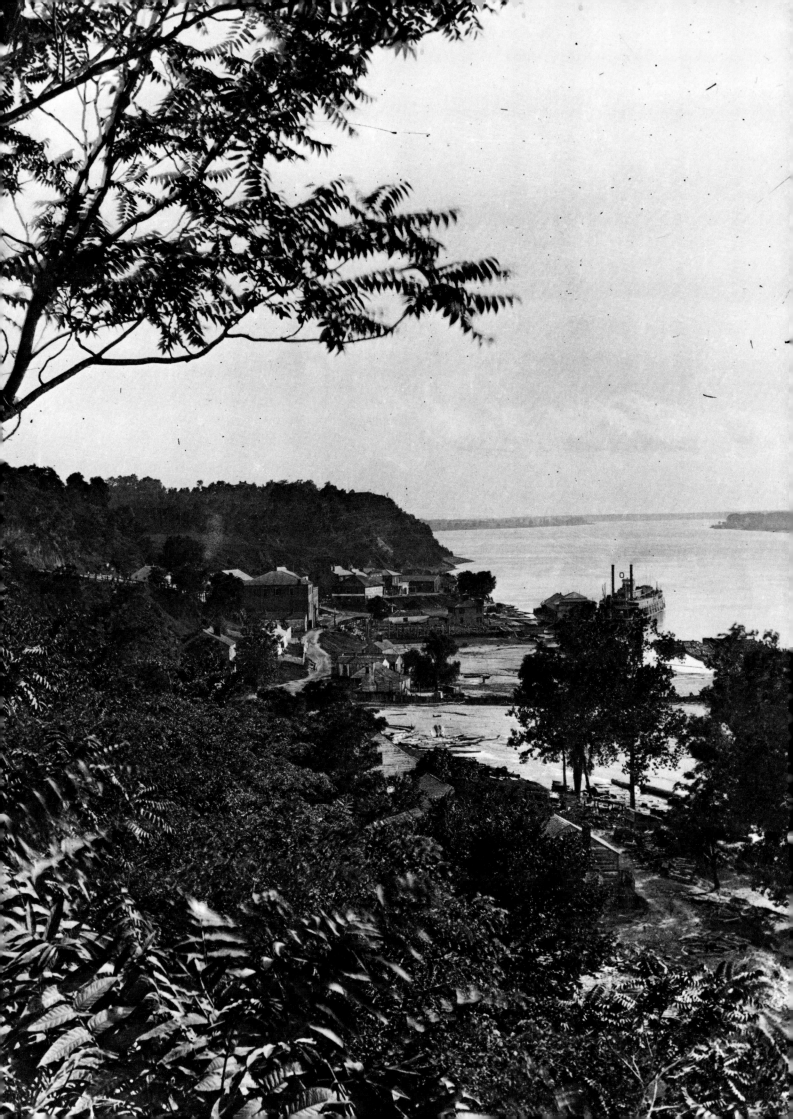

A Ghostly Bird

Melodious, gay, haunting, frightful, a steamboat's whistle sang like a ghostly bird from its lofty perch atop the pilothouse. As individual as the boat itself, the whistle announced which boat was coming from around the bend when it was yet miles away.

"It's the *James Howard*!" shouted a boy at play on the bluff high above the Natchez Under-the-Hill landing.

Or maybe it was the *Charles Rebstock*, the *Stella Wilds*, the *Belle Lee*, the *Guiding Star*, the *Golden Rule*, the *City of St. Louis*, the *Belle Memphis*, the *Natchez*, the *Robert E. Lee*, the *New Mary Houston* or any one of over 2,000 boats that traveled the Mississippi waters during the last three decades of the nineteenth century.

River-town boys knew the boats by their whistles; so did most others in the town. Two of the most famous whistles were those on the *Will Kyle* and the *Paris C. Brown*. It was said that a boy's greatest ambition in 1883 was to be able to imitate the "unearthly shrieks" of their steam whistles. The shrieking whistle of the *Will Kyle* was said to have brought on a storm when it blew upon the boat's arrival in Natchez. Passing a small town on the Ohio River on a Sunday morning, the *Kyle* is reputed to have blown its whistle as services were underway in a small church, causing the minister, followed by the entire congregation, to come "rolling out of church as though a hive of bees had been turned loose inside." It is said that the next day, two men who had heard the whistle during the night at another point along the river formed a posse to hunt the "great, wild animal" they had heard.

In Paducah, Kentucky, authorities adopted an ordinance in 1885 prohibiting steamboats from whistling while within a half a mile of the wharf. One reason may have been to prevent incidents like the one that occurred at the Natchez landing on an August day in 1889, when the steamer *Charles D. Shaw* began to whistle and startled a horse attached to an empty buggy. The horse bolted into a coal yard, ran over a woman, destroyed the buggy and made a big mess of the yard.

ia 2. Whistles achieved their unique sounds by their size and number of tubes. One to five tubes might be fashioned onto the base, and each had its own musical note. Rich musical sounds came forth from some whistles and one solid chord from others, depending upon whether the notes were blown separately or together. The most popular number of tubes seems to have been three, as on the whistle of the *Charles Rebstock*. ia 3. One newspaper's river editor in 1888 complained that steamboats did not clean out their whistles properly, resulting in less than optimum musicality from the chimes. He said that rust accumulated in the bowls of the whistles while the boats were laid up, and that a prompt and proper use of coal oil would cause the rust to loosen. The force of the steam would then clean out the whistles and make them blow as clearly and harmoniously as when new. The big cotton carrier *John A. Scudder* had a quite fancy five-tone whistle.

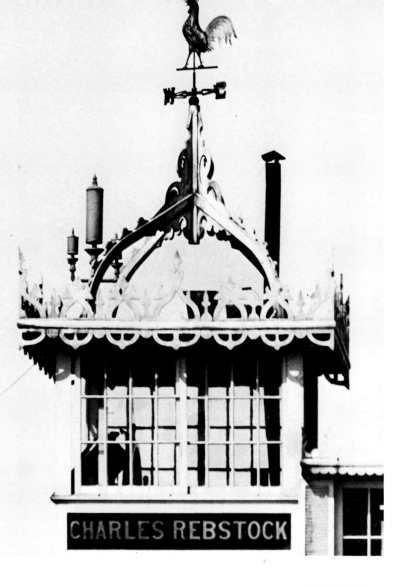

2

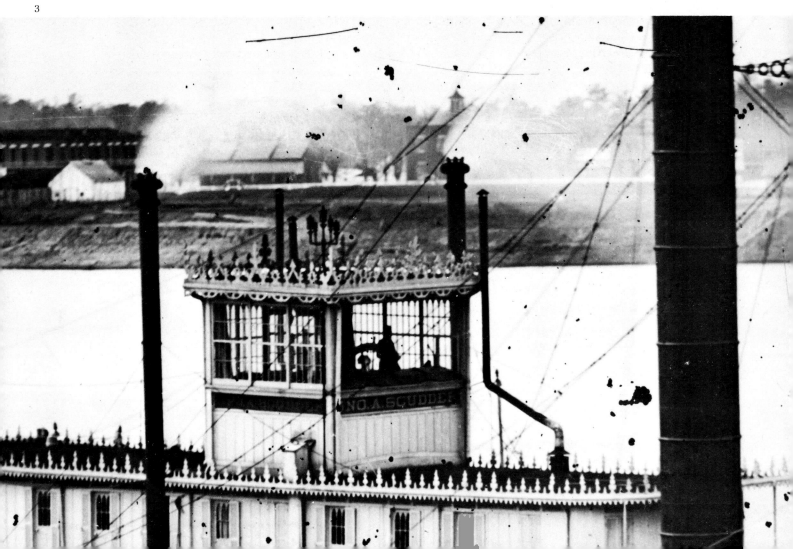

A Boat for the Times

"If luxury and comfort are what they want, then that is what I'll give them," Capt. John Tobin must have thought as he planned the boat he would call the *J. M. White*. It would be a grand boat, built for the Greenville and New Orleans Packet Company, in which Tobin was one of several partners. Skeptics predicted that river travel and transportation were doomed by the spreading networks of railroads. "Nothing like the boats we saw before the war will be seen again on the Mississippi," they said. When they saw the *J. M. White* gracefully making its way down the river in 1878, however, they had to admit that it was the grandest Mississippi River steamboat they had ever seen. Soon it was called "Mistress of the Mississippi." Though not the largest of all boats—the *Grand Republic* held that distinction—the *J. M. White* was enormous: 320 feet long and 91 feet wide. Ornate, commodious and sumptuous, it set a standard never again equaled.

On a cold December night in 1886, as the *J. M. White* lay at Blue Store Landing near Bayou Sara to take on a load of cottonseed, the second engineer, on watch with his partner, thought he saw a small lantern flickering just above the cotton cargo about midway down the main deck. He walked in that direction to investigate and to his horror saw not a lantern but flames rising from a cotton bale.

"Fire! Fire!" he yelled. The watchman roused at once and began to ring the huge bell; he rang it furiously until encroaching flames forced him to move.

Awakened by the clanging bell, the chief engineer, asleep in his quarters on the texas deck, sprang out of bed and found himself engulfed by smoke. He woke others in the quarters, and they crawled out onto the deck. Their only way of getting off the boat was to climb down one of the stanchions on the vessel's right side and onto the shore.

The pumps had been started, and two streams of water began to battle the flames. It was hopeless. The frightful swiftness of the fire overpowered all efforts to extinguish it.

Officers had aroused sleeping passengers, many of whom escaped by leaping into the water. Women and children screamed for help. A railroad superintendent, traveling with his wife and two daughters, reportedly threw the two children into the water but burned to death with his wife on the deck outside the ladies' cabin.

A fine prize ox, taken on at Vicksburg and on its way to New Orleans for an exhibition, was burned to death in the stable at the rear of the boat. Two of its five keepers perished with it.

The *Stella Wilds*, lying at the Bayou Sara landing, went to the scene of the disaster, as its skipper, Capt. Pennywitt, saw the flames. The *Stella Wilds* took many on board who had escaped and soon started for Baton Rouge. On the way down, the officers of the boat saw a man on a bale of cotton in the river and threw him a rope. As he tried to catch it, he rolled off the bale and was drowned.

Some reports say that 20 people died in the disaster. The boat burned in 15 minutes. The loss of the *J. M. White* and its cargo approached the price tag of the brand new boat: $300,000.

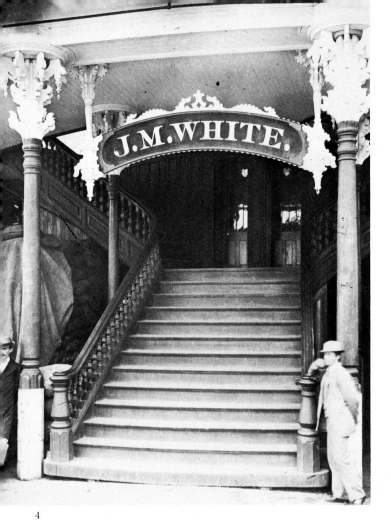

4

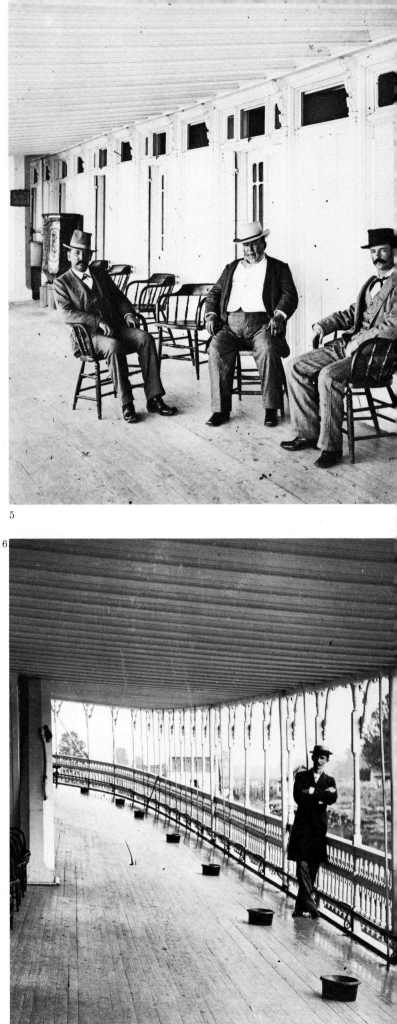

5

6

4. A wide curved stairway led from the main deck of the *J. M. White*, where passengers boarded the boat, up to the boiler deck. Attention to tastes of the period was evident everywhere—even the sign bearing the boat's name at the stairway was amply trimmed with gingerbread. 5. On the boiler deck, where the main cabin and staterooms (but no boilers) were located, the wide promenade around the entire boat provided spacious sitting areas. These gentlemen passengers, perhaps wealthy plantation owners and friends of the captain, sat outside the staterooms, the doors and skylights of which are evident in the background. 6. Extravagant in every detail, the *J. M. White* provided a spittoon about every six feet around the deck for the convenience of the men exercising or relaxing there.

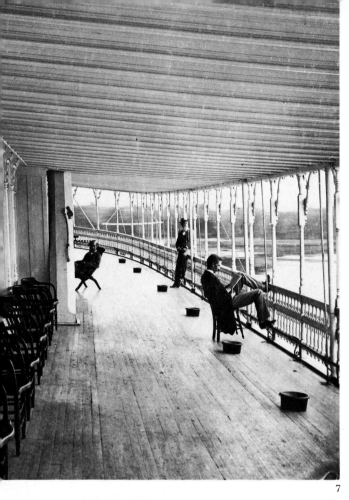

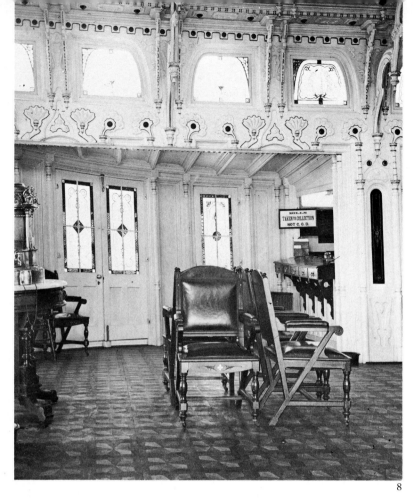

7

8

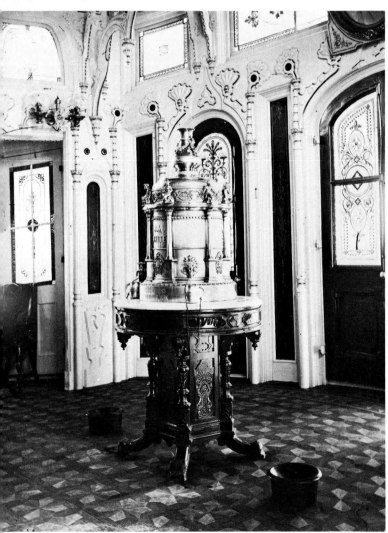

9

🙠 7. Though considered a fast boat, the *J. M. White* nonetheless traveled at steamboat pace, rarely surpassing 15 miles an hour. Reading, socializing and gazing at the river consumed hours and hours of steamboat travelers' time. 🙠 8. Inside the main cabin, architectural and decorative details were stunning. At one end was the purser's office and a large reception area, where wooden parquet floors, hand-carved moldings and embellishments on the walls and ceilings, etched and stained-glass windows and skylights and handsome modern furnishings gave the look of a first-class hotel lobby. 🙠 9. Mythological figures adorned the handsome Reed and Barton silver watercooler, itself an object of conversation and unrestrained admiration. Chains linked silver drinking cups to the cooler, which sat upon a marble-top table. 🙠 10. At the other end of the main cabin was the ladies' salon. Wall-to-wall carpeting, smartly upholstered furniture and a huge mirror, astounding in the intricacy of its frame, adorned the room. On a small ledge to one side of the mirror stood a silver hand bell to be rung for service.

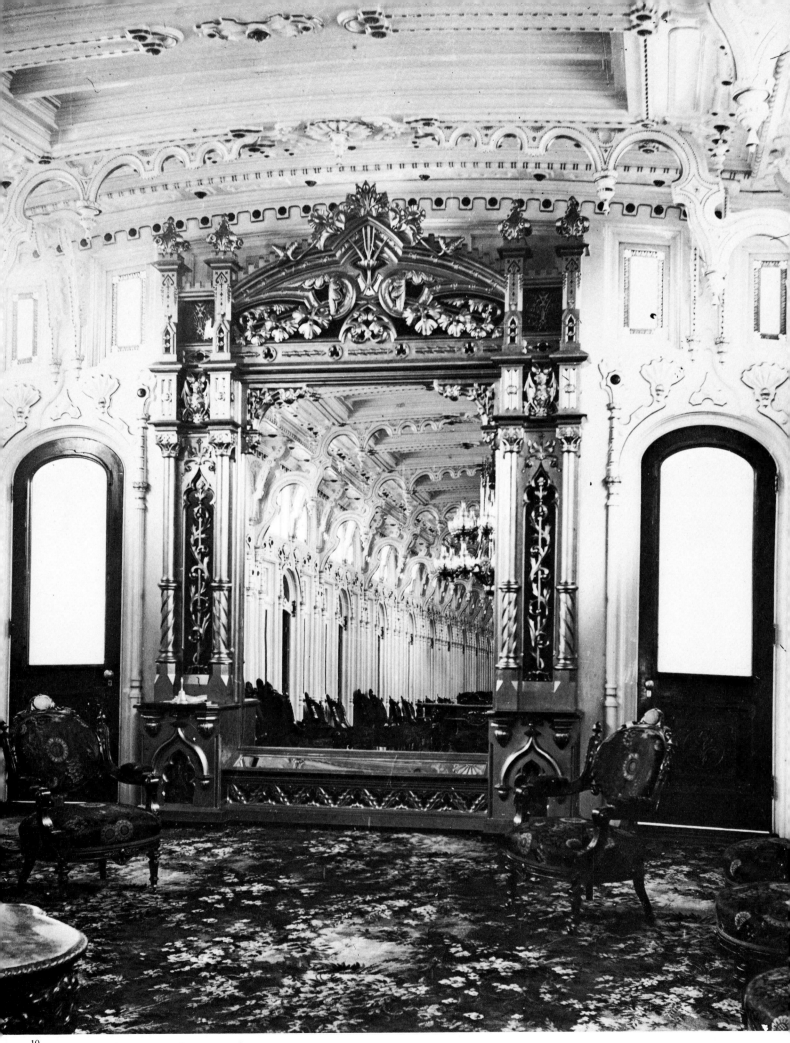

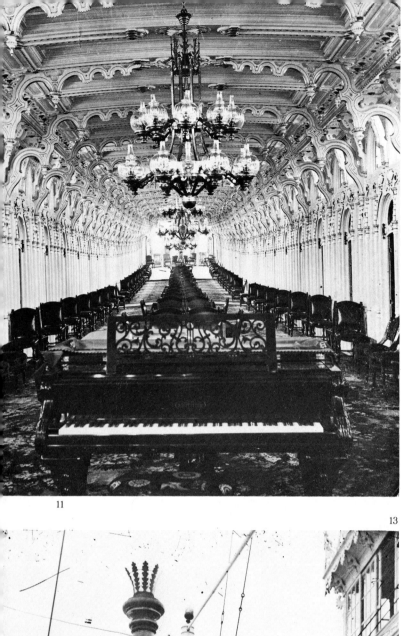

11

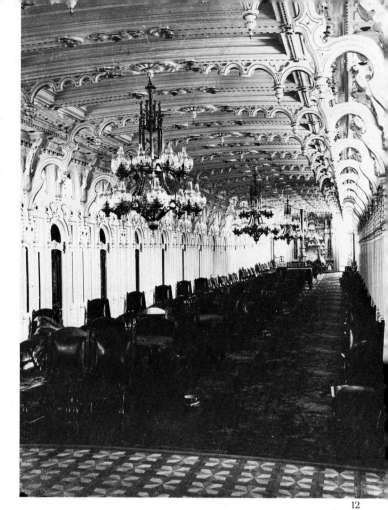

12

13 14

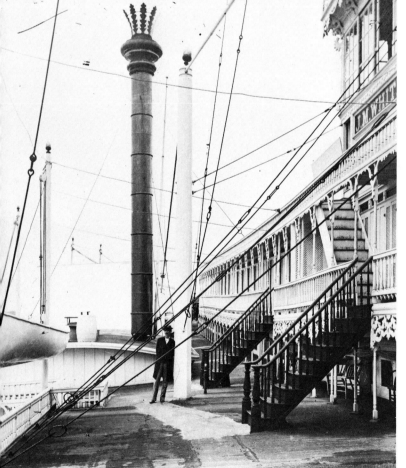

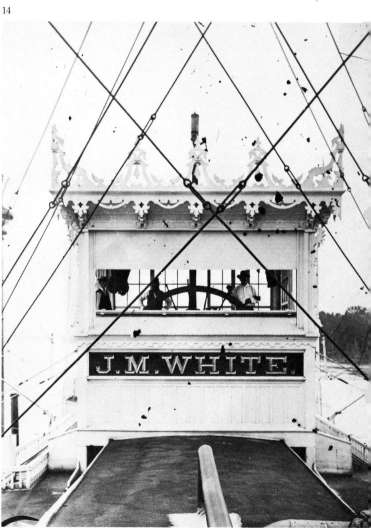

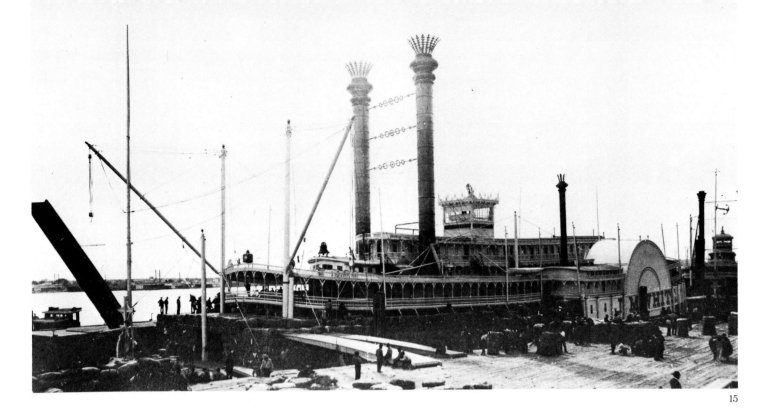

&. 11. Beneath the huge chandeliers, with globes etched "JMW," passengers dined or were entertained in the long main cabin, which was lined by 23 staterooms. In addition to these, there were two plush bridal suites. &. 12. When the main cabin was outfitted for dining, tables were brought into the long room. The sterling flatware and Irish linen napkins bore the *J. M. White*'s monogram, the china was decorated with hand-painted pictures of the boat, and the food itself was reported to be excellent. &. 13. The twin chimneys rose 81 feet into the air and were topped by decorative "feathers" that were eight feet tall. Short stairs led to the texas, the name given to the section of the boat where the captain and other officers resided. On the *J. M. White*, the texas housed 50 staterooms, including those of the officers. &. 14. Atop the texas was the pilothouse, where the whistle rose from the roof and the feather-topped chimneys were in easy view. The 12-foot wheel often required the work of two men. &. 15. Some say the *J. M. White* was never the money-maker its captain had expected it would be; others say it made plenty. Regardless of their arguments, the truth is that for eight splendid years, the *J. M. White* graced the Mississippi with its singular beauty and added its inimitable chapter to the romance of the river. &. 16. Another view of the *J. M. White*.

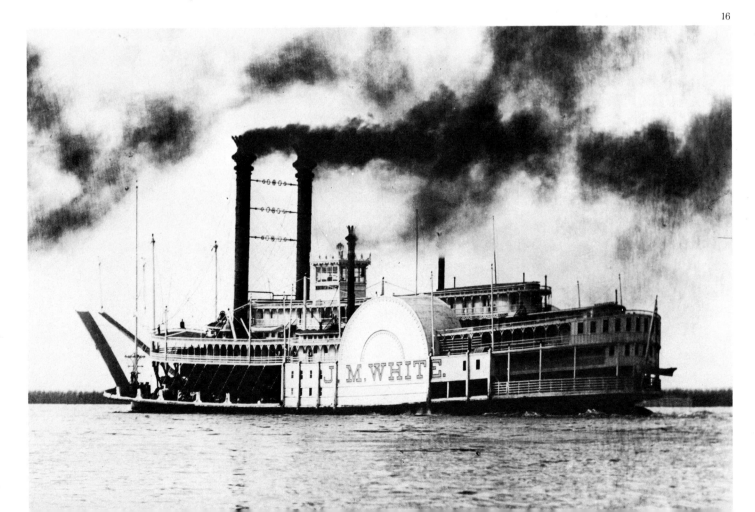

The Landing Comes Alive

Excitement mounted as the whistle's notes signaled the approach of the steamboat to the landing. At Natchez, the mule-drawn trolley clattered down Silver Street, and roustabouts rose from their shaded seats beneath the chinaberry trees. Drays, carts and hacks gathered in anticipation of the people and freight arriving. From high on the hill the Bluff City Railway, possibly the shortest incorporated railroad line in existence, sent its car down the steep incline with freight to be shipped on the arriving boat; in turn, the railway would receive freight to transfer up the hill to the juncture with the main railroad line. The wharfboat, the coal company and the wood yard came alive as smoke and steam clouded the air and frothy Mississippi River water whirled about the giant wheel propelling the boat toward the landing.

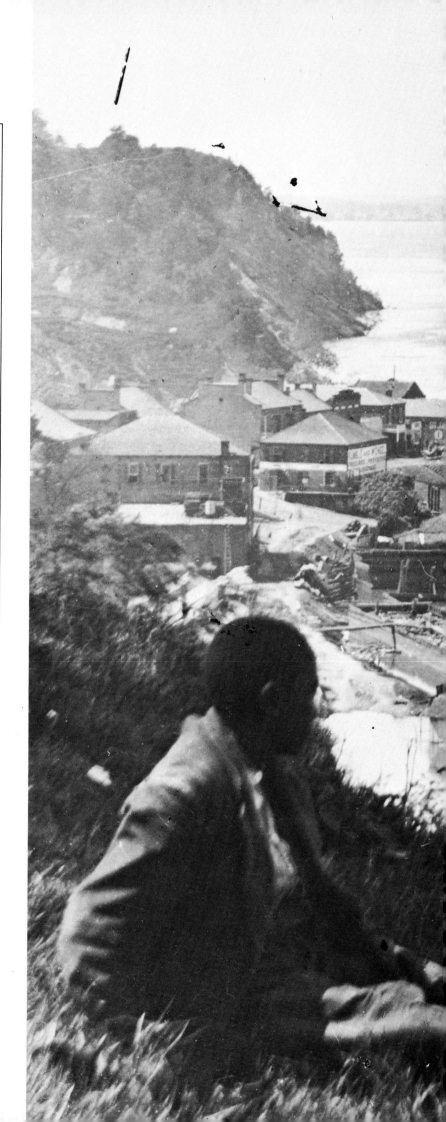

🙦 17. A river-town boy never tired of gazing down the river in hopes of seeing an approaching steamboat coming around the bend. Sitting some 200 feet above the landing, this river boy looked out upon a swollen Mississippi, its waters swallowing buildings at Natchez Under-the-Hill and much of little Vidalia, Louisiana, on the flatland across the river.

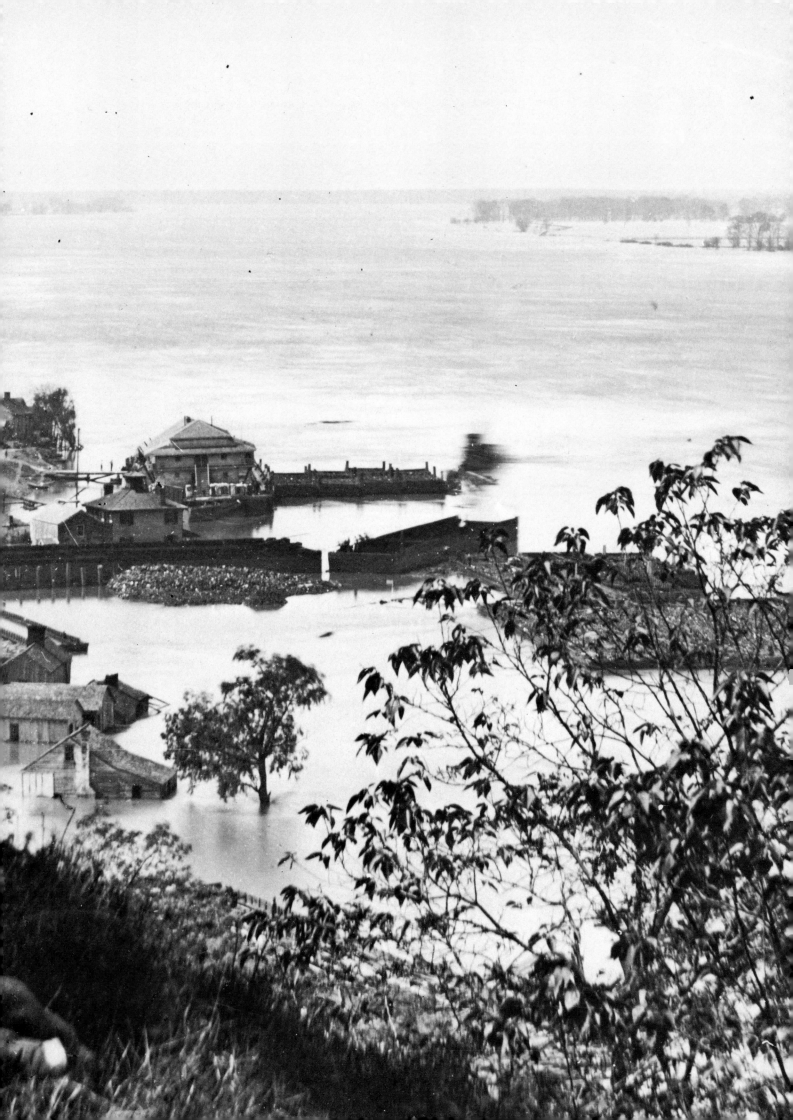

18. From all around the town, boys such as these hurried to see the boat land, always curious to see who got off, who got on and what interesting freight arrived. Maybe this was the boat bringing the dozen new racehorses expected for James Surget, or maybe the mule trader David McConchie disembarked with a hundred or more mules to sell, or maybe Thomas Reber's new streetcar or the Phoenix Fire Company's new steam pumper arrived. During the last years of the nineteenth century, river boys saw an average of 60 or 70 landings a month at a town like Natchez. 19. The *Carneal Goldman* landed at Natchez three times a week after making the trip to Vicksburg and back. It followed this schedule from 1885, when it was built, until 1892, when it was sold to a new owner in Madison, Indiana. The boat was then dismantled, and its hull was offered for sale. 20. Deckhands and roustabouts prepared for the landing as the wide stage was lowered onto the bank. The huge rope was loosened or pulled taut as needed to tie up the boat securely. Steamboats in the 1880s and '90s often had trouble finding enough roustabouts to round out a crew. Sometimes freight had to be refused because of insufficient hands, one of the many problems that plagued steamboat captains as they tried to keep the trade alive toward the close of the century.

18

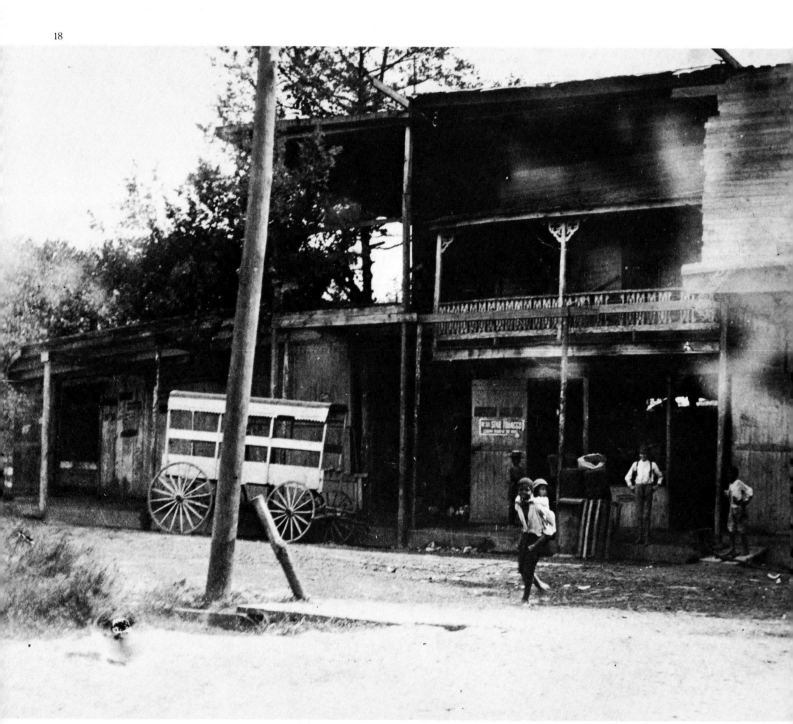

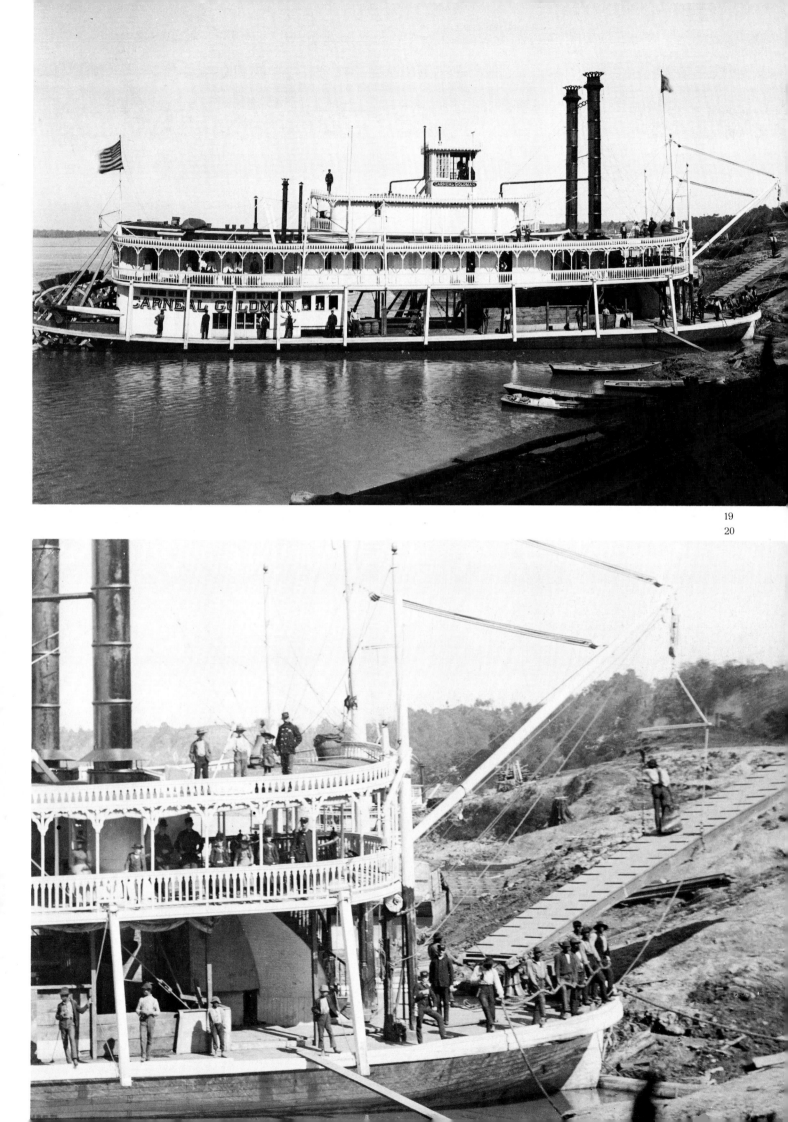

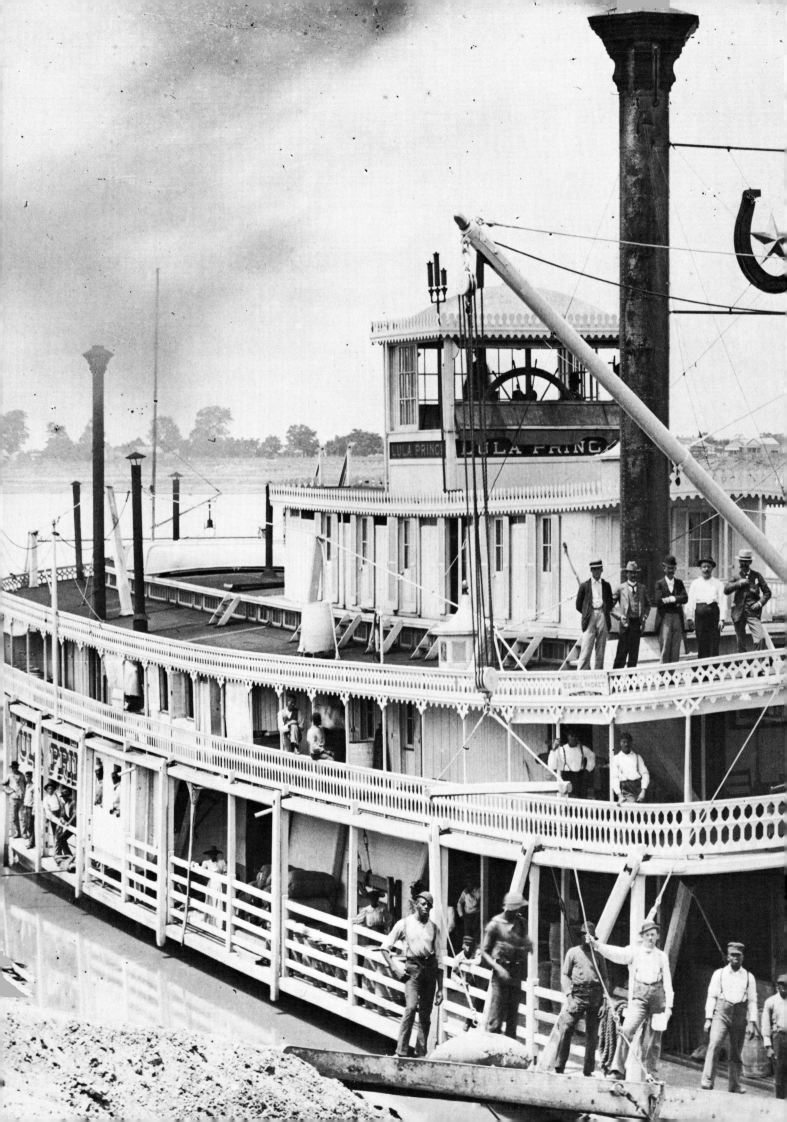

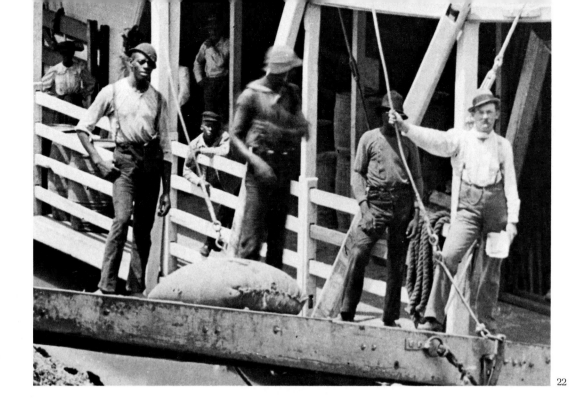

22

21. The *Lula Prince* worked in the Natchez and Bayou Sara trade in the 1890s, doing the same kind of moving of people and goods that the *Carneal Goldman* did. When the boat arrived, the stage was lowered, and the boat was tied up. The clerk then supervised the loading and unloading of the freight. 22. The clerk stood on the stage of the *Lula Prince* as the loading and unloading began. Freight list in hand, he carefully checked to see that the right bags and barrels were taken into the wharfhouse, where recipients would claim them or where a second boat would pick them up for another destination. 23. A full scale of officers and crew was essential to the smooth running of the steamboat. Captain, pilot, mate, engineer, clerk, steward, waiter, chambermaid and roustabout all filled important roles. From the pilothouse to the main deck, the crew of the *Carneal Goldman* is pictured here. The pilot may be standing on the roof of the texas and the captain in the pilothouse. The waiters and steward are on the boiler deck outside the main cabin, and the clerks, mates and engineers are on the main deck.

23

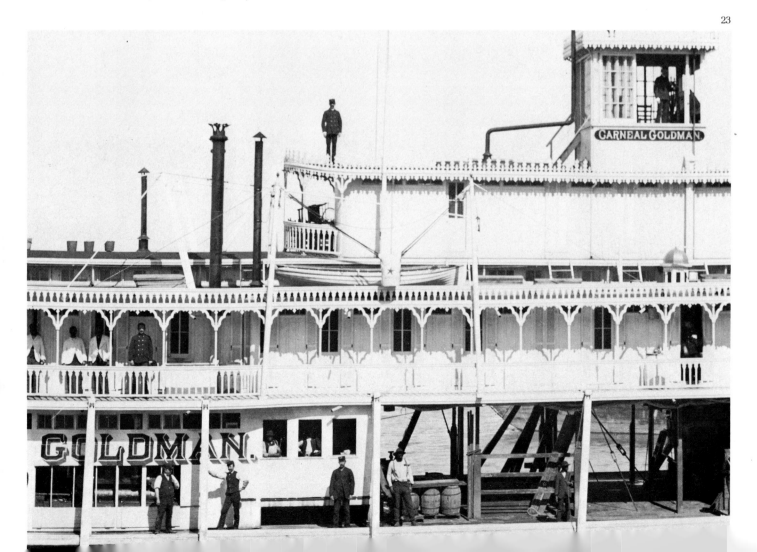

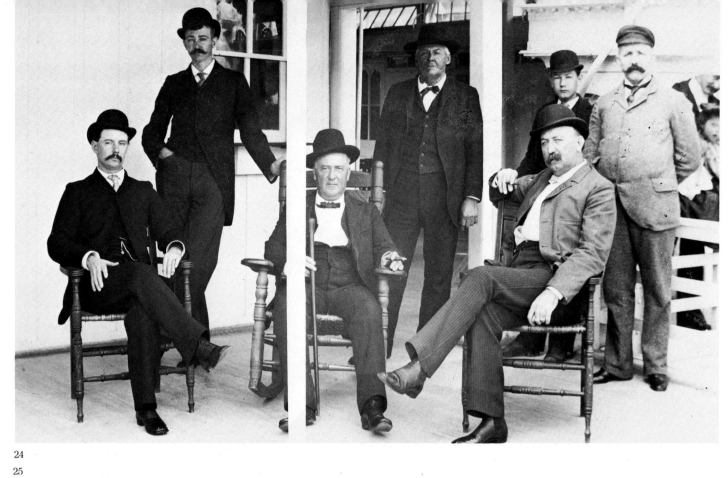

24
25

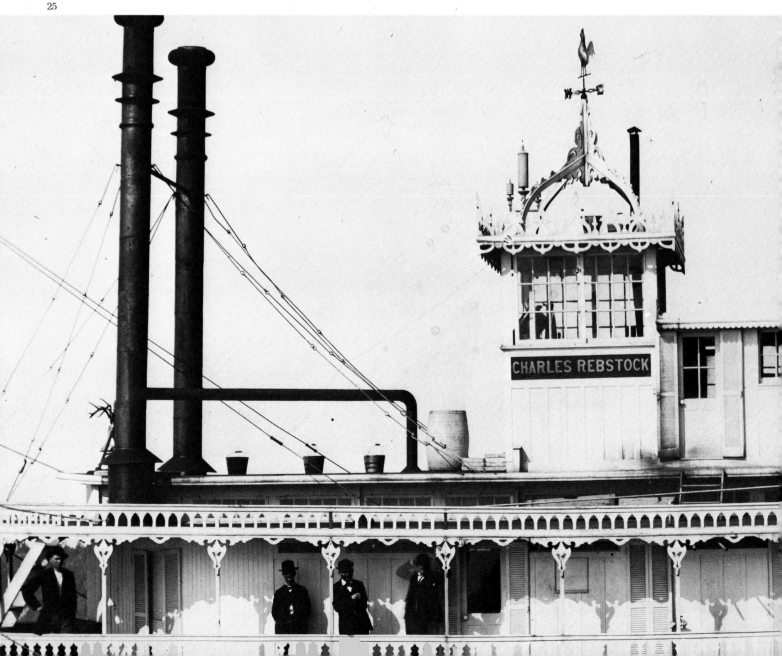

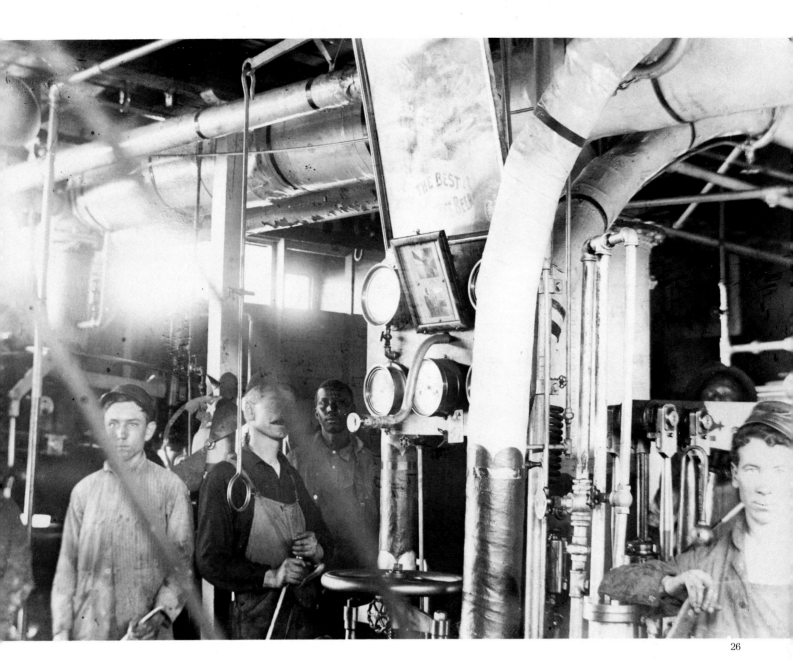

26

ɨ 24. These were probably the officers of one of the small boats. Such vessels usually followed the example set by the Anchor Line boats on the lower river as far as wages were concerned. In 1885, captains made $150 a month; pilots, $150; chief clerks, $125; chief engineers, $125; mates, $125 and carpenters, $75. Most had started out on the river as very young men. The captain, often the owner of the boat, ran the business. The pilot navigated, read the river, crisscrossed to find the best currents, dodged snags and driftwood and made notes of changes in the currents and banks to be passed on to other pilots on the river. The clerk kept books and acted as a business manager. The mud clerk supervised the loading and unloading of the cargo, while the mate supervised the roustabouts doing the loading. The engineer ran the engine room, where stokers fed the fires to keep up the steam. ɨ 25. When river editors mentioned the names of officers of certain boats, a popular thing to say was, "They are among the cleverest officers on the river." These gentlemen posing on the *Charles Rebstock* may have been its clever officers. River editors knew all the gossip on the river, and they enjoyed telling it in their regular columns. One steamboat clerk was reportedly furious at a river reporter who had mentioned in his column that the clerk's wife was traveling with him. The clerk had been courting a certain young woman in New Orleans, it was said; she visited his boat when it arrived and demanded an explanation. ɨ 26. Engineers had the hot, dirty work of keeping the steamboat's big engines going; when the pilot or the captain shouted orders from the pilothouse into the tube, the engineer replied. The speaking tube stuck out from among the gauges in this engine room.

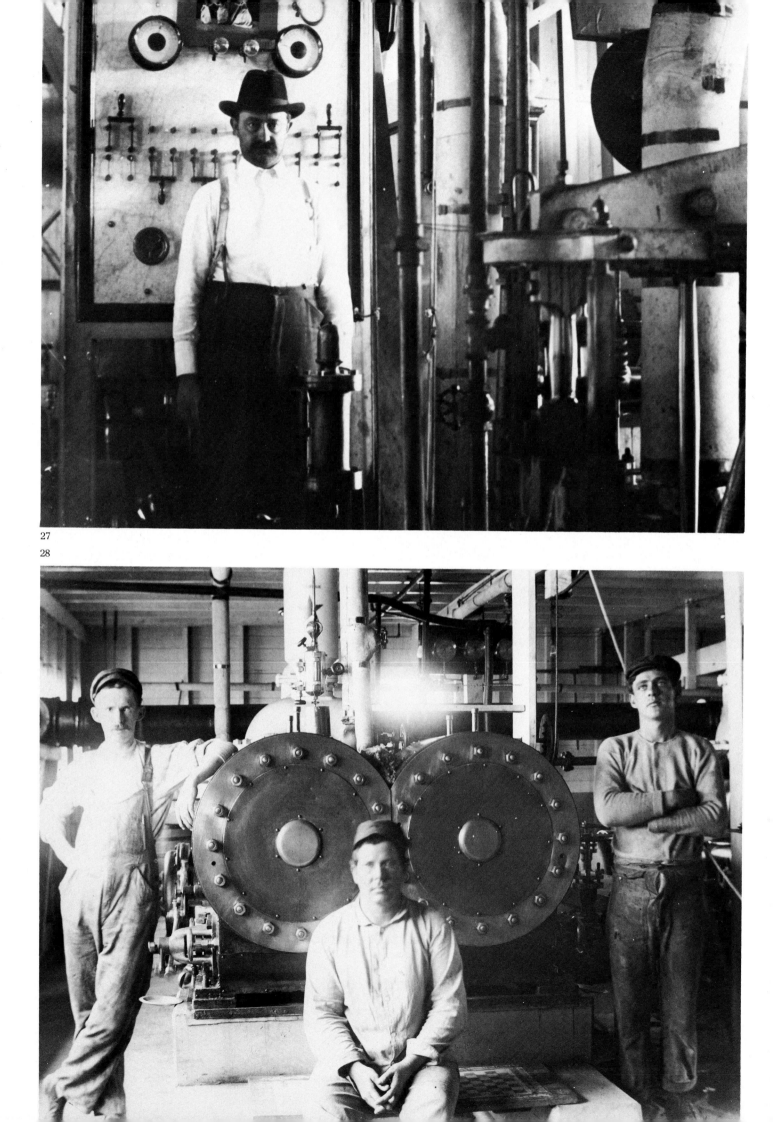

27
28

&. 27. Gauges, pipes and levers surrounded engineers and their engine-room crews. In pre-Civil War days, the engine room was the most dangerous place to be because boilers frequently blew up. Though explosions did take place after the war, they were far less frequent, and engineers were generally better trained. &. 28. Evidently some leisure time existed in the engine room, as a checkerboard was out and ready to be used when the crew had a break. &. 29. The chambermaids kept the cabins clean and did whatever other general cleaning needed to be done. These women on the *Charles Rebstock* were probably scrubbing railings or washing windows. &. 30. Trolleys, drays and carriages converged on Natchez Under-the-Hill when boats landed or departed. When two boats awaited loading or unloading, the activity doubled.

~ 31. The wharfboat, a familiar landmark at towns on the river, was made from the hull of an old steamboat. This one, made from the remains of the *Belle Lee*, served the Natchez landing from 1874 to 1886. The wharfboat, floating up and down with the rise and fall of the water, made landing easier on this fluctuating and unpredictable river. Wharfboats housed offices, storage areas, reception areas for boat crews and sometimes lodging and dining facilities.

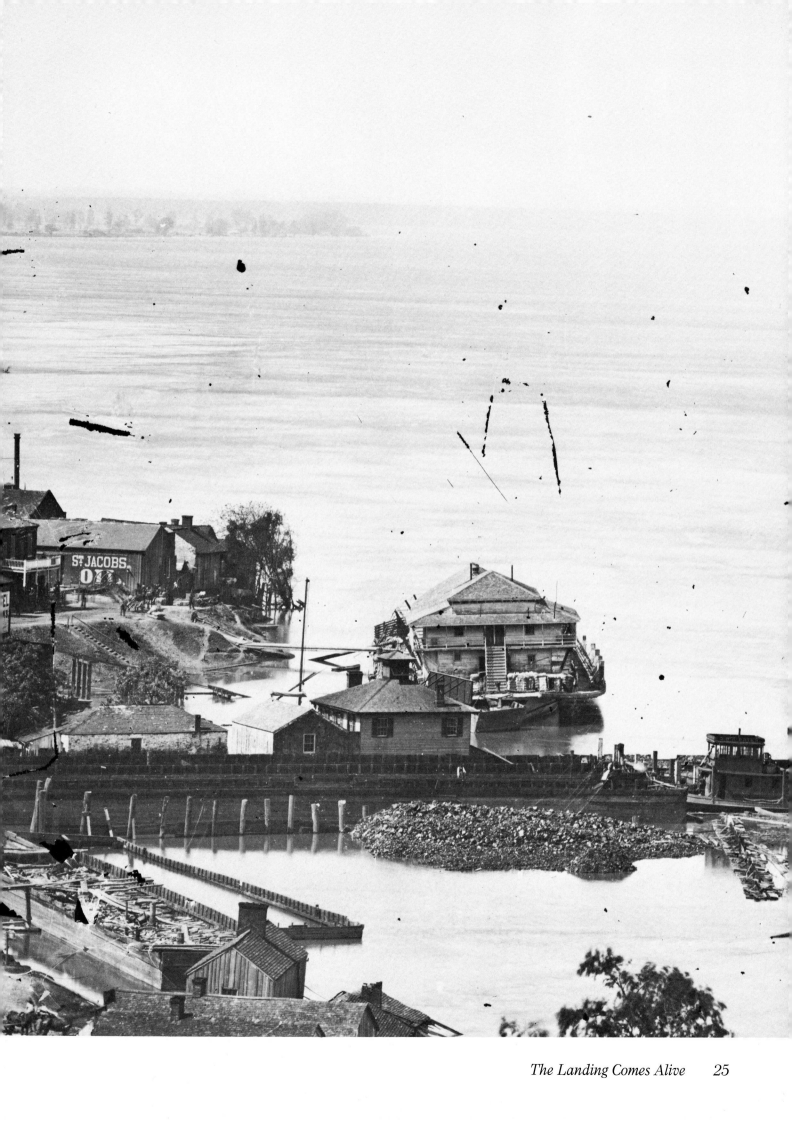

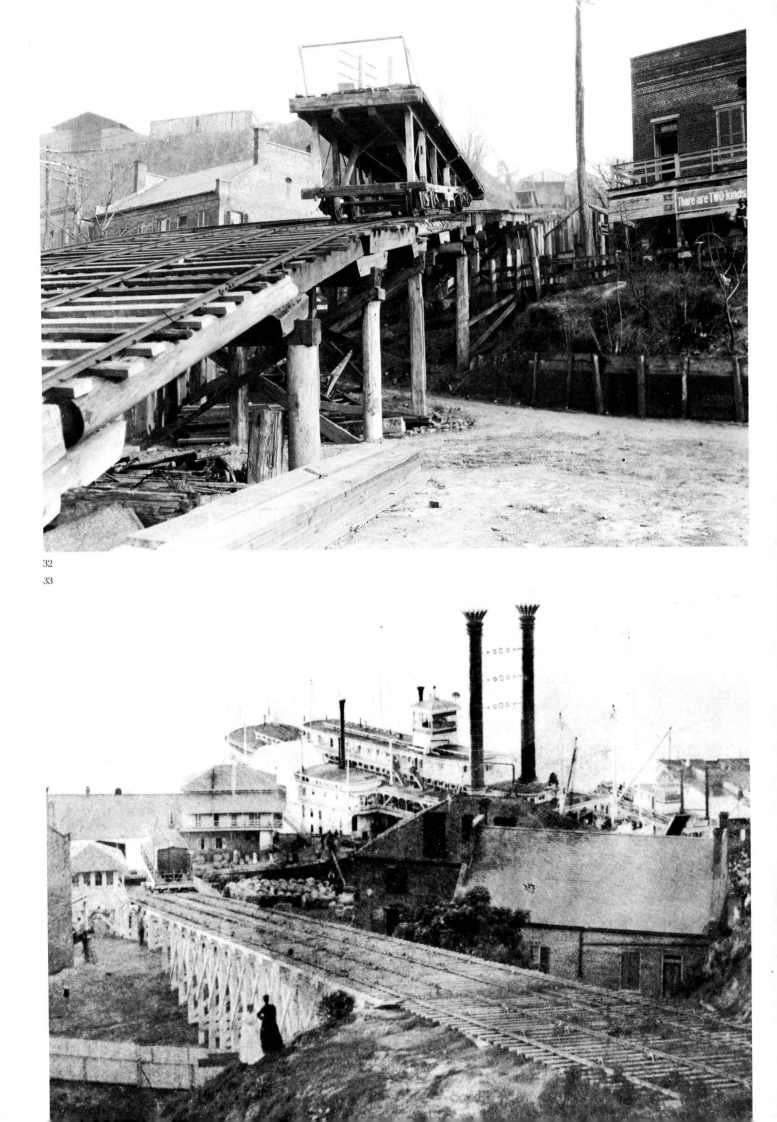

32

33

ᴥ 32. The Bluff City Railway ran down the steep incline to the wharfboat, where freight was loaded. Back up the hill, the little car awaited the transfer of the freight to a warehouse or to a railroad car that stood ready to take the freight into town or into an outlying region around Natchez. ᴥ 33. Occasionally, the little freight car took passengers up the steep bluff to the town. One spring day in 1886, a man teased a young woman saying that he would buy her a hat should she walk up the incline rather than wait for the car to come. It was reported that the young woman accepted the wager, began to climb the hill and saw the young man's jaw drop as "he stood open-mouthed as the ascent was being accomplished." The report went on to say that the young tease saw nothing that night "but visions of spring bonnets." ᴥ 34. Drays and carts, always plentiful, hauled freight from the landing to any part of the city, charging according to the number of animals required to pull the load—a dollar for a load drawn by three beasts, 75 cents for one drawn by two and 50 cents for a one-animal load.

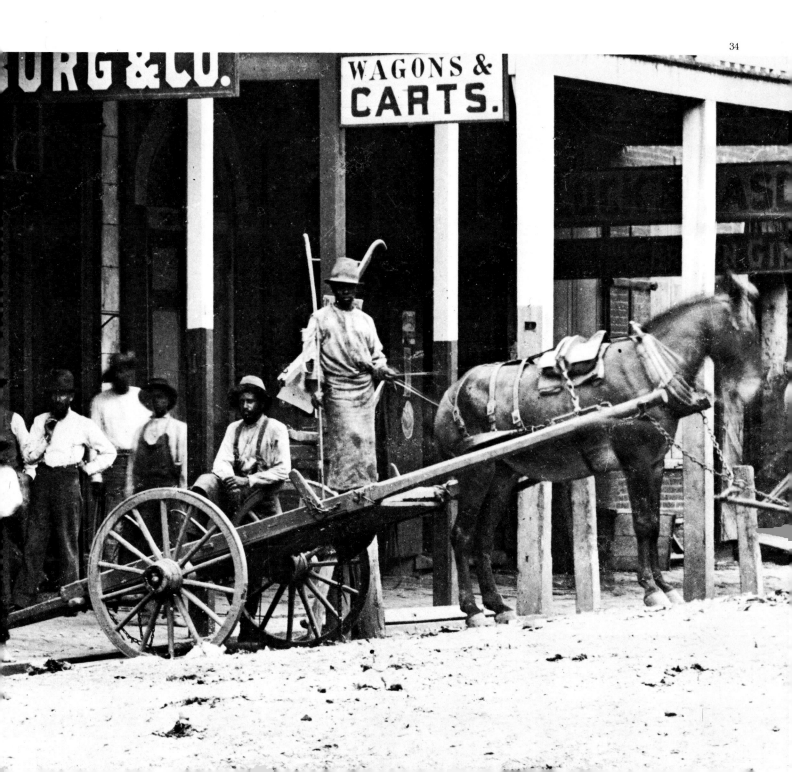

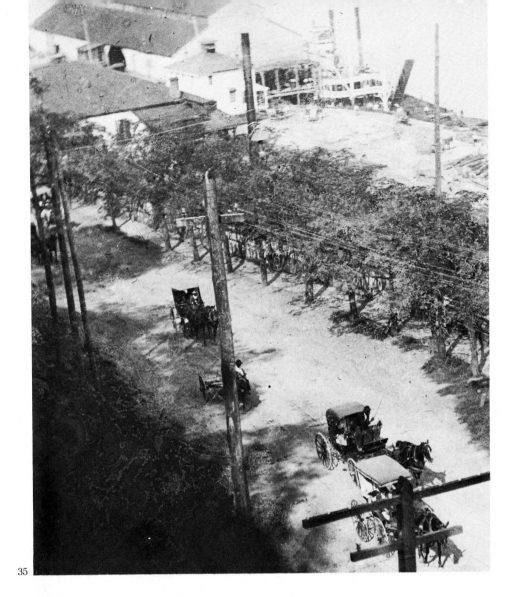

35

36

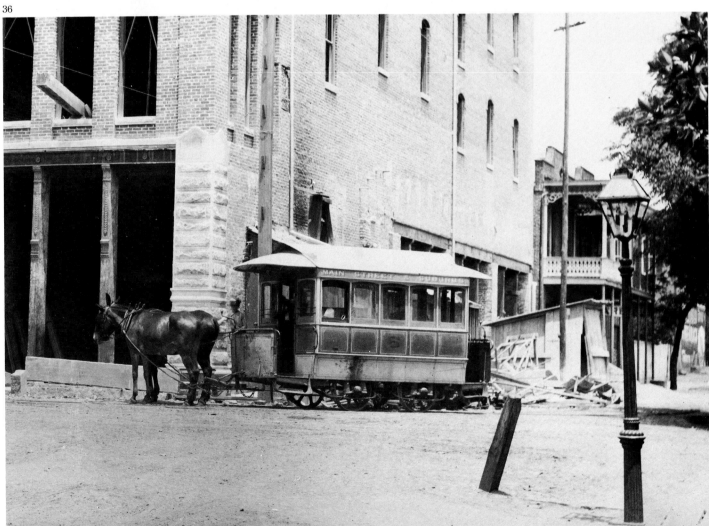

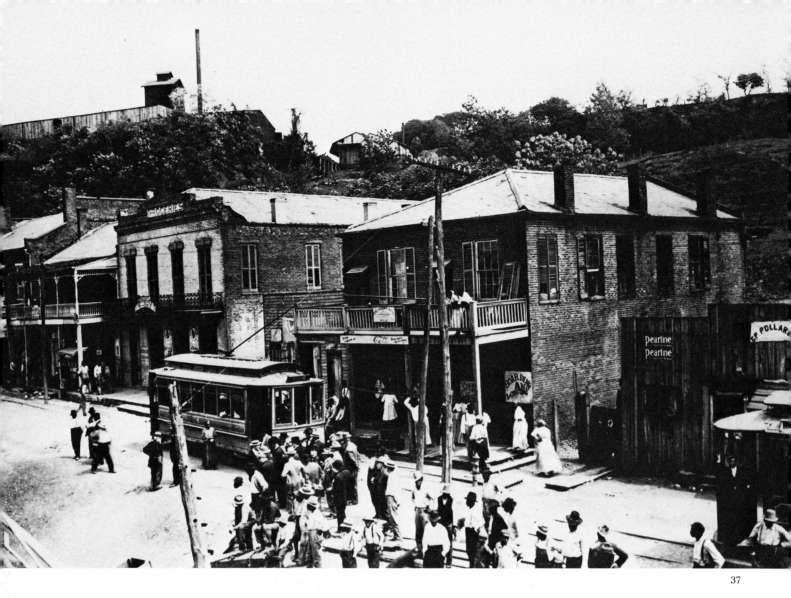

≈ 35. Passengers arriving at the landing in the 1870s and early 1880s traveled up Silver Street, where countless famous people had traveled before them, such as Henry Clay, the Marquis de Lafayette, Zachary Taylor, probably Mark Twain and Abraham Lincoln and Jenny Lind. Washington Miller, a black man who ran a carriage service for many years in Natchez, advertised in 1874 three first-class carriages, a furniture wagon and a baggage wagon available for hire to transport people and freight from the landing to any part of town. ≈ 36. By late 1885, the mule-drawn trolley ran up Silver Street and into the middle of town as another choice of transportation from the landing. Frequently, especially in the early spring, northern steamboats with large numbers of passengers stopped at the landing for an afternoon with the sole purpose of allowing people to tour the town. The Natchez paper noted on an August day in 1885 that ex-President of the Confederacy Jefferson Davis and Mrs. Davis took a drive about the city while their boat was at the wharf. ≈ 37. After the turn of the century, an electric trolley served the Natchez Under-the-Hill landing. Despite the decline in river traffic by that time, the river continued to serve local people and freight.

The Landing Comes Alive 29

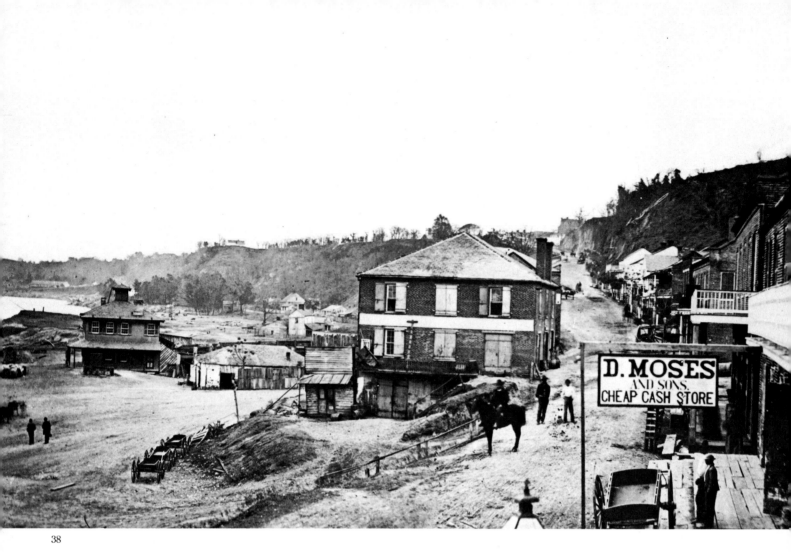

38

❧ 38. In the 1870s passengers disembarking at Natchez Under-the-Hill saw this small settlement, which consisted of a few modest houses and a number of businesses offering the basic necessities to those who depended upon the landing. Although lodging was available, most people chose to travel up the dirt street into town, where better accommodations were available. ❧ 39. Typical of a Mississippi River landing establishment, the saloon sold boat supplies right along with beer and whiskey. The gentleman with his family perhaps came to meet a friend or relative expected on the arriving boat. If the occupants of his cart were departing passengers, however, he may have had visions of returning to the saloon rather shortly. ❧ 40. Some of the businessmen at Natchez Under-the-Hill gathered for this photograph, the occasion for which is not known. It's a good guess that they were the ones who kept the landing—and consequently themselves—prosperous in the late nineteenth century. The children on the steps are those of J. B. O'Brien, who ran the Natchez coal company and was captain of a tugboat bearing his name.

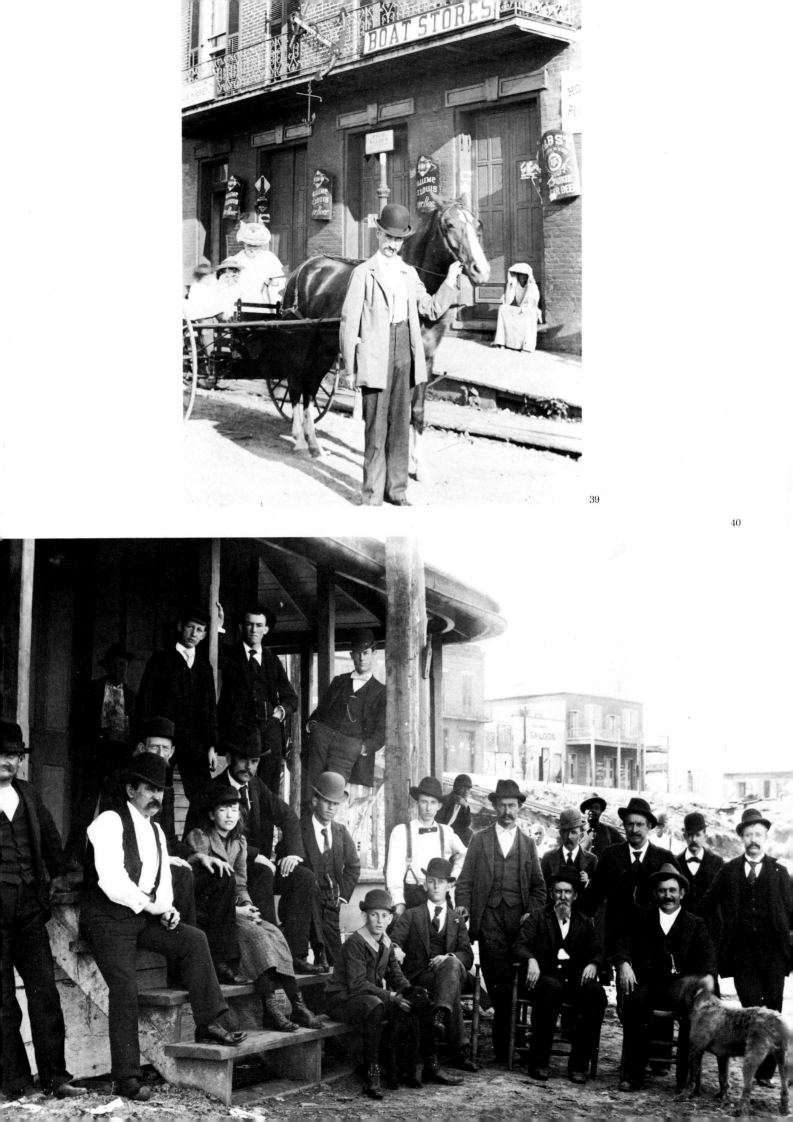

A River Town

Visitors disembarking at Natchez Under-the-Hill and traveling into the town on the bluff some 200 feet above the landing found Natchez a pleasant, attractive little commercial center. It served outlying plantations and small neighboring towns in inland southwest Mississippi as well as people in the flat farmlands across the river in Louisiana.

Laid out in squares in the 1790s by the Spanish who then governed it, Natchez had grown from an Indian village to a French fort and settlement in the early 1700s. Settled at first primarily on the river landing at Natchez Under-the-Hill, where it gained notoriety for its vice, the town grew to the top of the hill when families made wealthy by cotton built splendid mansions there as the nineteenth century progressed.

🪶 41. Fertile land for cotton, the invention of the cotton gin in 1793, the influx of slave labor and the development of Mississippi River steamboats contributed to the town's growth. Virtually untouched by the Civil War—although many Natchez men took part and lost their lives, and many families lost their fortunes—Natchez, like the Mississippi River steamboat, made a comeback in the postwar years.

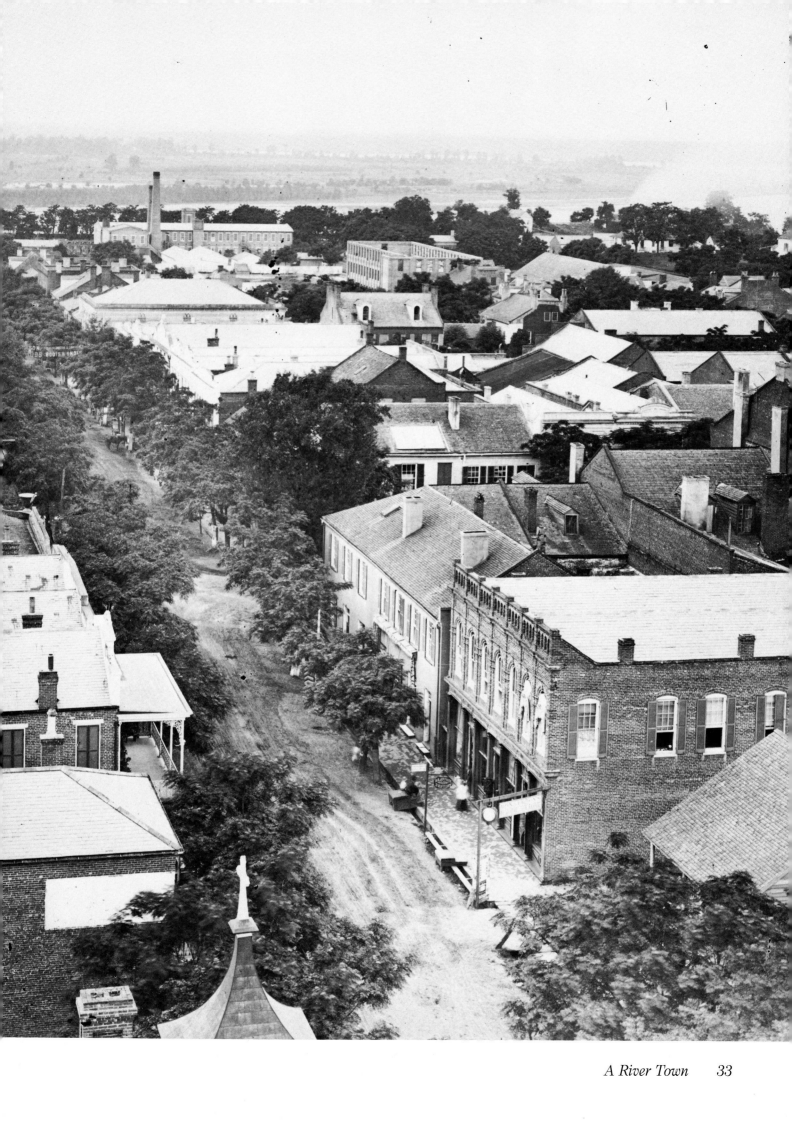

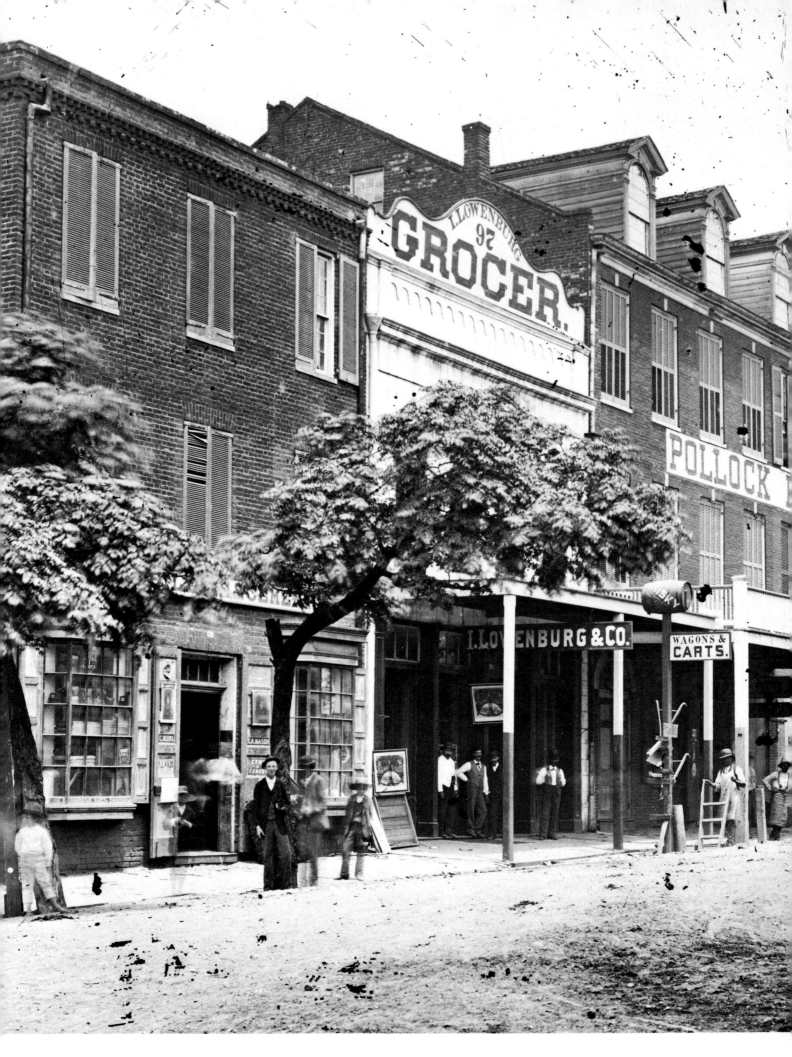

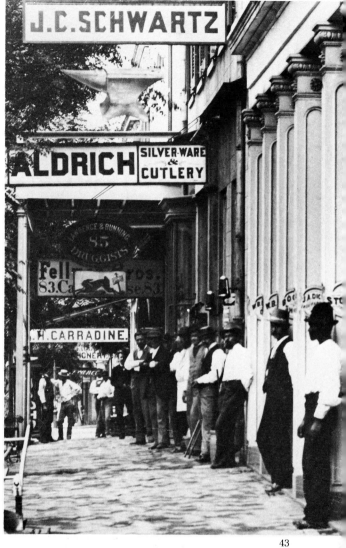

43

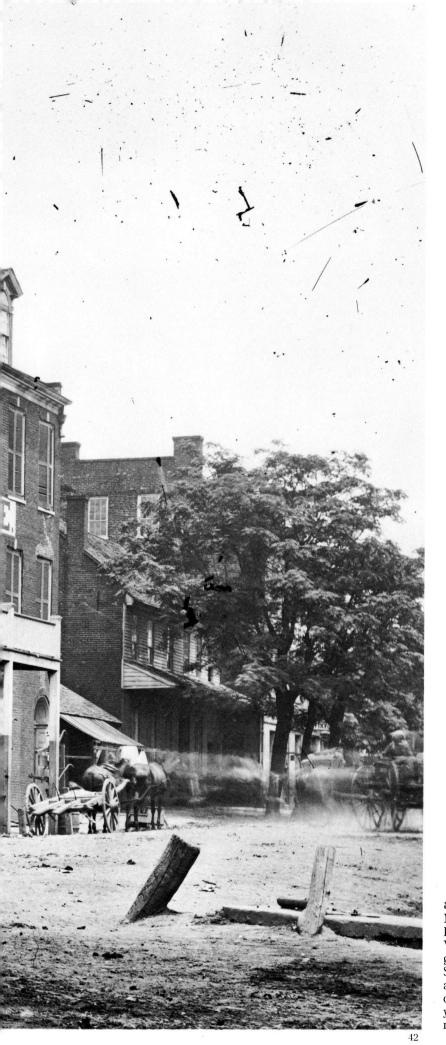

42. For visitors wishing to stay overnight, one of Natchez's hotels in the 1870s was the Pollock House on Franklin Street, which was in the cotton-trading district. Within a few blocks were shops selling just about all the goods a shopper in those days could have wanted. 43. Shoppers found all the necessities, as well as luxuries aplenty, when they came to Natchez. Hardware, drugs, clothing, farm supplies, jewelry, books, household items, yard goods, furniture, musical instruments, liquor, carriages, mules—all were available in abundance.

42

ᴥ 44. Some visitors went to doctors, dentists, lawyers and bankers while in town. In addition, they found a choice of restaurants, an opera house and imposing churches. ᴥ 45. As some of the most palatial mansions in the South had been built in Natchez during the days of great cotton wealth and had survived the Civil War, hosts of visitors off the boats took carriage rides around the town and into the surrounding suburbs to view them. A visitor to Natchez in 1891 wrote:

> Not a city in the land can present finer attractions as a winter resort for Northerners than this. Street cars run in four directions, the mules making good time. Being the first really high land north of New Orleans on the river, at an early day it was selected by the wealthy planters of Mississippi and Louisiana for their homes, immense outlays being made by each to imitate the English nobility, residences costing from $90,000 to $125,000, with private billiard halls, bowling alleys, tutor's apartments, etc., with fine servants' quarters outside but finished to comport with the mansions. In the spacious grounds are often fine artificial fish ponds while avenues of live oak and water oak, magnolias and cedars wind here and there in graceful curves, often weirdly draped with the long moss. The privilege of going through some of these palatial relics of "ante-bellum" days was given us—immense dining rooms with their large central fans still suspended where they were waved by some slave in the days of American royalty.

The writer went on to praise the beauty of "ancient candelabra, sideboards in mahogany, and bedsteads in mahogany with elegant carved canopies" as well as "exceptionally refined and cultivated people." ᴥ 46. Another favorite stop for steamboat passengers, from as early as the 1840s, was for many years the grounds of a Mr. Andrew Brown. After building a lovely home on a flat protected vale just north of the Natchez Under-the-Hill landing, Mr. Brown designed formal gardens known up and down the river for their beauty. ᴥ 47. Brown's gardens followed the graceful curvatures of the land. Paths, walkways and quiet places from which to watch the river were carefully woven into the design.

44

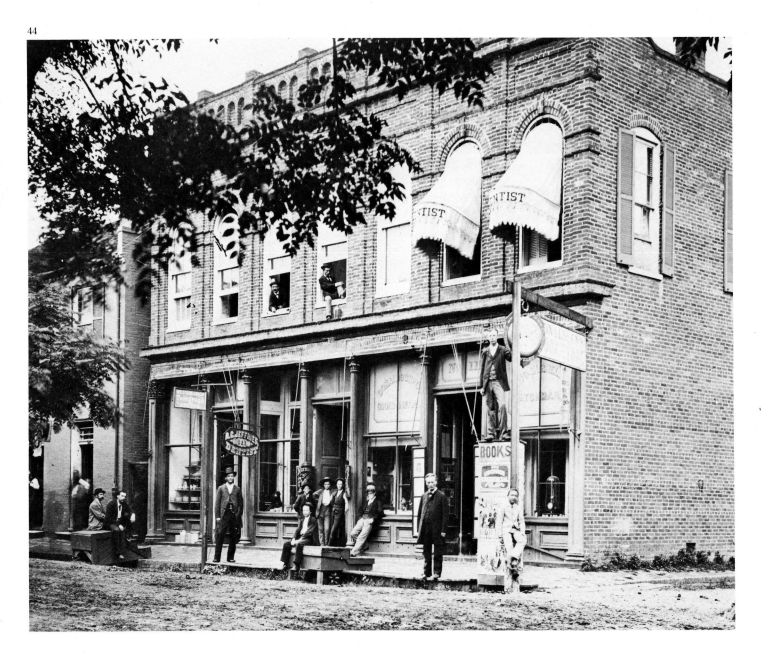

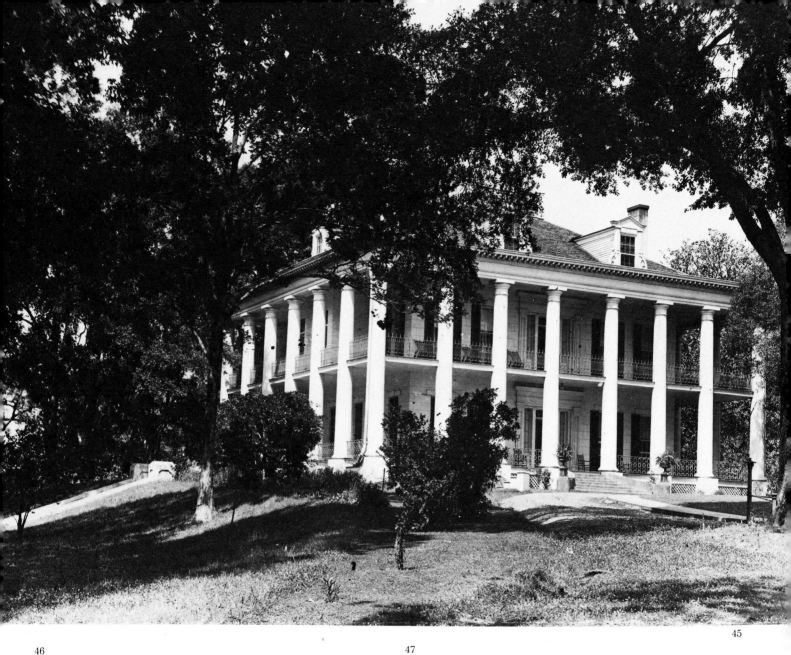

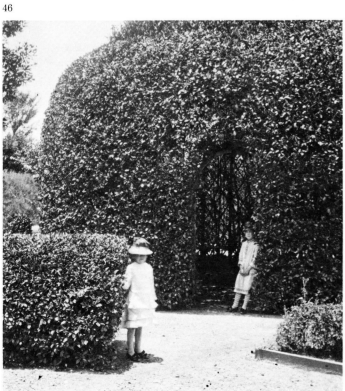

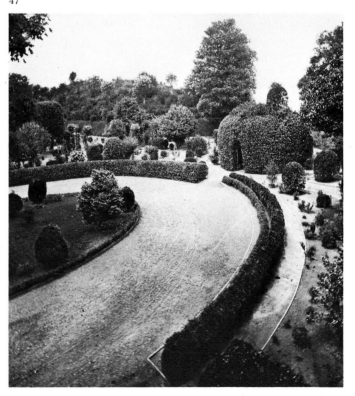

"Crazy on Cotton"

Boats large and small—cotton carriers, excursion packets, local traders and iron-hulled tows pushing acres of coal barges—in and out of the landings they steamed. Mammoth boats from Cincinnati, St. Louis, Memphis and New Orleans landed at towns like Natchez for freight and passengers, taking them on and letting them off as the tall chimneys snorted and puffed impatiently. Bales, barrels and sacks were passed on at one landing and off at another as the carriers went south and returned north.

Boats worked in "trades"—the St. Louis and Memphis trade, the Natchez and Vicksburg trade, the Cincinnati and New Orleans trade and on and on in countless combinations between ports. Small boats, such as the ones working between Natchez and Vicksburg, Natchez and St. Joseph or Natchez and Bayou Sara, were "local traders" or "short traders."

What a steamboat carried was a "trip" (a large trip of cotton, for example). A boat heavy with cargo was "flat in the water" or "loaded to the guards," or "its guards were dipping water." In cotton season, officially opening on the river on the first day of September, almost every boat carried a trip of cotton. Although steamboatmen turned their attention to passenger comfort and luxury in the years following the Civil War, it was cargo that would make or break river transportation and, on the lower river, "cargo" meant cotton.

Cotton-carrying boats were therefore designed to carry the maximum number of bales they could bear. Wide "guards" extending from the decks provided bases for mountains of bales. In every other available spot were piled sacks of cottonseed and cottonseed meal, barrels of cottonseed oil and other freight. Cotton season transformed passengers' cabins into dark caves, as bales were stacked nearly to the top of the boat. Strolls around the deck were confined to the uppermost part of the vessel and, not uncommonly, right on top of the cotton.

Planters grew cotton to a fault along the lower river. One observer from the North in 1883 said of Natchez, "People in this part of Mississippi are clean crazy on cotton. The butter on the table comes from the North, the hams from the Northern prairies, the potatoes from the North, but cotton comes right out of the soil and nothing else does. Given a man and a mule and they will take to cotton as naturally as a gander and a goose to a pond."

Merchants, like planters and steamboatmen in the small river towns, were dependent on cotton, too. During the seasons, sidewalks of shopping districts drew complaints from pedestrians because of cotton, boxes, barrels and goods on exhibition in front of the stores. Merchants hoped to draw in the country people who had come to town to sell or swap their cotton to get supplies and household goods. And it was reported that on a day in June a merchant on Natchez's Franklin Street might see a bale of cotton coming "half a dozen squares away" and jump on it like a spider on a fly, so rare was a bale during that time of year.

In mid-August, newspapers in cotton towns began to make such comments as, "It will not be long before the fleecy staple will begin rolling in, and business will open with a boom." The arrival in town of the first cotton of the season was noted with excitement. The first brought in for ginning in August 1884 came with a national flag waving over it. By the wagon load, the "fleecy staple" made its way from field to gin, where nearly 7,000 bales in one month might be readied for transportation or for storage in huge cotton sheds owned by local cotton factors and commission merchants. Some of the cotton compressed at small gins would be recompressed in New Orleans to reduce the bales by as much as a third before shipment to faraway ports.

Down from Memphis, stopping at perhaps 40 or 50 landings on the way to New Orleans, big carriers loaded 4,000 to 7,000 bales onto their decks for one trip. At a dollar a bale and two trips a week, profits were big, even if only during that time of year. Some big boats stripped their cabins for the season in order to carry as much freight as possible.

Enterprising merchants in the small river towns began to build mills to manufacture cotton cloth and to cash in on the growing demand for cottonseed meal and oil. In Natchez, by 1884, the cotton mills were manufacturing eight million yards of cloth a year, and its two oil works were also highly productive.

Some of the same businessmen owned the local boats, which were the lifelines to many plantations deep in cotton country on small rivers and bayous. These local traders carried perhaps several hundred bales of cotton on an average trip in the season, transporting the cargo to Natchez, where larger carriers would load it up for New Orleans or local merchants would take it on commission. The *Charles Rebstock* was such a boat, steaming back and forth three times a week between Natchez and St. Joseph in the early 1880s. The same trip was made in the 1890s by the *Saint Joseph*.

Of the large carriers making connections with boats like the *Charles Rebstock* and the *Saint Joseph*, there seemed inevitably to be one named *Natchez*. The cotton ports along the lower river were rarely without a boat by that name through the years and appropriately so, since it was at Natchez that the whole cotton craze on the river began. The famous *Natchez* boats were built by the well-known river man T. P. Leathers who, in fact, was at the helm of the *Natchez* that lost to the *Robert E. Lee* in the famous race of 1870.

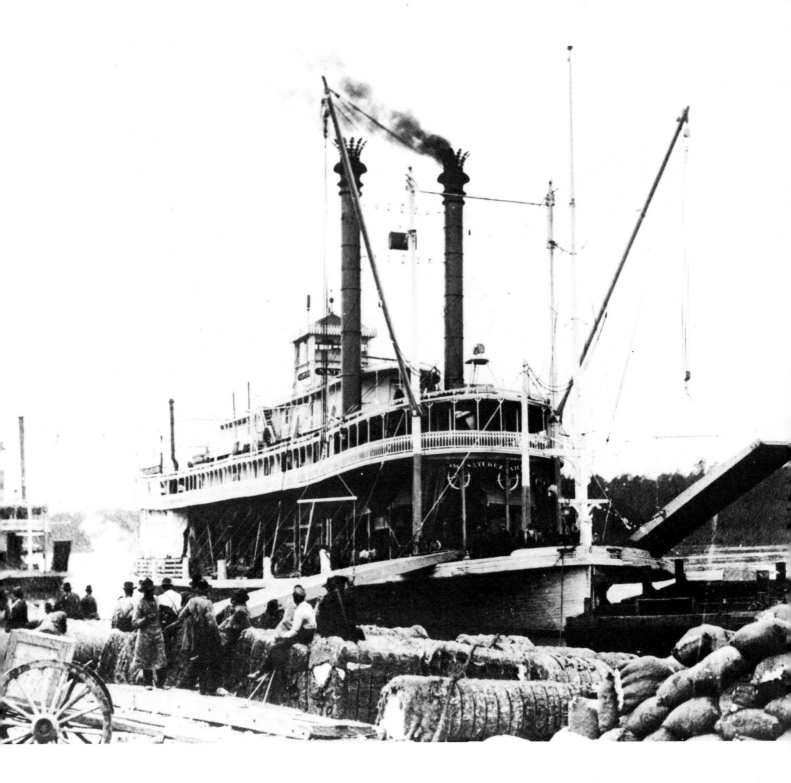

ಜಿ 48. The *Natchez* approached a landing where roustabouts waited to load and unload cargo. The boat's gangplank, called a stage on Mississippi River steamboats, jutted out in front of the boat and was maneuvered into place on the landing by the lowering of the boom to which it was attached. The little dray to the left probably brought a couple of bales for shipment and was waiting to carry some arriving cargo to its destination. The boat might have made as many as 50 landings before reaching its destination in New Orleans.

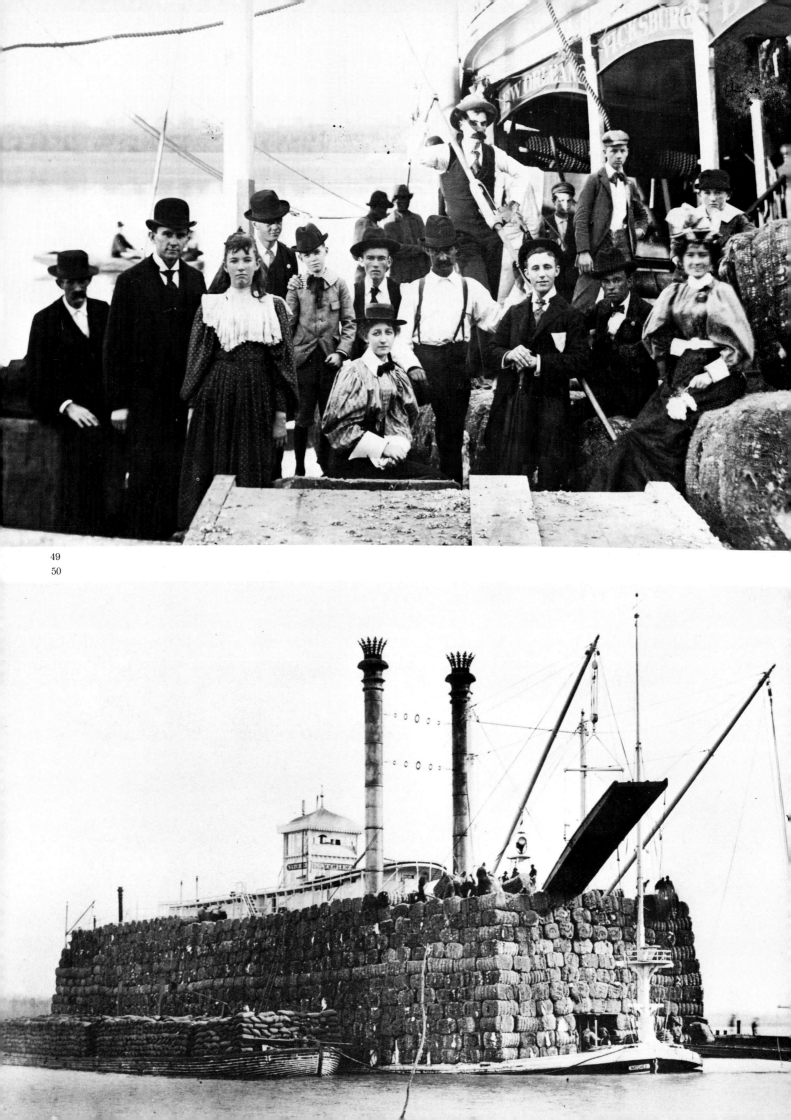

49
50

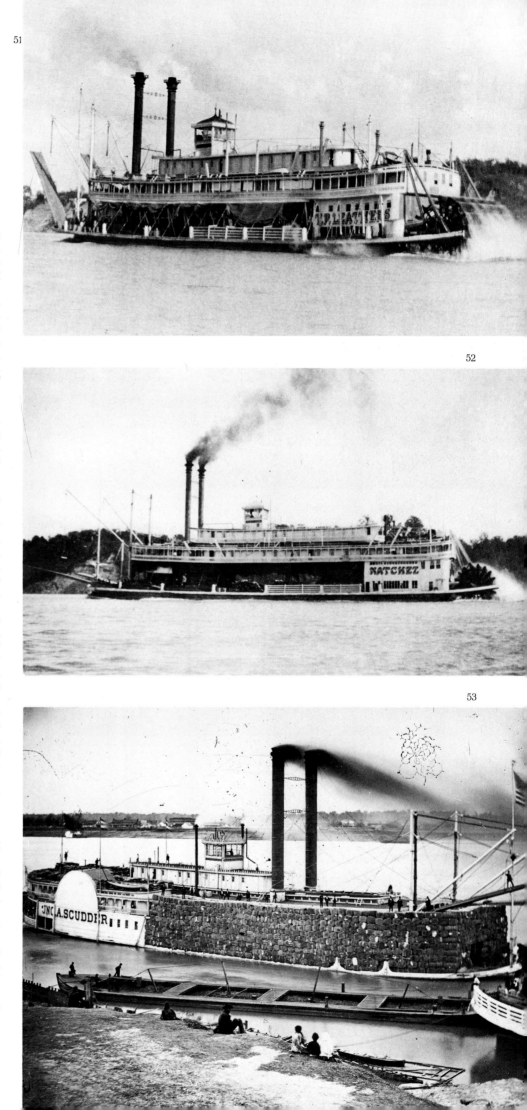

🍂 49. Cotton on the landing, all over the steamboat decks and guards and on drays and wagons moving through the town didn't seem to bother people in river towns where the economy depended on a good cotton season. These people boarded the boat right along with the cotton that had already begun to fill the main deck. 🍂 50. "Loaded to the guards," as the river men said, the *Natchez* was smothered in cotton on this trip and carried, in addition, a large tow of cottonseed or cottonseed meal alongside it. The last *Natchez* and the last *T. P. Leathers* were among the most popular medium-sized cotton carriers on the lower river. Both were owned and operated by the Leathers family, and both were built in 1891 to replace boats by the same names that had been lost in river disasters. 🍂 51. The *T. P. Leathers*, the third boat to bear the name of the famous captain, was among the last boats to operate successfully in the cotton-carrying trade on the Mississippi in the nineteenth century. Capt. T. P. Leathers, whose family carried on the trade for some years after his death, spent a lifetime on the river, where he survived many disasters. In what seems a strange twist of fate, the seasoned river man, at age 80, was struck by a bicycle near his home in New Orleans in 1896 and died from injuries sustained in the accident. 🍂 52. The last *Natchez*, when not loaded up to the texas with cotton, displayed a handsome form as it churned the Mississippi waters on its way up and down the river. Both the last *Natchez* and the last *T. P. Leathers* were about 225 feet long and 40 feet wide. This *Natchez* was the only stern-wheeler by that name and was commanded by Capt. Bowling Leathers, son of the famous captain. When Bowling's wife Blanche received her pilot's license in 1894, she often commanded the boat. In its first year, the *Natchez* made 50 trips between New Orleans and Vicksburg and carried a total of 56,847 bales of cotton; 78,037 sacks of cottonseed; 628 bales of moss; 32,651 sacks of cottonseed meal; 2,287 sacks of rice; 771 barrels of oil; 11 hogsheads and 3,329 barrels of sugar; 2,035 barrels of molasses; 52,901 pieces of oak staves and 6,286 miscellaneous packages. 🍂 53. The *John A. Scudder* pulled into the Natchez wharfboat with "its guards dipping the water," one way river men had of describing a boat loaded with cotton. The wide guards extending from the decks appeared at times to skim the very surface of the river, as they certainly did this day on the *Scudder*. One of the champion cotton carriers in the Memphis and New Orleans trade from 1873 to 1885, the big *Scudder* was dismantled at the end of its career, and its hull was converted into a wharfboat at Vicksburg.

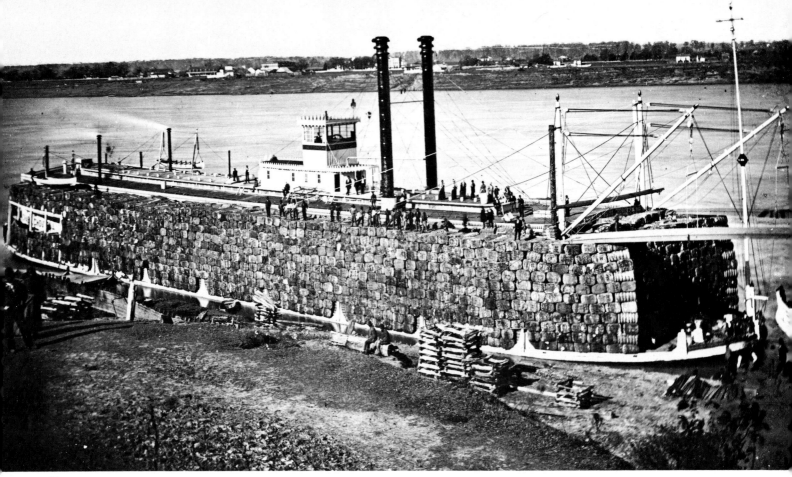

54

54. Another Memphis and New Orleans cotton carrier, the *Charles P. Chouteau* held the record for transporting the most cotton in one season—nearly 77,000 bales. The largest single trip for this boat was nearly 9,000 bales, carried in 1878. Just such a load as this caught fire on the *Charles P. Chouteau* as it was stopped at a landing near Greenville, Mississippi, in 1887. Starting on a lower tier, the fire spread rapidly in the high wind. The boat burned right down to the iron hull that had given it the nickname "Iron Charley." 55. From 1878 to 1887, the giant *Charles P. Chouteau* was the largest stern-wheeler on the river. While built specifically to carry cotton, the boat also carried passengers, who obviously accepted the fact that they might not see the light of day from their staterooms or the main cabin during the entire trip. A load such as this demanded the work of many roustabouts, some of whom stood on the top tiers of cotton as the boat came into the landing.

55

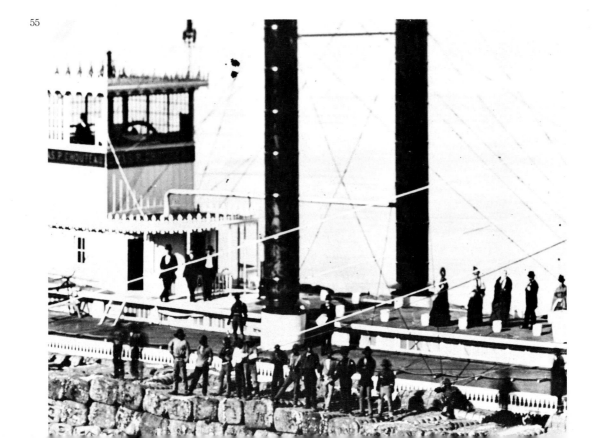

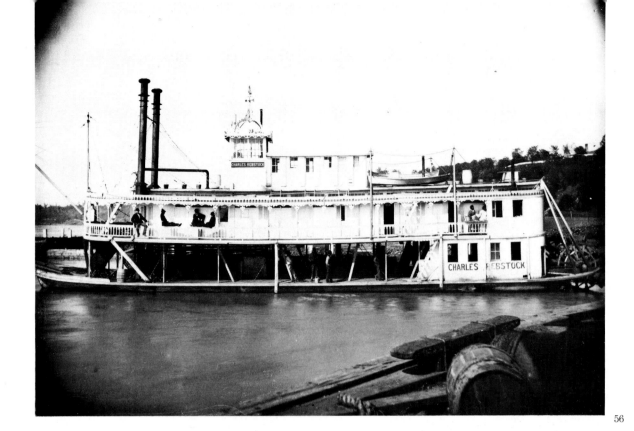

☙ 56. Typical of the picturesque little boats known up and down the river as local traders or short traders, the *Charles Rebstock* made the run from Natchez to St. Joseph three times a week for businessman Joseph N. Carpenter, its owner. The *Charles Rebstock*, commanded by a young captain named Charles D. Shaw, carried plantation supplies and household staples on the trip out and brought back cotton and fresh farm produce to Natchez. Boats such as this took orders from country people and general stores, purchased the products when in Natchez and delivered the requested goods on the next trip out to St. Joseph. The *Rebstock* worked at Natchez in the early 1880s and was sold in 1883 to a Yazoo City, Mississippi, man. It then passed into the hands of an Iowa river man, who ran the little boat as a local trader until it burned in late 1885 at Cordova, Illinois. ☙ 57. The *Saint Joseph*, another local trader, ran three times a week to Vicksburg and back in the 1890s. These small boats carried several hundred bales of cotton when fully loaded. A fairly typical size, the *Saint Joseph* was 175 feet long and 32 feet wide. When it was launched in 1893, a report said that it had "all the appliances modern genius can invent and skill execute." Surviving good and bad economic times, the *Saint Joseph* worked throughout the 1890s in and around Natchez. It was sold in 1905, taken to Pittsburgh and renamed *Island Queen*.

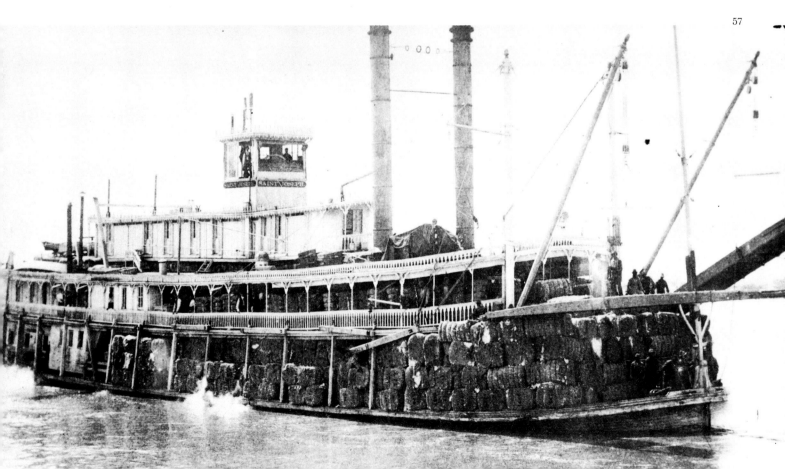

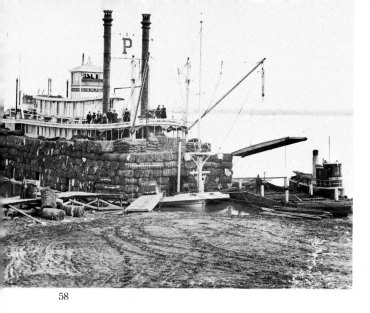

58

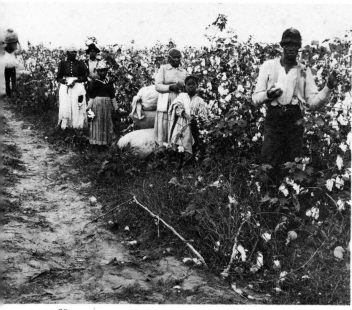

60

59

🍂 58. The *Bob Blanks*, one of the last of the successful cotton boats, was launched in 1903 and burned in 1912. During these years, more and more cotton shifted to the railroads for transportation and on the river, the shift was away from the cotton carriers and toward the barge lines. By 1920, diesel was replacing steam to provide power for Mississippi riverboats. 🍂 59. The last of its kind on the lower Mississippi, the *Tennessee Belle* provided yet another generation the opportunity to experience the coming and going of a cotton-laden steamboat. The *Tennessee Belle*, built in 1927, worked on the river until 1942 when, just a few miles below Natchez, it burned. 🍂 60. When cotton pickers went to the fields in the rich river lands on the lower Mississippi, steamboatmen began to prepare for the coming season by overhauling their boats and lining up business on the river landings. Through the humid days of late summer and early fall, cotton pickers, much as they had for several generations, gathered the valuable crop in the first step on its journey to the river landing.

44 "Crazy on Cotton"

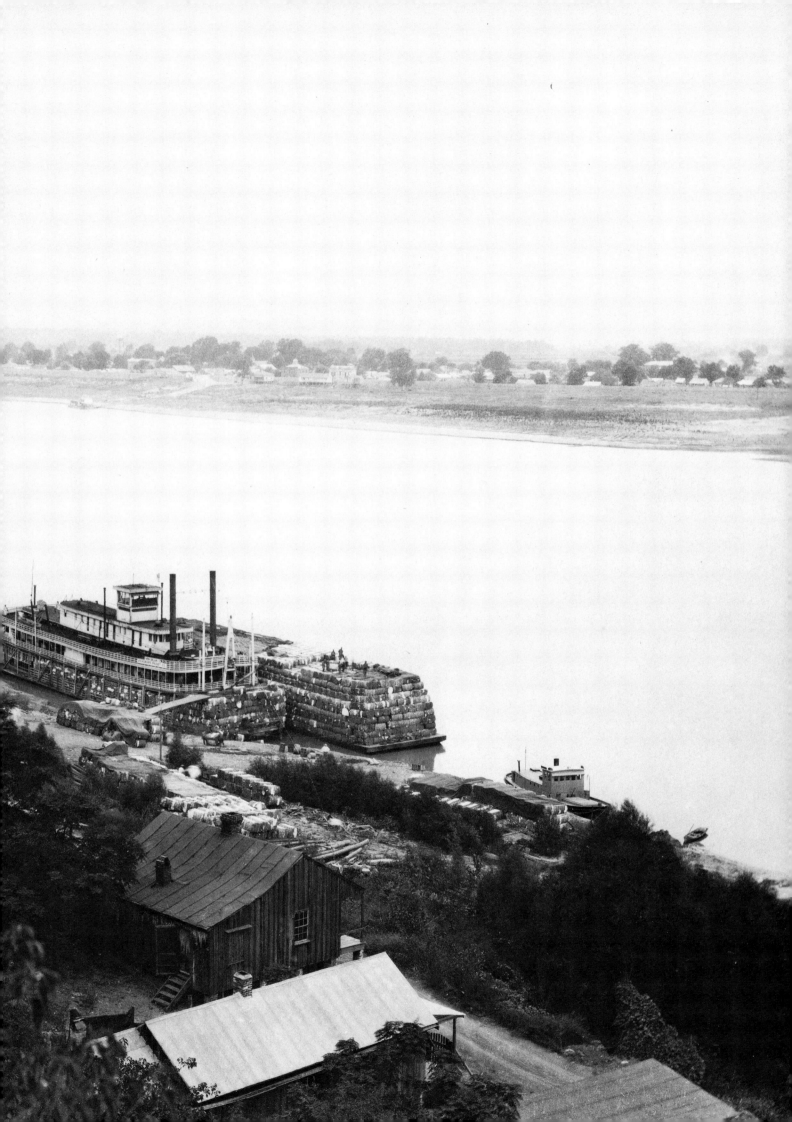

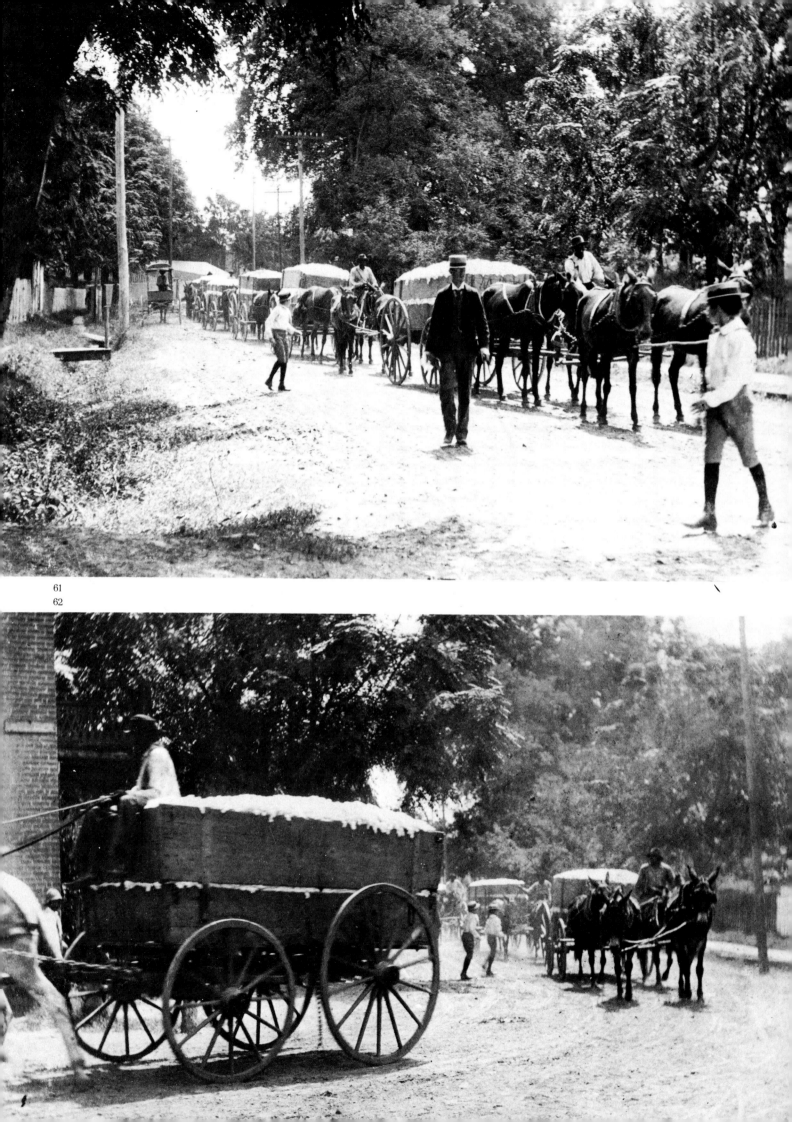

61
62

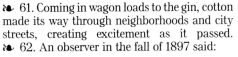 61. Coming in wagon loads to the gin, cotton made its way through neighborhoods and city streets, creating excitement as it passed. 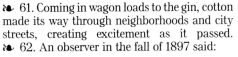 62. An observer in the fall of 1897 said:

> The influx of caravans of cotton-laden wagons attracts the attention of the stranger and the resident. We were looking at numbers of them passing over the thoroughfares of Natchez yesterday, each vehicle groaning under the weight of the fleecy staple. The propelling power varied from oxen to mules—principally the latter. Observing a small wagon, loaded with cotton, drawn by mules, driven by a negro, with the look came the thought that the scene was a living picture of the South's rulers—the negro, the mule, and cotton.

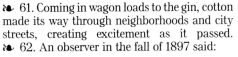 63. Planters, field workers and gin managers gathered in anticipation of the busy season, a time when the entire town's attention understandably turned to cotton, since a good year for cotton meant a good year for the town. Weighing the first bale, perhaps, the well-dressed gentlemen might have included a planter, a cotton merchant, a steamboat captain or a mill owner, all parties vitally interested in the fate of the bale. Each season it was announced who brought the first bale into town, which agent took it on commission, where it was ginned and which carrier took it to its destination. 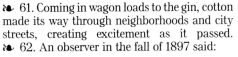 64. Transported by mule-drawn wagon, cart or dray to the landing, cotton awaited the steamboat that would carry it to its destination. The mule played an unquestionably important role in the production of cotton in the South, and Southerners never underestimated the importance of the animal. When Rumble and Wensel's 30-year-old mule "Old Rock" died, an obituary appeared in the local paper. Stories praising mules' intelligence abounded, like the story of the mule that jumped overboard from a boat in 1888 as the boat steamed down the river. On the return trip, the crew noticed a mule trotting along the bank and acting as if it wanted to get aboard. Believing it must be the mule that had jumped ship, the crew landed and put down the stage, and the mule trotted aboard and took its place in the pen.

63
64

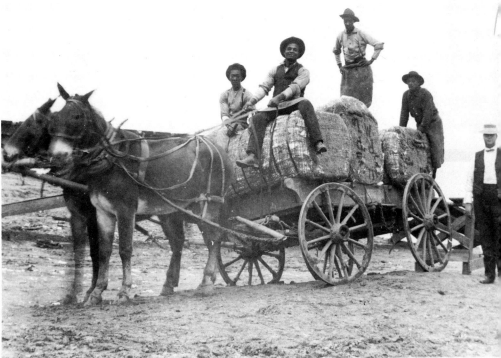

Cotton, Coal, Mail and Molasses

Tons of freight moved down the river to Southern markets throughout the year, and the big boats from the North stopped to discharge their freight whether there was cotton to pick up or not. They brought barrels of meat, salt, apples, cornmeal, flour and oats; kegs of New York butter; boots, shoes, millinery and dry goods from the East; iron products from Pittsburgh; whiskey and mules from Kentucky; and bales of hay.

At a small town like Natchez, a wholesaler such as Rumble and Wensel might have received on a typical day from a Cincinnati or St. Louis boat a hundred or more barrels of flour; a couple of dozen boxes of cheese; ten barrels of meal, beans, dried apples and pickles; 500 pounds of bologna sausage; 30 boxes of crackers and a lot of vinegar, cider and Blue Ribbon beer. The same shipment might have brought the J. C. Schwartz hardware store 400 kegs of nails, perhaps the new steel ones; a couple of Buck Brilliant stoves; and a shipment of guns from New York.

Before leaving a wharf such as that at Natchez, the big boats might have picked up, in addition to cotton and meal, a big shipment of lumber. During one several-week period in June, 750,000 feet of lumber left Natchez. The largest mill, owned by Rufus Learned, served customers in New Orleans, St. Louis and points between, selling them both lumber and shingles. The reported capacity of the mill in 1886 was about 35,000 to 40,000 feet of lumber a day.

Boats leaving New Orleans and heading north carried sugar, rice, molasses, coffee and, in season, often thousands of fishing poles. On the way up the river, along the "sugar coast" (so-named for the acres of sugarcane grown there), the boats picked up more sugar and molasses.

One product came south in enormous quantities—coal. From Pittsburgh, on acres of barges lashed together and manipulated by powerful towboats, the coal began traveling down the river in the 1840s. Coal fired the engines of steamboats and mills and warmed the homes of the South from about that time on through the nineteenth century. While steamboats continued to use wood as an alternate fuel during that same period of time, coal was cheaper, more available, easier to store aboard the boat, more efficient and safer—especially when the boat was loaded with cotton and the tiniest spark could ignite the entire load in a matter of minutes.

At a company such as O'Neil's at Natchez Under-the-Hill, an affiliation with the Pittsburgh Coal Company virtually assured the local merchant of having a constant supply on his decked flats. Local customers depended on his coal and, of course, riverboats did also. Occasionally, a steamboat running behind schedule and not planning to stop at Natchez whistled for the little tug *J. B. O'Brien* to bring out a flat of coal. The flat was taken out to meet the big steamer, lashed to the boat while the coal was shoveled on board and then cut loose and escorted back to the yard by the tug.

❧ 65. Steaming down the river past Learned's Mill, the stern-wheeler sent smoke into the air and perhaps whistled as it approached the Natchez landing, just ahead.

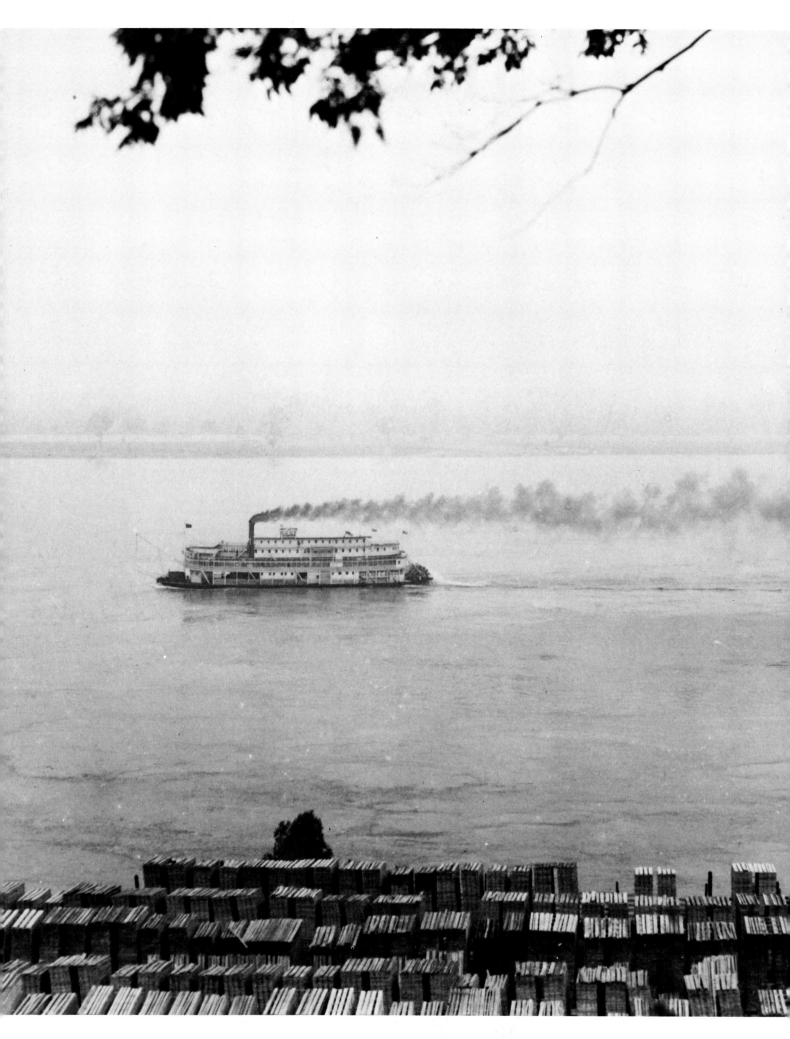

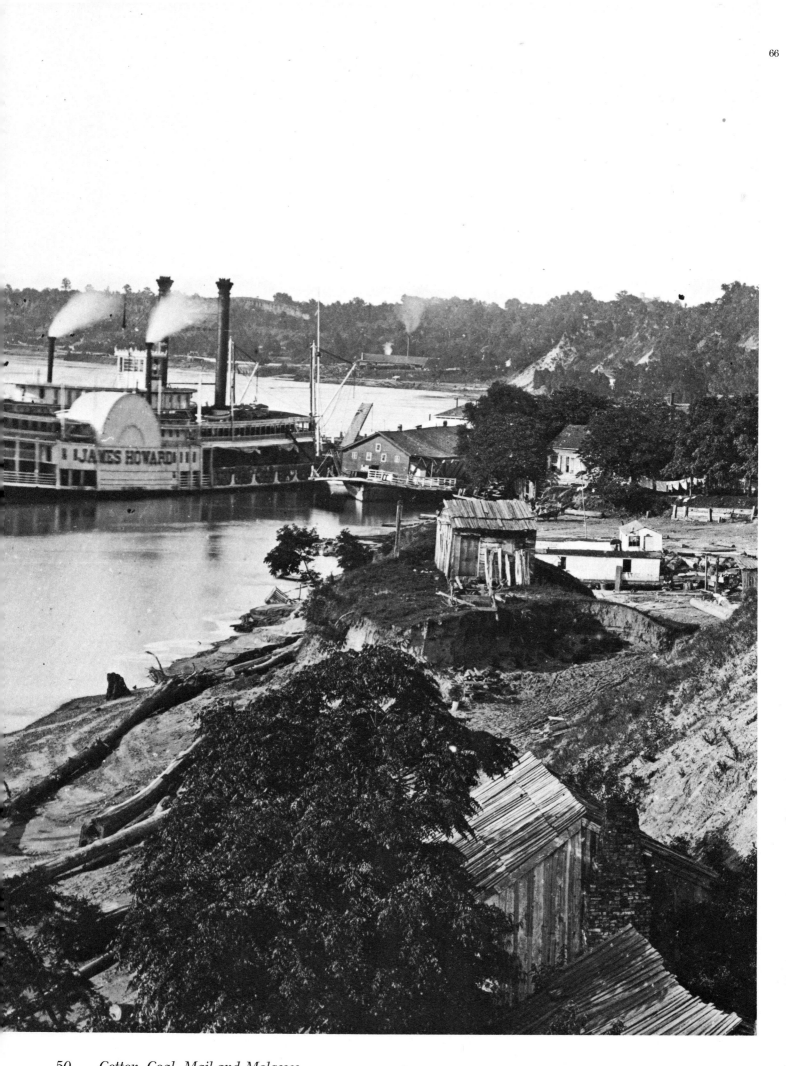

Cotton, Coal, Mail and Molasses

ᡱ 66. The big side-wheeler *James Howard* pulled into the landing and tied up to the wharfboat, where it picked up and discharged freight. This may have been the trip made by the *James Howard* in 1872, when Grand Duke Alexis of Russia was a passenger bound for New Orleans and the Mardi Gras. Built in 1870, the boat carried many tons of freight on the river during its 11 years. When it burned in 1881, it was carrying a huge cargo of sugar. ᡱ 67. Rumble and Wensel was one of the most successful businesses at the Natchez Under-the-Hill landing in the late nineteenth century. Besides the groceries and liquor advertised on the sign, the company dealt in cotton. The O'Neil & Co. coal yard was also a landmark for many decades.

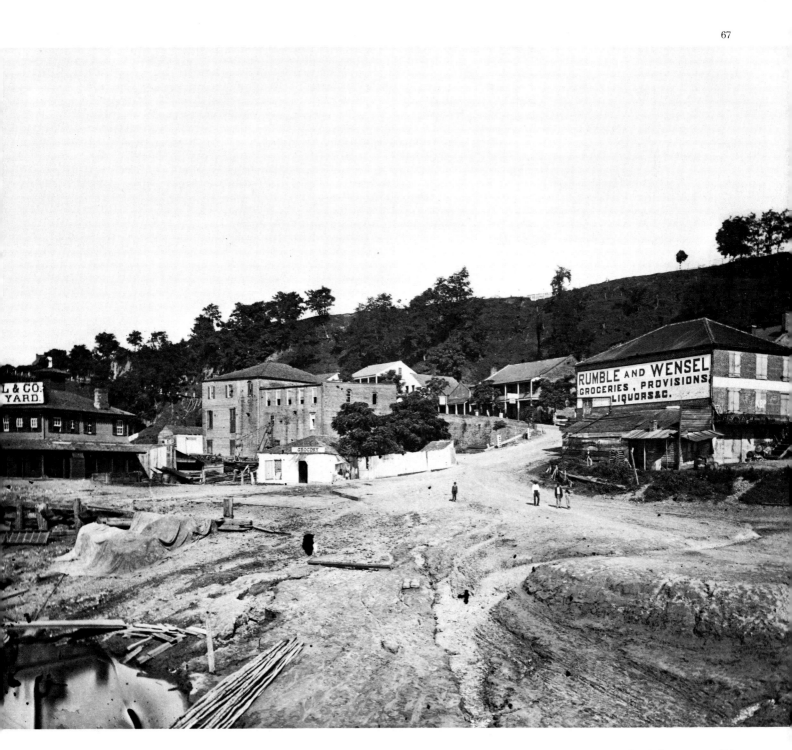

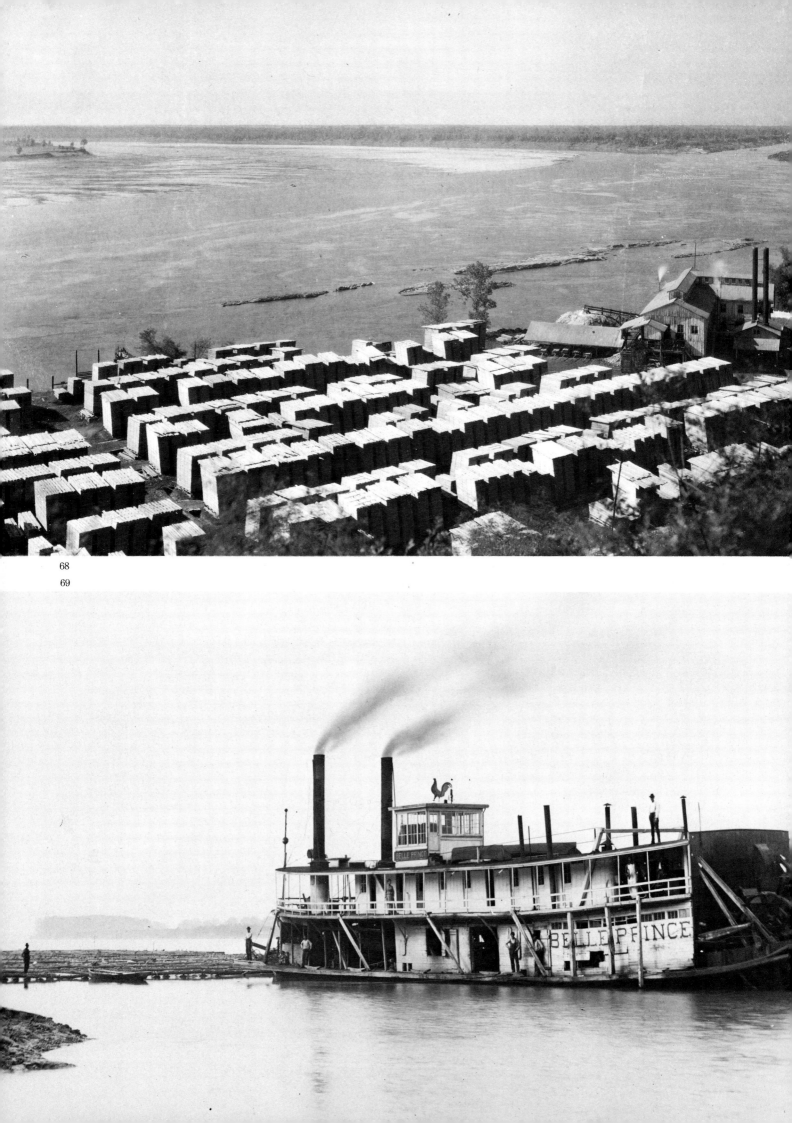

68

69

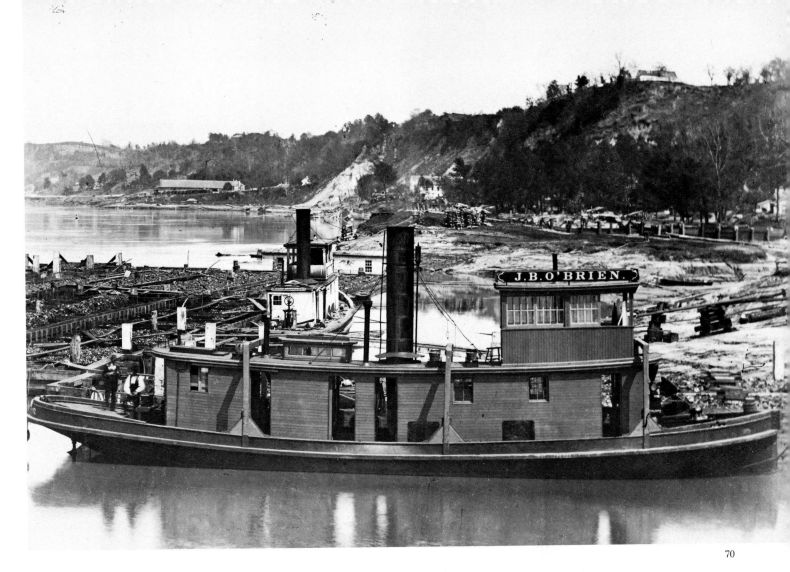

&. 68. Learned's Mill, putting out thousands of feet of lumber per day, kept some 50 men working at the mill and another 65 getting lumber out of the swamps of the Yazoo and Mississippi Rivers in the 1880s. &. 69. Boats such as the *Belle Prince* pushed huge log rafts on the river to mills, where the logs were made into lumber. Towboats such as this grew in importance as the years passed. &. 70. The *J. B. O'Brien* was at its post next to the coal fleet when it was not out on the river. Like other iron- or steel-hulled tows, the *O'Brien* moved huge rafts of timber, too. In the 1880s, particularly, it brought timber tows down from the Yazoo River for Learned's Mill and often took big tows to New Orleans. Though it was owned and operated by the coal yard and did daily work in that capacity, the little tug always seemed to be doing other work around Natchez. It went to the rescue of boats that had broken their shafts or rudders or had grounded on a sandbar or on the riverbank. It took barges out to rescue people and freight off boats in danger of sinking. And each year, when the ferryboat went for its annual overhauling in New Orleans, the *J. B. O'Brien* stood in for it. &. 71. Whether towing a damaged boat into the landing, pushing a coal boat into the river to meet a passing vessel wishing to load in a hurry, taking people across to Vidalia and back or pushing a barge loaded with cattle across from Louisiana during high water, the *O'Brien* was so invariably a part of the scene at Natchez Under-the-Hill for more than 20 years that when it went away for an occasional overhauling, it was said that the harbor looked dead without it. Built in 1878, the *J. B. O'Brien* in 1891 was given a brand new pilothouse, completely transforming the appearance of the boat.

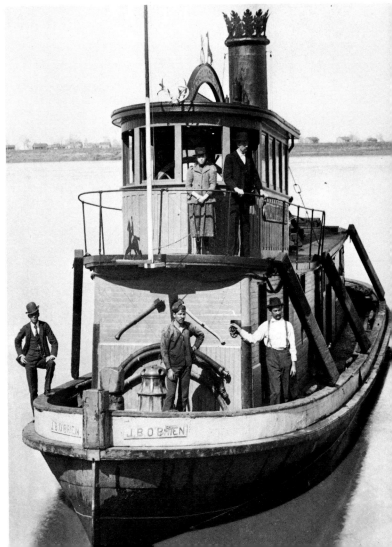

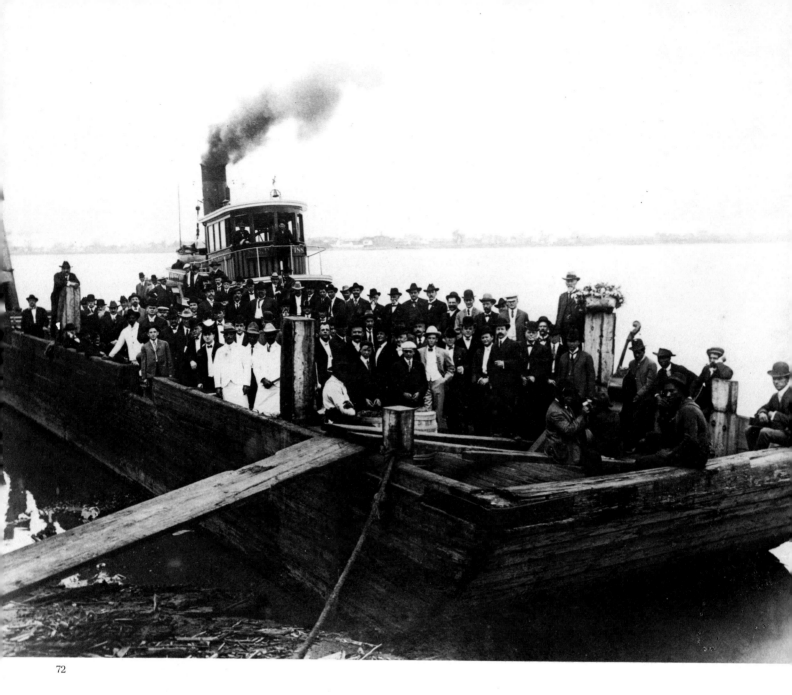

72

 72. Continuing to stand in occasionally for the ferryboat, the *J. B. O'Brien* by the turn of the century had been given a new name, the *S. S. Prentiss*. Here it took a large party on a barge to some now unknown destination along the river. The group appears to have been headed for a special occasion, as musicians and bartenders or waiters in their white jackets were aboard, and one passenger carried a big basket of flowers. 73. For a few years in the 1890s, the *G. W. Lyon* worked in and around Natchez, sometimes carrying freight to small nearby landings, sometimes pushing a tow of freight but usually carrying a small number of passengers, as it was here. A luxury boat it was not—passengers obviously dodged piles of equipment strewn on the main deck as they boarded the little boat. 74. In comparison to the *G. W. Lyon*, the *Liberty* was the picture of neatness, as shown by the barrels and bags tidily arranged on its deck. The *Liberty* came to Natchez in 1896 to replace the *Lula Prince* in the Natchez and Bayou Sara trade. Capt. Tom Prince, the owner of the *Lula Prince*, was in the North when his boat sank. He purchased the *Liberty* to bring back with him within a week or two after the accident. The *Liberty*, built in 1889, had 26 staterooms and was allowed to carry a hundred passengers. Several months after arriving in Natchez, the captain had a new texas built for the boat, which worked out of Natchez until it was sold at Memphis in 1902.

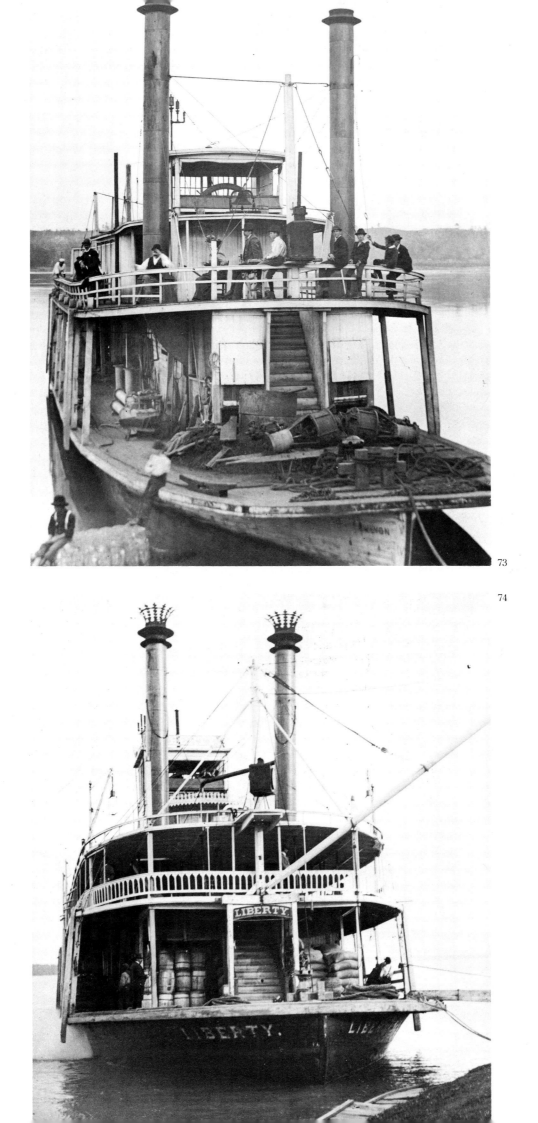

73

74

The Anchor Line

A tonic to river trade and travel in the last three decades of the 1800s, with their prompt and regular stops at the landings on the lower Mississippi, were the sleek and spacious boats of the Anchor Line. One of the most successful steamboat companies on the river, its boats worked between St. Louis and New Orleans.

Through the 1800s, river towns were greeted by steamboats with names such as *Reindeer*, *Antelope* and *Beaver*; *Sunshine*, *Sunrise* and *Sunset*; *Eagle*, *Oriole* and *Goldfinch*; *Nymph* and *Gladiator*; *Mist* and *Morning Light*; *Justice* and *Liberty*; and *Concert* and *Conductor*. The most popular boat names, however, were those of people or places. For the Anchor Line, the boat name was usually that of a city located on the Anchor Line route—*City of St. Louis*, *City of New Orleans*, *City of Bayou Sara* or *Belle Memphis*.

In addition to passengers and freight, the big Anchor Line boats for many years carried the mail. Before the Civil War, just about every steamboat captain accepted personal and business mail and duly distributed it as he made his way up and down the river. After the war, boats submitted bids to the U.S. government in order to become "official" mail carriers. Other steamboats were warned that it was against the law for mail without proper postage to be accepted or delivered. On short runs, such as between Natchez and Vicksburg, local boats carried the mail.

The line started out in 1859 as the Memphis and Saint Louis Packet Line. It managed to stay in business during the Civil War by operating in the parts of the river that the Federals occupied; after the war began, it extended trade down to Vicksburg and finally to New Orleans. This line gradually evolved into the Saint Louis and New Orleans Anchor Line, adopting the huge anchor as its symbol in 1874.

The Anchor Line exploded with activity in the early 1880s. The *Belle Memphis* and the *City of Providence* were built in 1880; the *City of Vicksburg*, the *City of Baton Rouge* and the *City of New Orleans* in 1881; the *Arkansas City*, the *City of Cairo* and the *Will S. Hayes* in 1882. The *City of St. Louis* was built in 1883 and the *City of Bayou Sara* in 1884. Later, in 1887, came the *City of Monroe*.

Except for the *Bluff City*, built in 1896, all Anchor Line boats were side-wheelers rather than stern-wheelers. Early in steamboat history stern-wheelers were numerous, many built by river pioneer Henry Shreve. Side-wheelers soon outnumbered stern-wheelers, however, as they became faster, easier to maneuver and more appealing to passengers, who found them less shaky. Gradually, stern-wheelers made a comeback as the century drew to a close since improvements gave them greater power and made them ideally suited for pushing barges, the last and certainly least glamorous role of the Mississippi River steamboat.

75

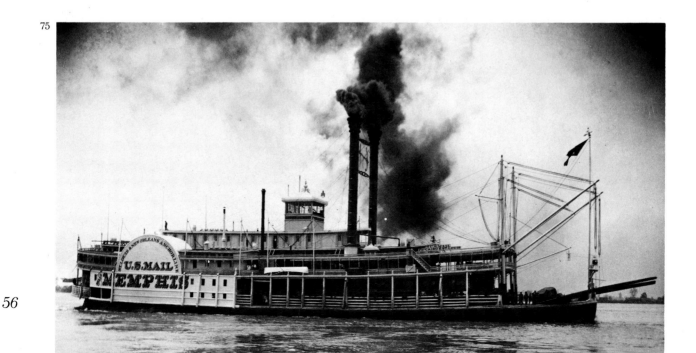

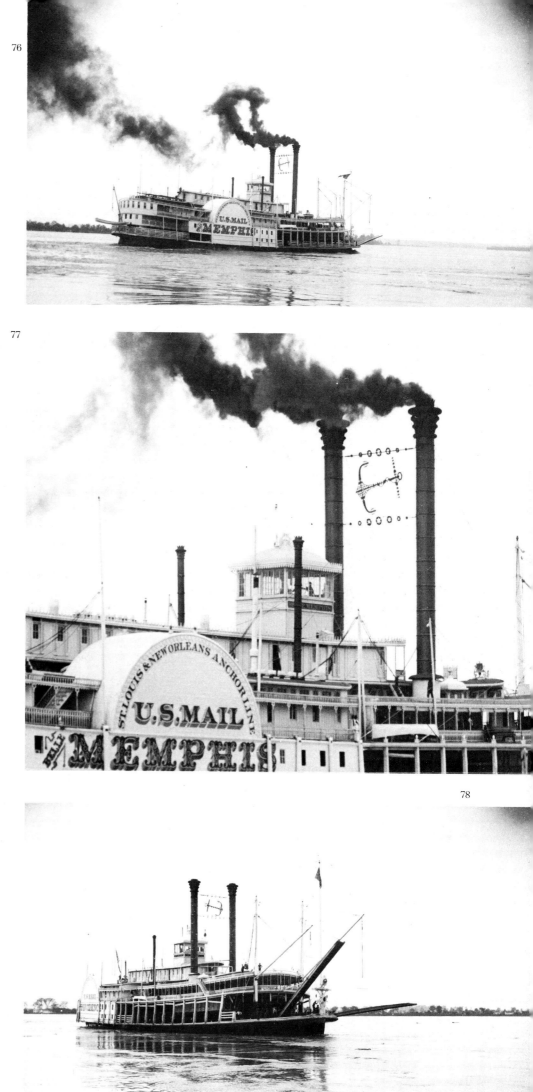

❧ 75. The *Belle Memphis* headed out from the landing. Built for the Anchor Line in 1880, the beautiful side-wheeler steamed out of St. Louis in early 1881 on its maiden voyage to Memphis. There, the people of the city presented the boat with a piano and a set of flags. Most of the Anchor Line boats were named for cities on the river, and the tradition of presenting the city's namesake with gifts, especially flags, became traditional. ❧ 76. *The Belle Memphis* steamed up the river with the lowlands of Louisiana and one of the many bends of the lower Mississippi in the distance. In the late 1890s, one of her pilots was Horace Bixby, of Mark Twain fame. ❧ 77. Smoke rose from the tall chimneys as the pilot navigated against the current. The giant anchor was the familiar Anchor Line symbol, known by all on the lower river. The *Belle Memphis*, after serving ports from St. Louis to Memphis and from Memphis to New Orleans for 16 years, hit a snag near St. Louis in 1897 and was damaged beyond repair. ❧ 78. The *City of Providence* turned into the landing, the protruding stage ready to be lowered as the boat reached the wharf. From the day it was finished in 1880 until the Anchor Line went out of business in 1898, the *City of Providence* was a favorite on the lower river.

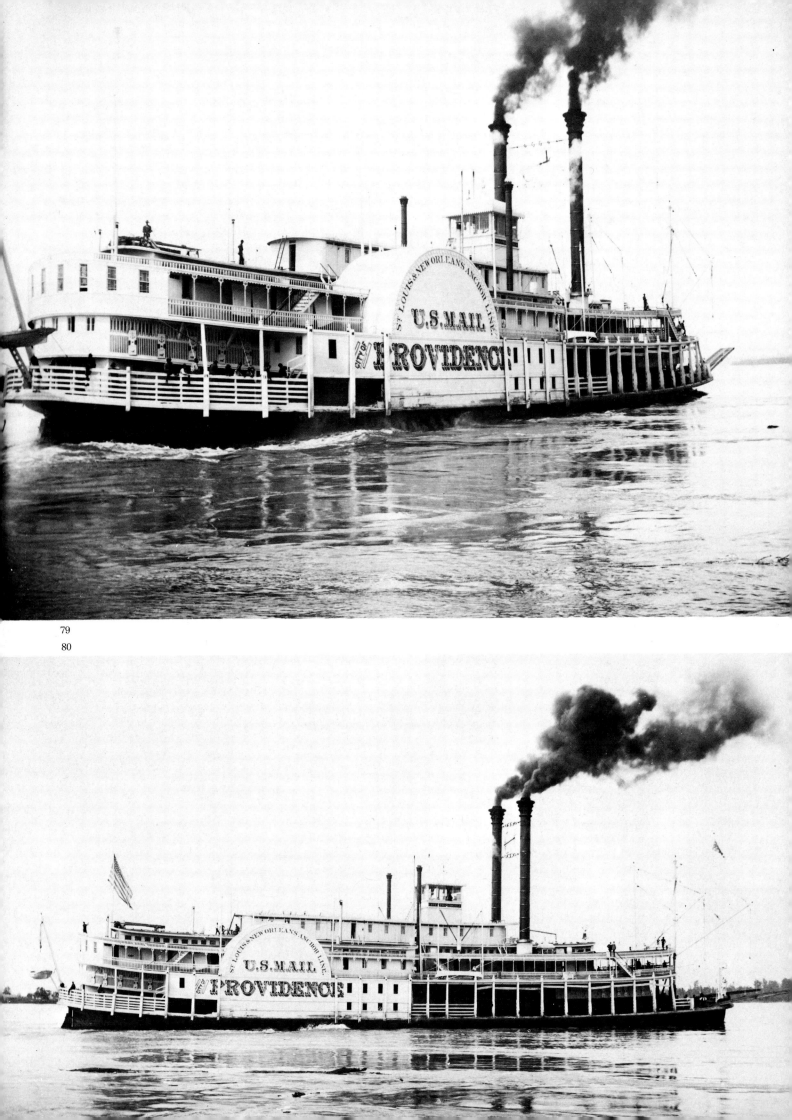

79

80

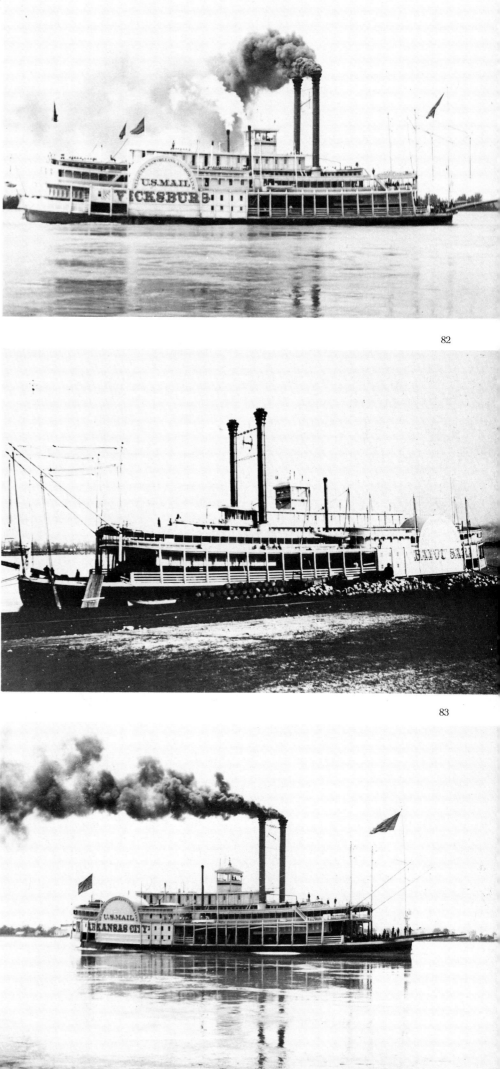

82

83

79. A few officers on the texas deck watched as the *City of Providence* left the landing. 80. Flags and smoke blowing, the *City of Providence* headed northward toward St. Louis on one of its hundreds of trips. St. Louis was the boat's final resting place as it was sold to an excursion company there when the Anchor Line went out of business. A professional gambler who worked aboard the boat when it went into the excursion trade said that the *City of Providence* drew huge crowds of people "lured there by cheap excursion rates," but that the games the people played on board were "fixed to rob the players." The long-lived boat was destroyed by ice in 1910; it was the last of the Anchor Line boats to go. 81. Most Anchor Line boats, like the *City of Vicksburg*, were about 275 feet long and 45 feet wide. The *Belle Memphis* was slightly smaller, perhaps the reason it was frequently described as "graceful." These boats carried immense loads of freight during their lifetimes—thousands of barrels of meal, grits and pork; sack after sack of corn, oats, new potatoes, new wheat and other groceries; lumber and, of course, cotton. Late in 1889, the *City of Vicksburg* appeared at the Vidalia landing with so much cargo that most of the townspeople came to the wharf to see everything unloaded. They witnessed an ironic scene as the *Vicksburg* unloaded horses, mules, wagons, plows, wheel and drag scrapers, tents, camping equipment and about a hundred laborers, all brought there for the railroad construction underway. The building of railroads, while threatening the future of the steamboat business, provided profitable trips for big boats such as those in the Anchor Line. In 1894, the Anchor Line sold the *Vicksburg* to an excursion company in St. Louis and, along with many other boats, it was badly damaged in the 1896 tornado there. In 1898, the *Vicksburg* was sold again, rebuilt and renamed the *Chalmette*. Under its new name, the boat operated as a cotton carrier along the old familiar route between St. Louis and New Orleans. It sank in 1904. 82. The *City of Bayou Sara* was one of the biggest Anchor Line boats, measuring 300 feet in length and nearly 50 feet in width. It survived only a year, however. Built in 1884, the luxurious boat burned beyond repair in 1885 near New Madrid, Missouri, while taking on a load of corn headed for the Southern markets. Eight people died in the fire, and the cargo was a total loss. 83. The *Arkansas City*, built for the Anchor Line in 1882, came as far south as Natchez for the first time in 1888. It continued to make the run to Natchez and back to St. Louis for the next eight years until it was demolished in the 1896 tornado in St. Louis. When the Anchor Line went out of business in 1898, many businessmen looked back to the 1896 tornado as a major turning point. The *Arkansas City* and the *City of Cairo* were totally demolished, and both the *Vicksburg* and the *Monroe* were badly damaged. The *Vicksburg* was sold; the *Monroe* was rebuilt. Several months after the tornado the *City of Hickman* sank. The *Bluff City*, built in 1896, burned in 1897. All of the disasters, along with the unmistakable decline in business on the river, led to the end of the Anchor Line.

84. "The most elegantly furnished steamer on western waters" were the words used by the St. Louis *Globe-Democrat* to describe the *City of Monroe* when the boat made its maiden voyage in 1888. Down to Memphis it steamed, and on south to Natchez, where a large delegation from Monroe, Louisiana—a town on the Ouachita River that the Anchor Line boat would serve only indirectly—held a ceremony to present the new vessel with the traditional set of flags. Between the smokestacks hung the huge anchor, and the deck bell stood in the maze of wires and riggings. The bell, rung by the captain or pilot from the pilothouse, gave signals for landings, departures, passings of other boats, distress and greetings, just as whistles did. In later steamboating days, whistles were used more frequently than bells. Steamboats evoked deep feelings within the people of the river towns they served; they became friends, partners, almost family. Certain boats were more dearly loved than others, and the difference was often made by the crews working on them. The *City of Monroe* was one of those dearly loved boats; it was staffed by officers well known for their hospitality and generosity. The captain often kept the boat overnight at ports like Natchez in order to invite the young people of the town aboard for a dance. He also made special efforts to accommodate passengers who had personal schedules to keep. The clerk on the *City of Monroe* was so popular that he received a gold watch from a group in Cape Girardeau, Missouri, who chose him as the most popular clerk on the river. 85. The *City of Monroe* departed for "the Bends," that part of the river above Natchez and on toward Memphis where it seems to twist and turn countless times. In the distance two other boats steamed down toward the *Monroe*. Being the boat going up the river, the *Monroe* had to yield to the signals of the boats traveling down, which were more at the mercy of the river's current. The *City of*

Monroe was another boat that suffered damage in the 1896 St. Louis tornado, but its future was literally extended as the boat was cut right down the middle, lengthened about 50 feet and outfitted with electric lights and fans in every room. It ended up with a boiler deck large enough to accommodate a tennis court. The renovated boat was called the *Hill City*. 86. The *Hill City*, fashioned from the extended hull of the *City of Monroe*, became the largest boat on the Mississippi when it was completed in 1897. It was 327 feet long and 44 feet wide and was called a "marine monster" by many. The Anchor Line went out of business less than a year after the *Hill City* was launched, and the big boat was purchased by a captain who continued to operate it from St. Louis to New Orleans. The boat survived a sinking and a raising in 1900 and was remodeled in 1903 to take excursionists on the river during the 1904 St. Louis World's Fair, operating under yet another name, *Corwin H. Spencer*. It was destroyed by fire the next year.

87. (*Overleaf*). Cargo poured off vessels like the big Anchor Line boats and onto the river-town wharves; from there, local boats moved much of it onto their decks to disperse it among the smaller river, bayou and plantation landings. Such a boat was the *Minnie*, going to St. Joseph and back three times a week during the late 1870s. The *Charles Rebstock* replaced the *Minnie* in the early 1880s, and the *Minnie* entered another trade on a nearby river. The wood pile on the deck was the boat's fuel. Like many other riverboats, the *Minnie* continued to use wood when it was readily available. Coal had, of course, by this time become the more desirable fuel, but for years great quantities of wood were burned. A little boat like this one might burn as many as 20 to 30 cords a day.

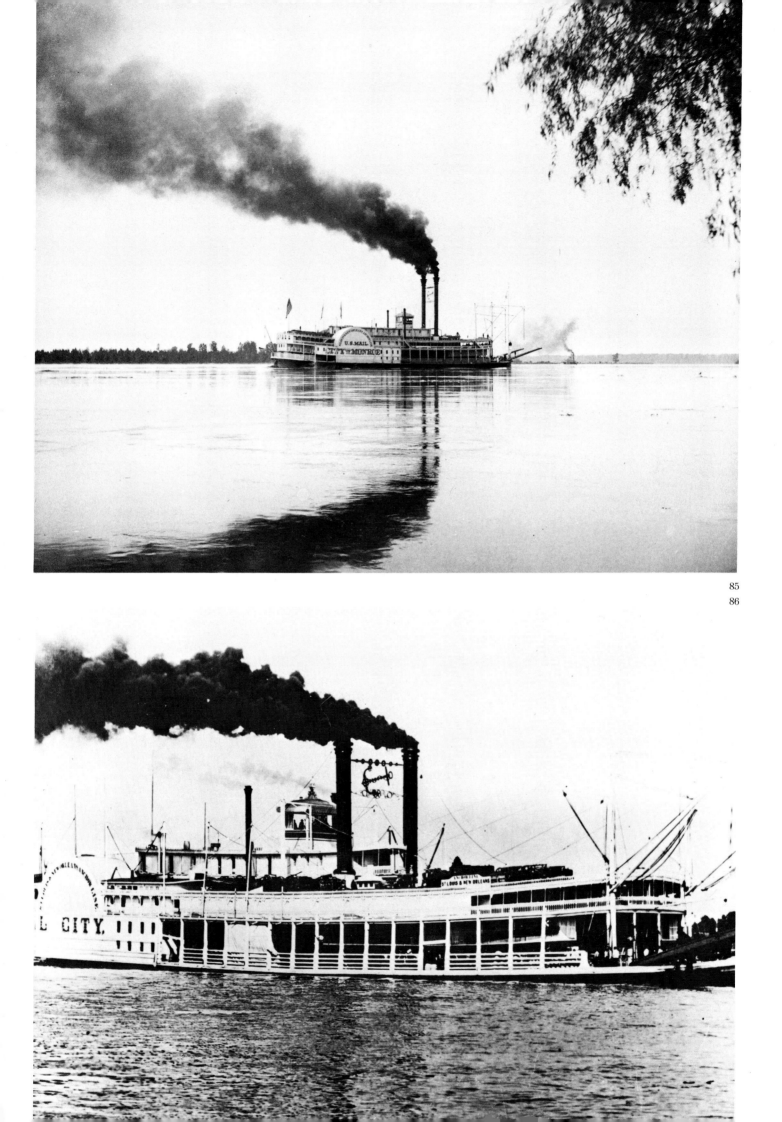

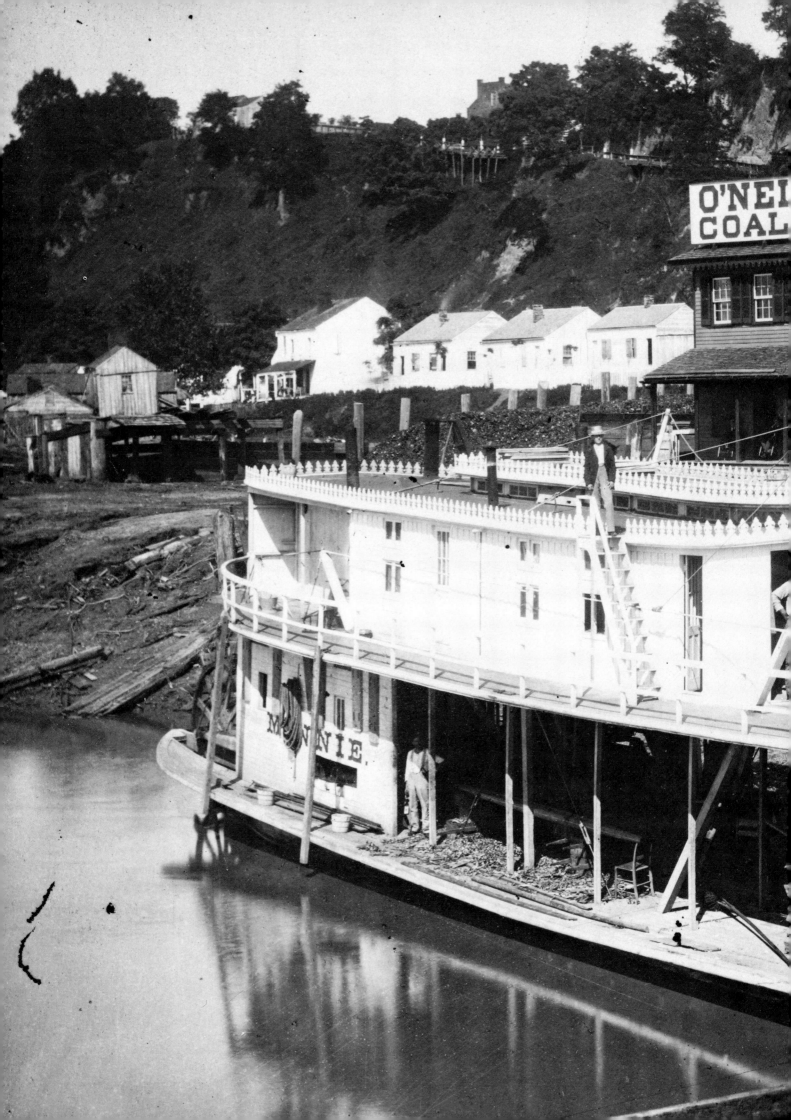

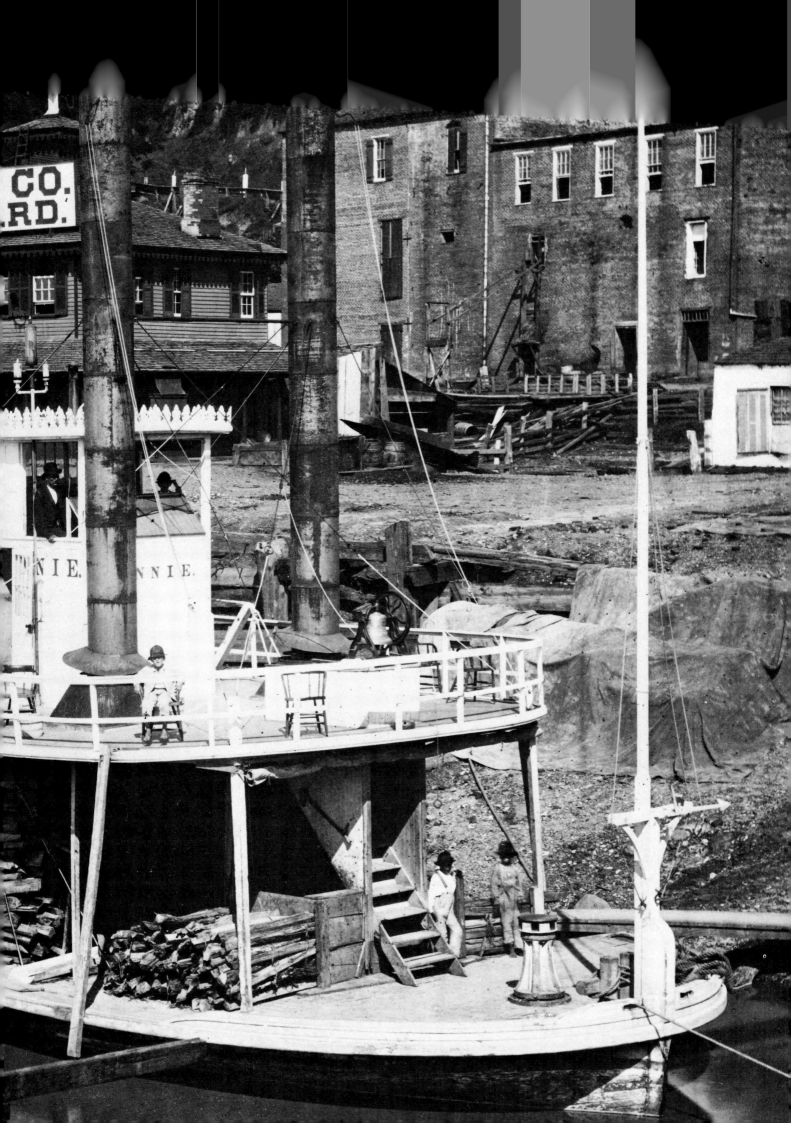

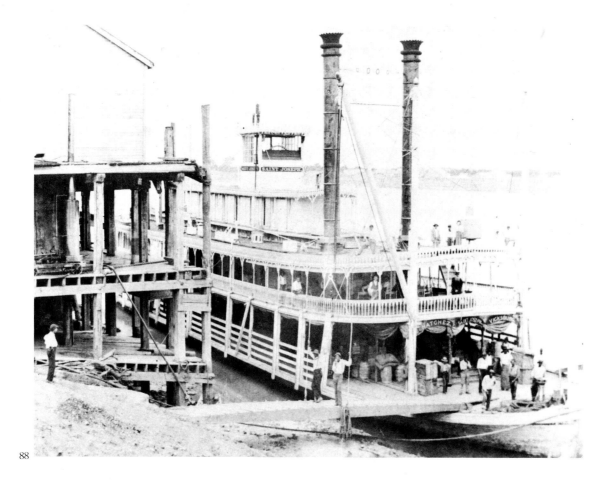

88.

In the 1890s, when the *Saint Joseph*, a Natchez and Vicksburg packet, was not loaded down with cotton, it had other cargo to carry. Here, roustabouts at the wharfhouse loaded supplies going out to perhaps 30 different places on the next trip to Vicksburg. 89. Small landings buzzed with activity when the local traders stopped with incoming freight for stores or plantations. 90. General stores in small outlying settlements depended on the one-to-three-time-per-week stops of the little boats, which brought the supplies needed by country people who could not make frequent visits to larger towns. 91. Stores in these outlying areas were gathering places for the people who lived nearby. On the days when new shipments came in by steamboat, laborers looking for work stood by to help unload the freight.

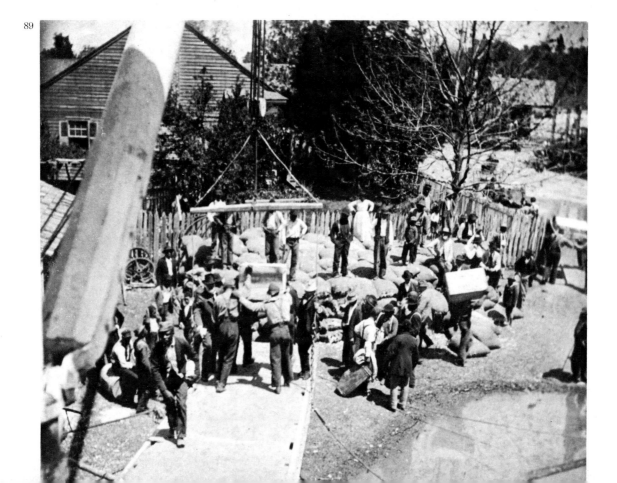

89.

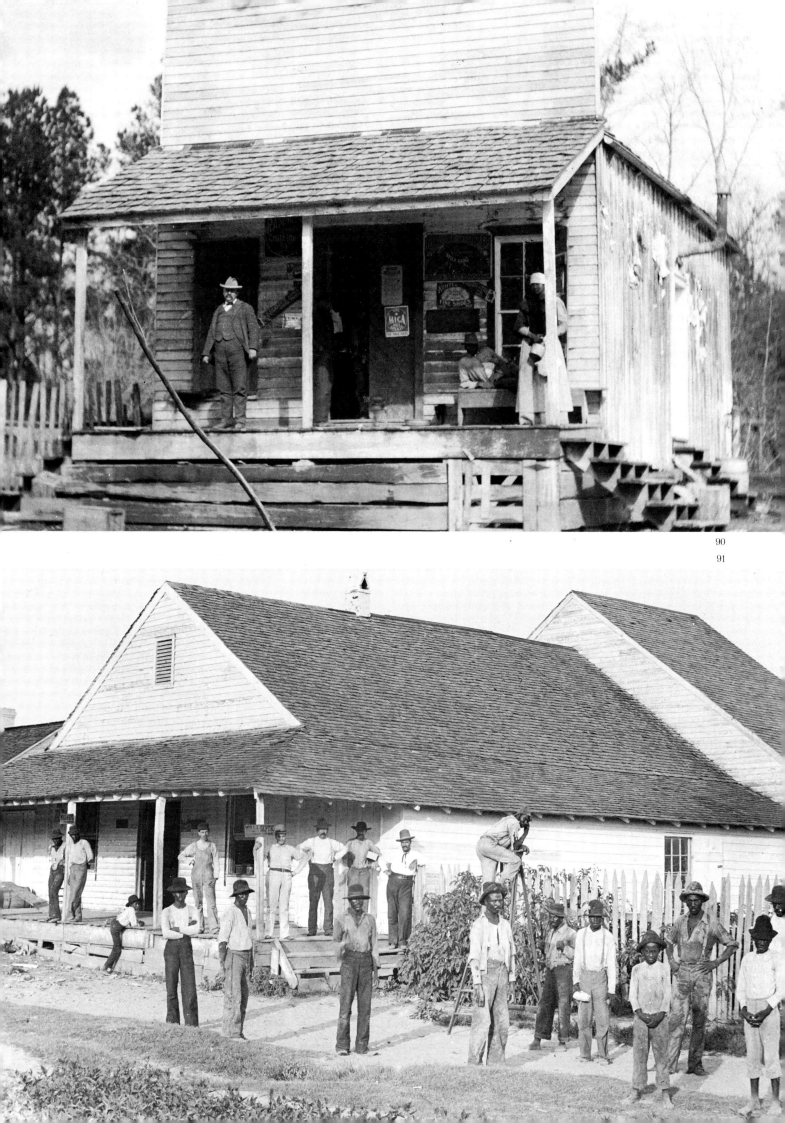

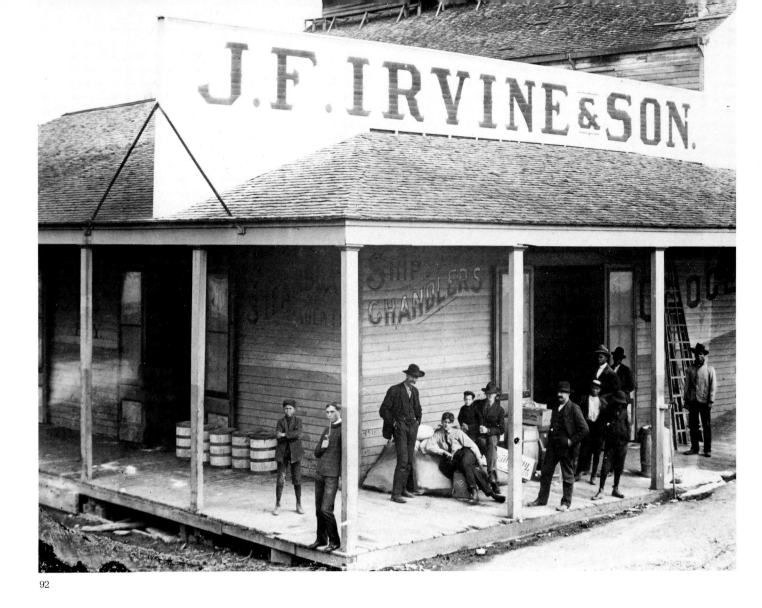

92

≥ 92. Bayou Sara was a landing served by both large and small boats. One of the busiest shops in town was the boat supply store, where other general merchandise was sold, too. ≥ 93. Saloons on the landings were also served by steamboats and were popular places for crews to visit on layovers. ≥ 94. One of the popular saloons along the lower river was Max Mann's Saloon at Bayou Sara, where there appears to have been plenty of whiskey and ice-cold beer. One packet-line president posted in the cabins of all his boats in 1884 a sign ordering his officers not to play cards or become intoxicated while the boats were in port or underway.

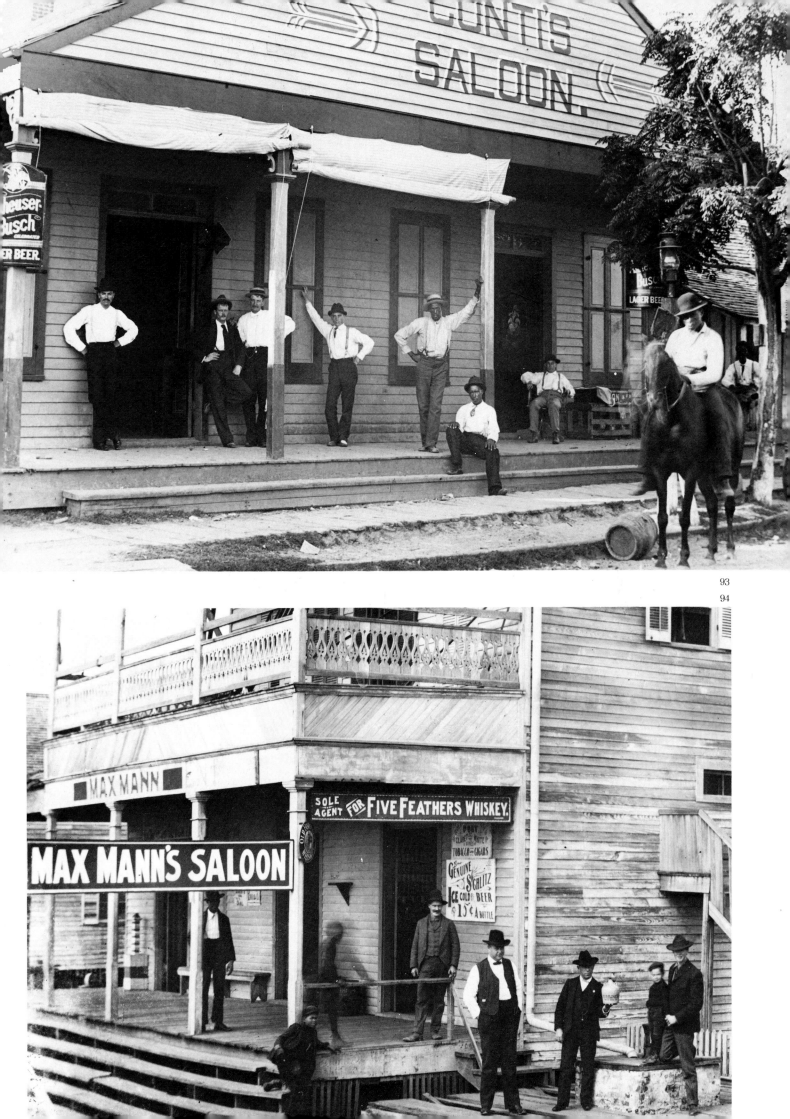

"The Dull Season"

The Southland spent roughly half of each year in between cotton seasons and, though there was other freight for steamboats to carry—often even big loads—captains frequently looked to passengers for increased revenues during the off-season. Passengers were called "excursionists" and from February, just before Mardi Gras in New Orleans, until the stifling summer heat commenced in May or June, the large boats enticed the Northerners aboard. Whether to celebrate in New Orleans or simply relax in the mild spring weather, they crowded the decks of boats such as the *Guiding Star* and the *New Mary Houston* to wave good-bye to the ice and slush as they pulled out of Cincinnati. In St. Louis it was the same, as excursionists boarded the Anchor Line boats and others to leave the chill of their wintry city behind.

For trips such as these, the railroads' advantages paled beside the leisure, comfort and luxury offered aboard the steamboats. While praise for the extravagance and beauty of pre-Civil War boats fills volumes, the fact is that the boats of the postwar years were by necessity superior. Staterooms were roomier, more private and more comfortable than most of those on earlier boats. Elaborate furnishings were complemented by hot and cold water, excellent food and drink and service as superb as that in the finest hotels. Low rates didn't hurt, either.

For $12, a passenger could travel from Natchez to New Orleans for the 1884 Exposition, stay aboard the boat in a stateroom while there and return to Natchez. Six years later, Anchor Line boats offered passage from Natchez to the St. Louis Exposition and back for $25. The summer rate (including meals and a stateroom berth) on Anchor Line boats between Natchez and New Orleans was $8 for a round-trip ticket in 1896. Some say that the meals alone were probably worth the fare.

In the early summer of 1888, the *Guiding Star* was said to have cleared about $10,000 in the spring excursion season. In March of 1896, two months before the fateful tornado in St. Louis, it was said that Anchor Line boats enjoyed larger numbers of tourists than they had in many years, and that a trip on the Mississippi had become "a standard one in the itineraries of American tourists." Passenger lists declined dramatically in the following years, however. The Anchor Line, trying desperately for a comeback following the devastating tornado, issued a 32-page brochure, *A Romantic Trip to the Sunny South*, illustrated with scenes along the river, a map, a passenger schedule and rates, but still went out of business the next year.

During the summer months, known as "the dull season," many of the big boats simply withdrew from the river or, to use the river man's words, they "choked a stump." Others entered local excursion businesses for a few months. The *Guiding Star* and the *New Mary Houston*, among others, spent some summers taking excursionists to Coney Island of the West, a resort near Cincinnati owned by a steamboat captain. Hordes of people took advantage of these short boat trips. The *Charles Chouteau* on one summer day in 1885 had 2,064 excursionists aboard. Still other boats continued in their regular trades during the summer months but often lowered their fares to attract more passenger business. In July 1890, housewives from Madison and Louisville traveled by boat to Cincinnati to shop for the day, since the cost of going there was "not much more than street car fare" would have been to go shopping at home.

In the small towns where local boats continued their short regular runs without benefit of cotton revenues, townspeople were urged to patronize the boats so that the captains would not have to pull out of the trade. Support your boats, they said, "lest you be deprived of the great convenience" of having them. The captains put their minds to work, too, and organized special moonlight excursions, removing cabin furniture to create a dance floor on board. Food, drink and a string band provided summer magic on the river and helped the boat stay afloat financially.

The local boats made special trips for fishing parties, Fourth-of-July celebrations, weddings, baptisms and baseball games in neighboring towns. Sometimes weddings and receptions were held on a steamboat. The spacious main cabin of the *Guiding Star* accommodated 500 people for one wedding reception. And when Mr. Wilson Rumble married Miss Mary Haralson in 1888, the *T. P. Leathers* took Natchez wedding guests to Bayou Sara for the event, waited through the ceremony and then took on board the bride, groom and many friends, all of whom traveled on to New Orleans.

Steamboat crews tirelessly cultivated the locals. Chefs baked cakes for charity events; young townspeople were invited aboard for a party when the captain's daughter accompanied him on a trip; the remains of a person who died away from home were returned home for burial, courtesy of the captain. These and other little acts of friendship and hospitality endeared the steamboatmen to the town.

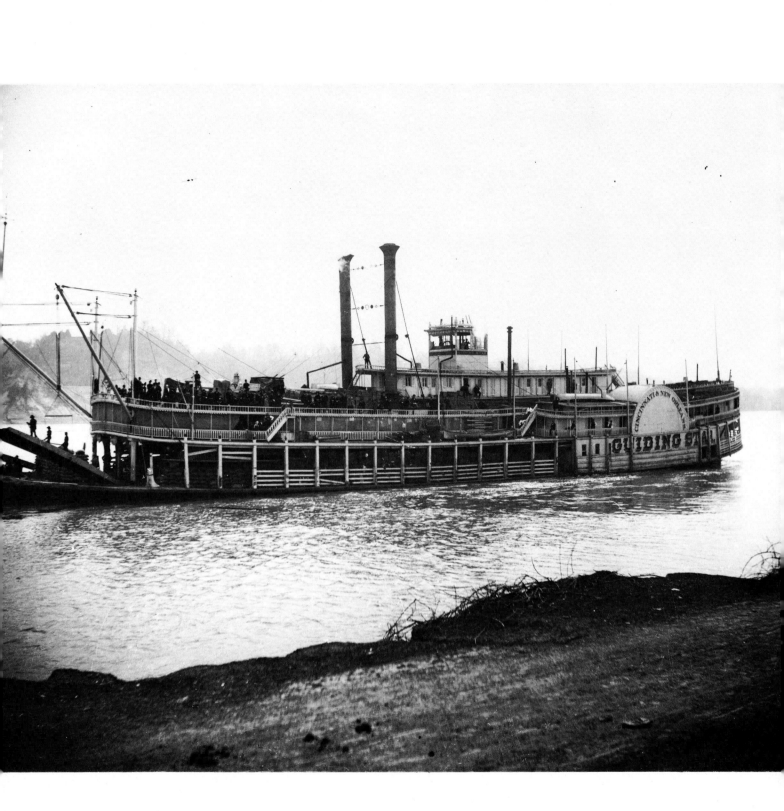

࿇ 95. The *Guiding Star*, one of the biggest and most popular boats from 1878, the year it was built, to 1893, the year it was wrecked, appears to have had a large passenger list. The 50 large staterooms were probably full on this Cincinnati-to-New Orleans trip.

🍂 96. The clothes worn by the passengers suggest that this may well have been a Mardi Gras excursion. It is also possible that this trip occurred in 1888 during one of the big passenger seasons for the *Guiding Star*. 🍂 97. Stewards, waiters and cabin attendants lined up along with passengers as the *Guiding Star* neared the wharf. This may have been the disastrous trip of January 1888, when everyone aboard would have been more than anxious to arrive in Natchez. On that trip, the boat was delayed several days on a sandbar between Helena and Memphis. Then, a barge it was towing, laden with 600 boxes of starch, 1,000 bags of corn and several barrels of whiskey and oil, began to sink. Part of the cargo was lost. The next day the boat ran into a snag and completely demolished its rudder. In addition, a fire broke out on board, and the boat was grounded again. Several days later, it finally docked in Natchez. 🍂 98. Passengers of all ages traveled on a boat like this one. It carried hundreds down from the North and back each year. The *Guiding Star* was caught in ice in January 1893, was grounded and broke completely in two, a total wreck. Nearly two years later, in August 1894, someone reported that the wreck of the *Guiding Star* had finally been broken up. It was referred to as "a nuisance to steamboats during high water."

96

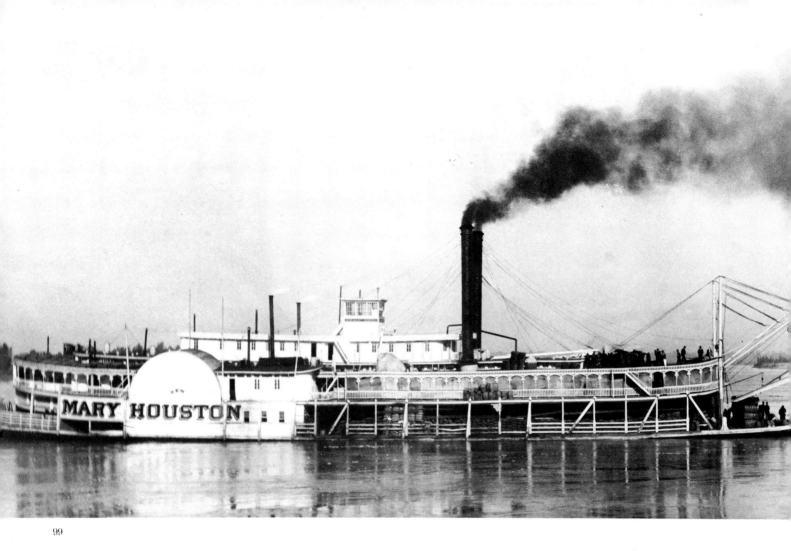

99

ᴔ 99. The *New Mary Houston*, long and low in the water, was launched in 1877 and even 12 years later was declared "a picnic to travel on." It was one of the first boats to have an electric searchlight. Affectionately called "Dirty Moll" or "Sloppy Molly," the big stern-wheeler carried hundreds of passengers and tons of freight between Cincinnati and New Orleans for about 15 years. In 1891 the round-trip fare was $35, and the journey took about 25 days. Surviving minor accidents through the years and a near disaster in 1886 when, heavily loaded, it was swept by a heavy wind over the falls near Louisville, the *New Mary Houston* sank in January 1893, when ice crushed its hull. The boat could not be saved, but the hull was repaired and converted into a barge. Step by step, the wrecking and rebuilding were reported. "The wrecking of the *New Mary Houston* is almost complete. The only distinguishing mark remaining is the last three letters of her name," one river editor wrote. And a few months later, a report said, "The last vestige of the famous steamer *New Mary Houston* has disappeared as the barge made from her hull has been named *Ed Gibbs*." Beautiful, long-lived steamboats like the *New Mary Houston* were not easily forgotten. In 1897, a reporter said, "The ice in the river reminds us of the winter of '92–'93. On Sunday, Jan. 29, the *Mary Houston* was cut down at 2 P.M. with her commander, Capt. Kates, at his post, and when she broke in two, the heart of the good old man went with her, for . . . nothing could replace Dirty Moll." ᴔ 100. Dining rooms on steamboats were set up in the main cabins, where cabin passengers could step directly from their staterooms. Three times a day bells called them: to breakfast, perhaps from 7:00 A.M. to 10:00 A.M.; to dinner at about 2:00 P.M.; and to tea or supper at perhaps 7:30 in the evening. When the meals were finished, the long, wide cabin was rearranged to suit whatever social or entertainment event was planned. Often the ladies retired to the ladies' cabin to sing or socialize; the gentlemen, to the bar. ᴔ 101. "A man that drinks it could grow corn in his stomach," some said of Mississippi River water. Passengers on the Anchor Line boats need not have worried about that, however, as their food and drink equaled that of any fine restaurant of the day. The service was unexcelled, too, even when, as was the case here on the *Belle Memphis*, there were only two diners. Service, in fact, was sometimes too good. An announcement in 1886 said with relief that a reform measure had been adopted to free steamboat passengers from the constant attention of waiters. The new rule stated that waiters "would stand off at a reasonable distance from the table and when their presence is desired, the one wishing it gives a slight tap to the bell."

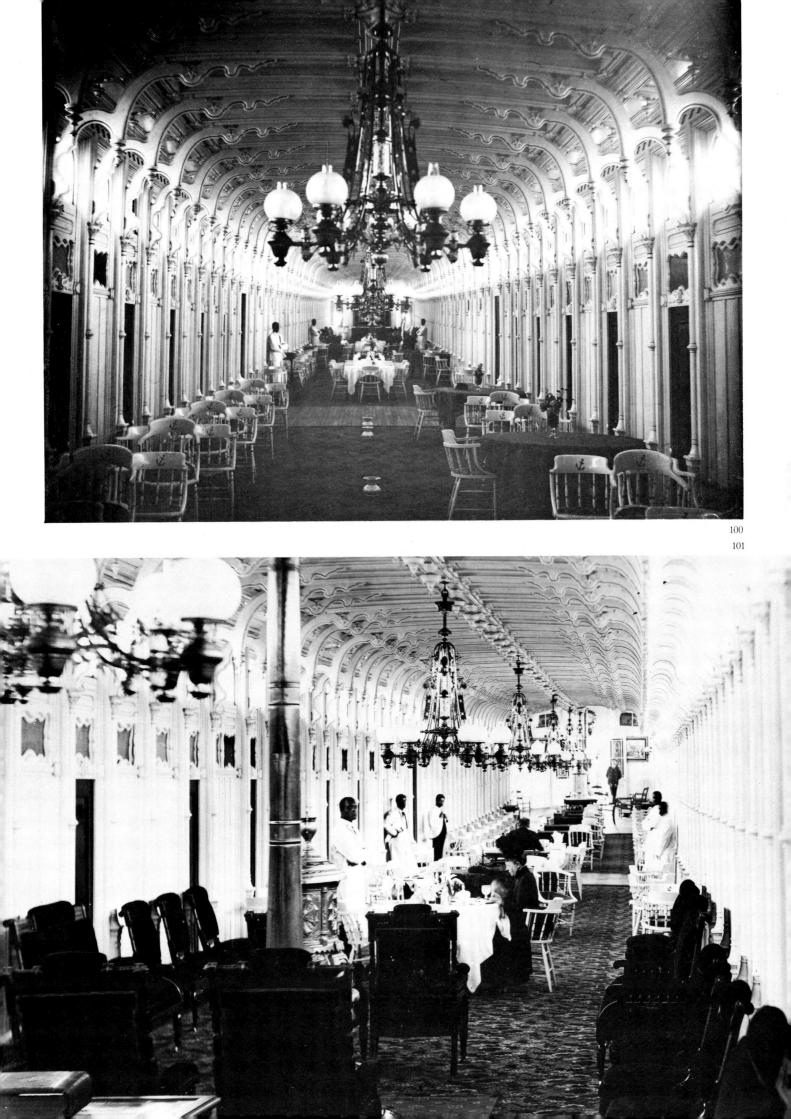

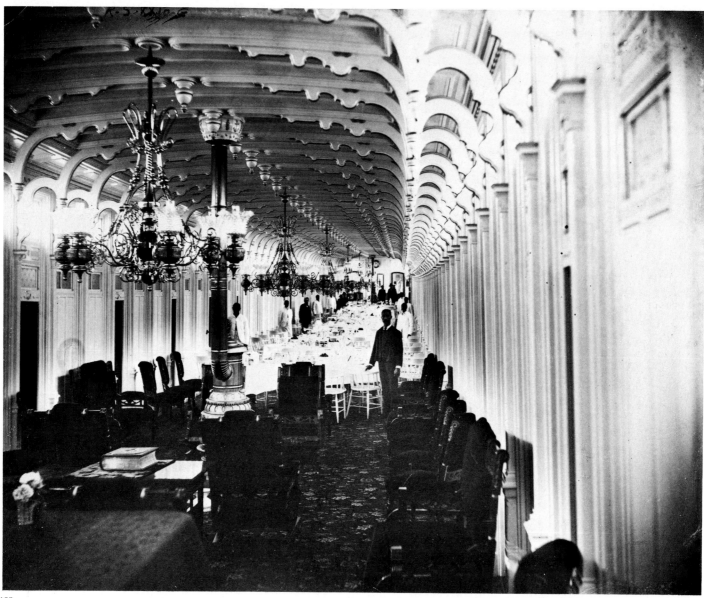

102

103

æ 102. Viewed from the ladies' cabin, where gentlemen were admonished not to occupy chairs until the ladies had been seated, the dining room of the *City of Monroe* awaits a crowd of passengers. Breakfast might include choices such as broiled beefsteak or mutton chops, fried onions or codfish balls, calves' liver, stewed kidney with tomato, eggs, corned-beef hash, jambalaya or veal cutlets, served with an assortment of breads such as muffins, Sally Lunn, rye toast, corn bread, French rolls, waffles or milk toast and with a choice of drinks such as green or black tea, chocolate, coffee or hot or cold milk. The elaborate dinner menus might begin with soups, followed by fish and roast meat. Hot entrées might include scallop of chicken with mushrooms and green corn, veal with dumplings and green peas, fish fillets with truffles or mutton garnished with new potatoes. In addition, there would be a wide choice of cold dishes, such as boned turkey with champagne jelly, and condiments, such as shrimp paste and pickled onions. Pies, cakes, tarts, puddings and little confections such as candy kisses, cream figs or lemon drops might round out the menu, with nuts and fruits offered with coffee. æ 103. Chefs, stewards and waiters took pride in the presentation of the food and in the service to passengers. The silverware was balanced in front of each plate, a decorative touch for which the Anchor Line waiters were known. æ 104. Here, on the little *Saint Joseph*, waiters have successfully copied the big boats' style of setting tables. The small boats, like their big counterparts, also went to great efforts to serve excellent food and to provide the best service. When Effie Ellsler, billed as "America's greatest actress," traveled on the *Saint Joseph* between Natchez and Vicksburg in the spring of 1896, it was reported that the markets were being scoured for the best foods available to make the dinner special. æ 105. This Anchor Line dining room does not appear to be expecting a large crowd. Perhaps a small group of passengers boarded the boat between mealtimes, or perhaps someone arose later than the regular breakfast hours. Some boats were quite strict about serving only during scheduled times, while others graciously accommodated passengers in special circumstances.

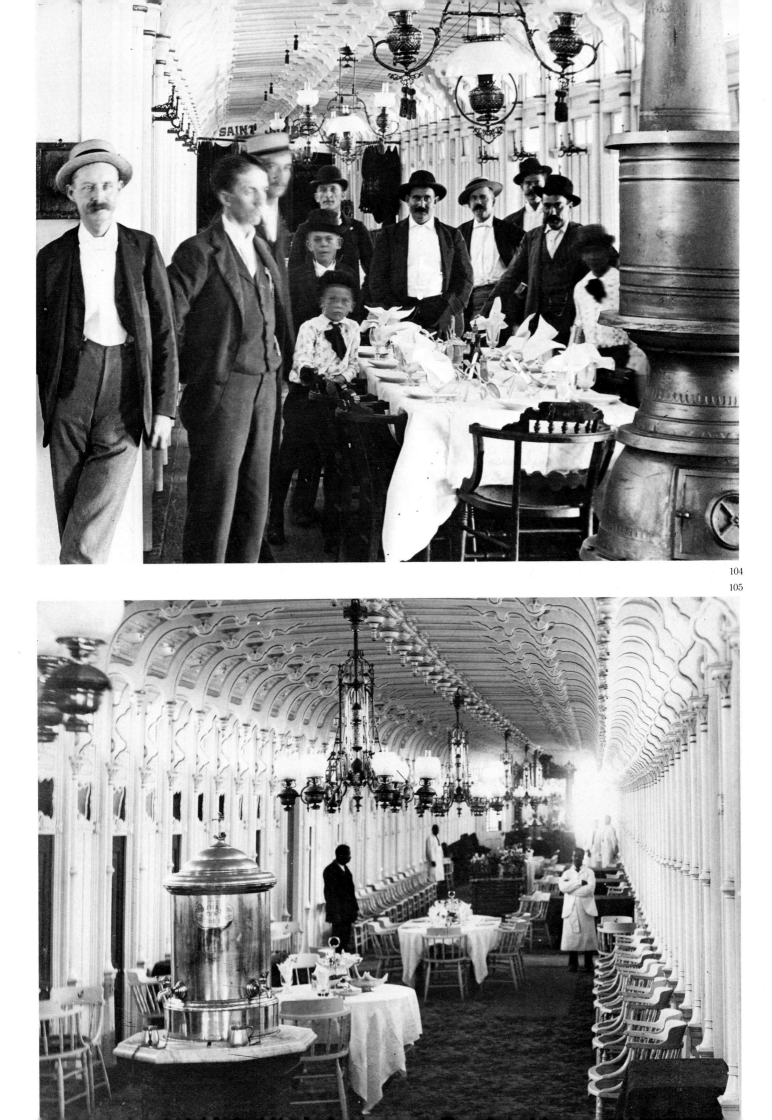

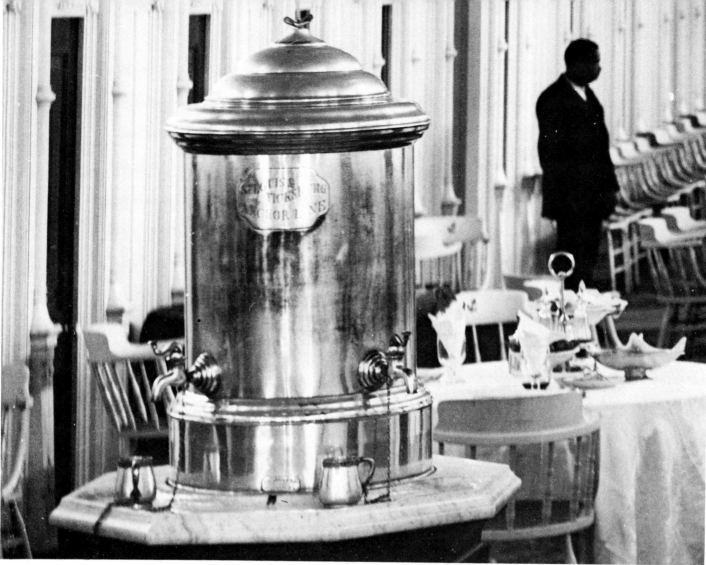

106

107

108

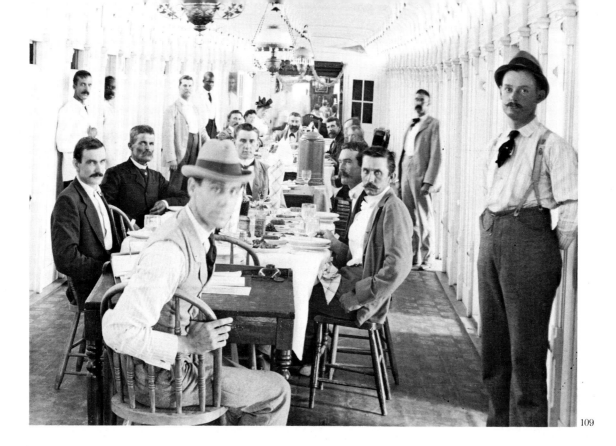

☙ 106. Accessories such as the silver watercooler adorned all of the big boats. Silverware, napery and china were selected carefully to reflect quality and good taste. ☙ 107. Small boats reflected a sense of style, too. The main cabin of the *Charles Rebstock* gleamed. The ladies' cabin was easy to spot as, inevitably during this period, it was carpeted even if no other floor on the boat was. ☙ 108. The watercooler on little boats like the *Rebstock* might not be silver, but all the accessories were decorative, as this heater certainly was. ☙ 109. The crew traditionally sat at a special table designated the "captain's table," here in the foreground, with the clerk sitting nearby at his desk. Electric lights illuminated the main cabin of the *Lula Prince*, but the photographer no doubt asked for additional light, as it can be seen streaming onto the floor from a few open stateroom doors on the right. ☙ 110. As the years went by, women broke through some of the old barriers aboard steamboats, as they obviously did in other places, too. Here, in the 1890s on the *Lula Prince*, the "ladies" were not content to sit in the ladies' cabin and sing religious songs.

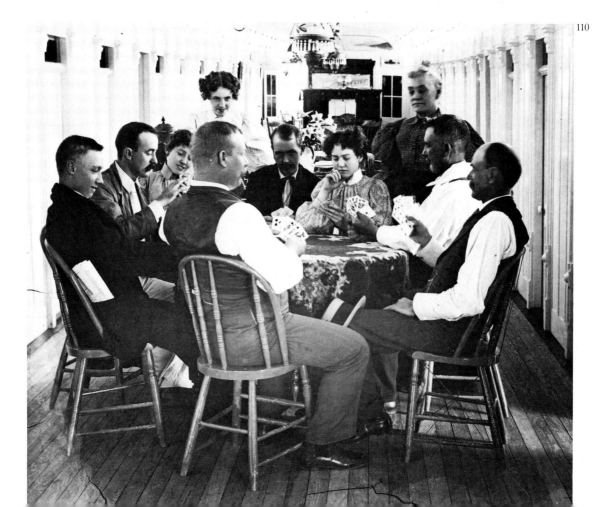

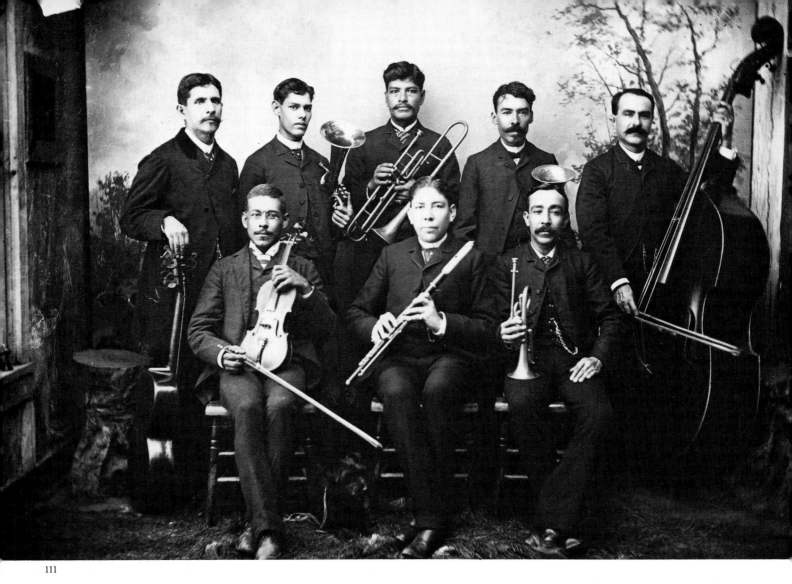

111

112

🔊 111. An abundance of good times aboard the *Stella Wilds* was all to the credit of the Mexican Band, perhaps photographed on the same day that the crew posed for its photograph (see no. 112) and maybe even on the day of the maiden voyage in 1886, when the band played the "Stella Wilds Mazurka," written by its leader, Prof. T. F. Gloria. The Mexican Band played regularly aboard the boat for several years. On the first trip out to show off the new boat, speeches and presentations were followed by champagne and dancing. 🔊 112. The crew also contributed to the good times aboard the *Stella Wilds*, for their organization and attention to detail determined the successful operation of the boat. Surely the dead tree branch has a significance, but the quite serious-looking officers do not present a clue to its meaning. 🔊 113. The trend toward having merry parties aboard steamboats peaked in the Gay Nineties. A moonlight excursion aboard the *Saint Joseph* in May 1897 was described as "a most brilliant and enchanting scene," where beautifully dressed ladies were seen "flitting here and there and gliding in and out in the merry mazes of the dance" to the music of a string band. These boat parties continued into the early 1900s, particularly in the small river towns. Whereas the big excursion boats making long trips from the North were virtually nonexistent after the turn of the century, new local boats, such as the *Betsy Ann*, built in 1899, and the *Little Rufus*, built in 1903, were just getting started. This boating party was probably arranged by Joe Franklin, third from the left, who worked as purser aboard both the *Betsy Ann* and the *Little Rufus*. Frequently, on a Sunday afternoon, groups such as these made short trips on the river during the summer months. 🔊 114. The *Betsy Ann*, built for businessman Rufus Learned and named for his wife Elizabeth, was a Natchez and Bayou Sara boat during the early part of the century, transporting freight and mail. It is reported to have carried many an excursion party on its decks, too. One of the last beauties from the steamboat days, the *Betsy Ann* moved about on the river after it was sold by Learned in 1921. The boat plied the Mississippi until it was dismantled in 1940.

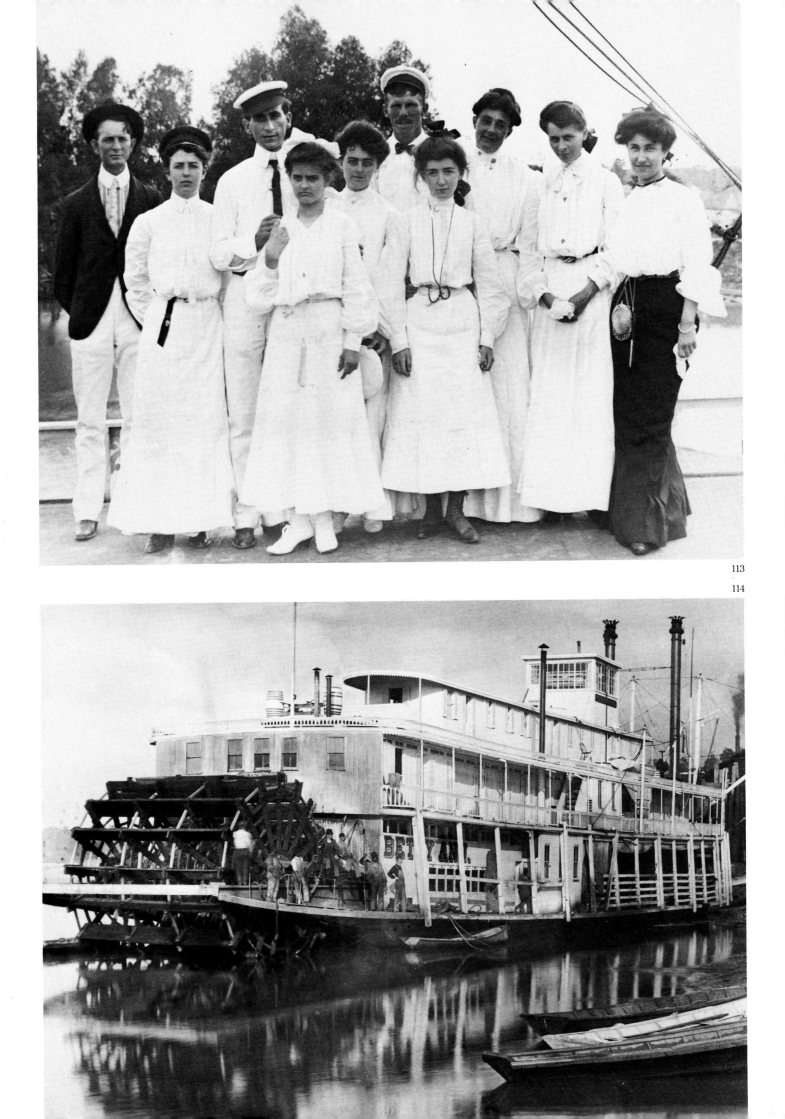

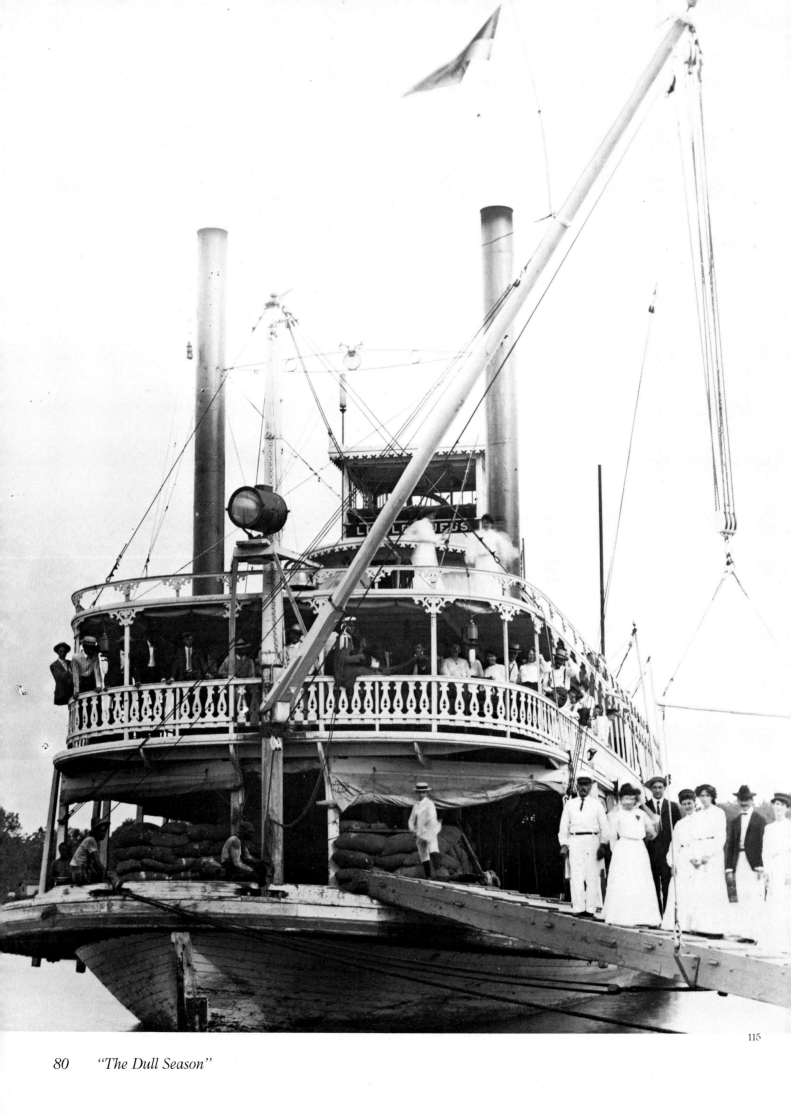

80 *"The Dull Season"*

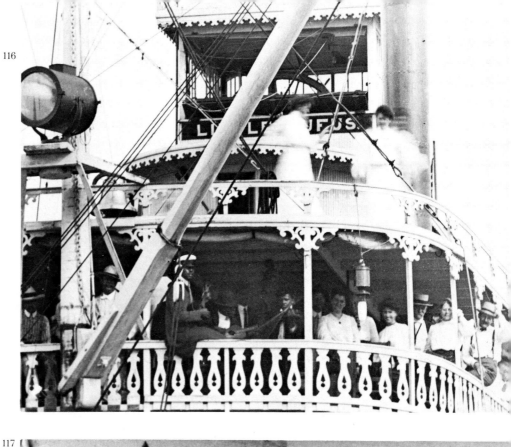

116

117

118

☙ 115. An excursion party aboard the *Little Rufus* in the early 1900s prepared to set out into the river. A few latecomers stood on the stage, ready to board the already crowded boat. ☙ 116. Even before the boat left the landing, the band began to play. Up on the hurricane deck, two young women, impatient for the dancing to begin, simply could not wait any longer. ☙ 117. A young fellow, dressed in his summer knee pants and the essential straw hat, was lucky enough to go along on this party, and it appears that he felt swell about the whole thing. ☙ 118. The deckhands, in sharp contrast to the smartly dressed revelers, probably saw duty in the engine room on the trip and stood by for departure and landing chores.

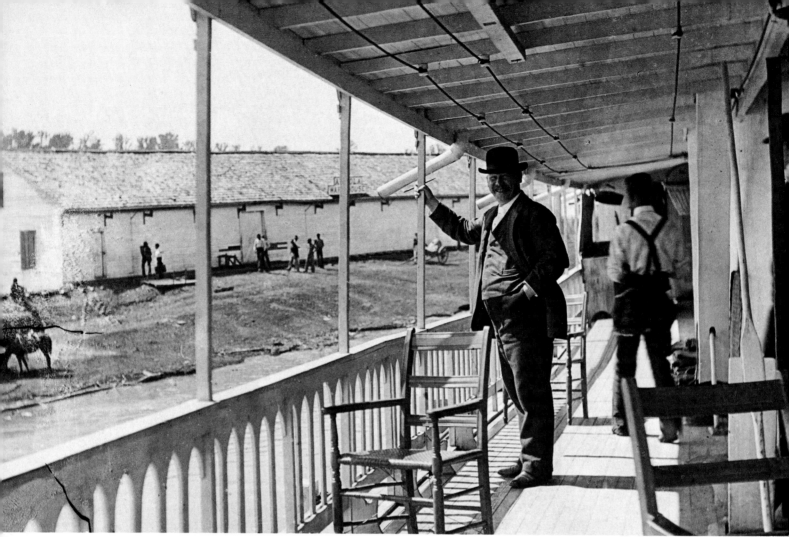

119. Businessmen were frequent passengers on steamboats. This one turned his attention momentarily to the photographer and away from the activity at the Angola, Louisiana, landing, where the boat had stopped. 120. Many hours to pass, even on the short trips, gave men and women an opportunity to talk, whether of business or social matters. 121. Judging by photographs of people on board steamboats, one would believe that they enjoyed every minute of their trip. Perhaps "the dull season," when there was less cotton with which to cope, was the best season for passengers. 122. Another kind of boat frequently appeared early in the "dull season." Shanty boats were small vessels where families made their homes, enabling them to move around the river for the best climate and the possibility of getting work of some kind. These boats appeared at Natchez and other towns during the winter and spring, sharing the river's edge with huge excursion boats like the *Guiding Star*.

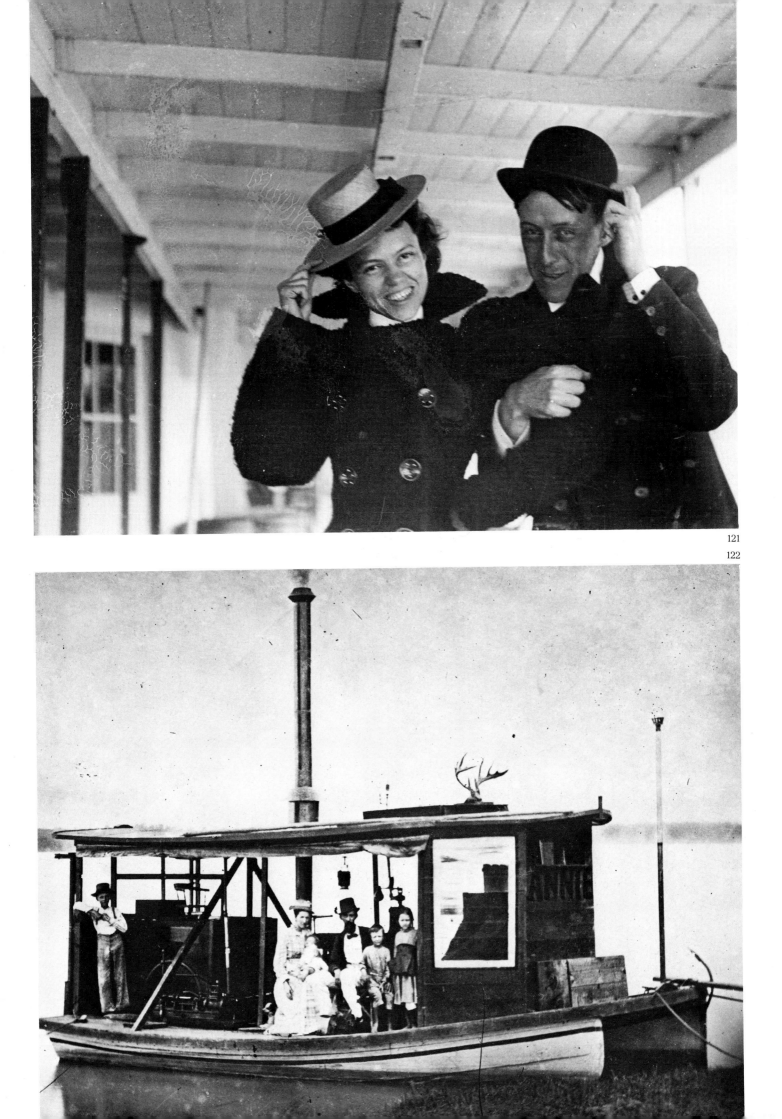

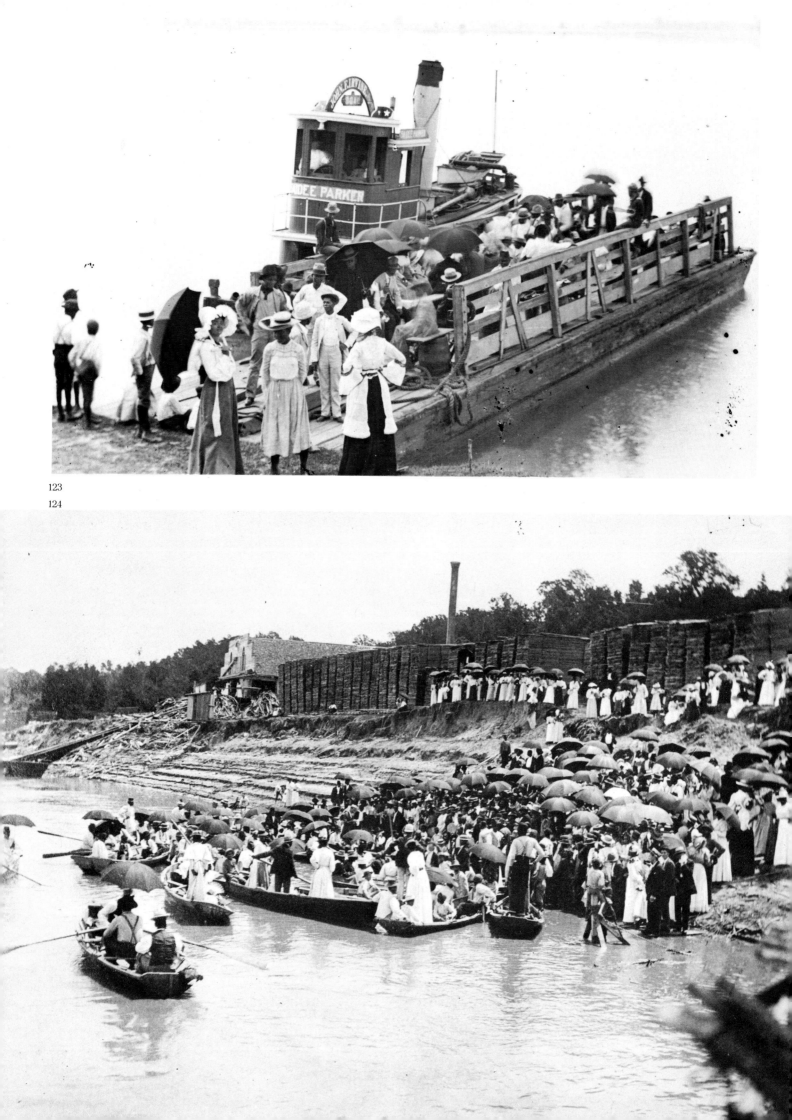

123

124

123. Small barges pushed by tugboats served as ferries, making short trips across the river and down to a nearby landing to take people to family reunions, weddings and baptisms. ❧ 124. Baptisms in the river were frequent happenings among the black population. A favorite place for these events was near this sawmill, where the sloping riverbank made the walk into the water—and the viewing—easy. ❧ 125. At a big baptism in the river just below Learned's Mill in the spring of 1890, it was reported that several thousand were watching from the banks, and that the "singing of crowds and shouts of those having their sins washed away could be heard at great distance."

125

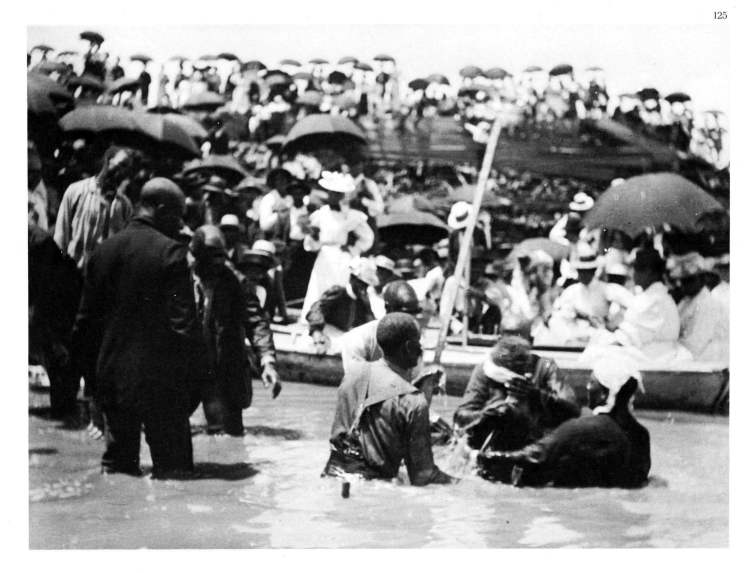

Deluges and Delays

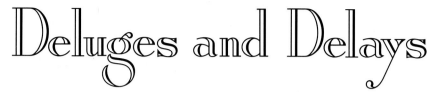

Even the railroads did not entirely escape the raging spring waters that with deadly regularity submerged the banks of the Mississippi, devastating people, animals, crops and river trade in the lower valley. Railroad tracks, like country roads and village streets, disappeared beneath the muddy water when levees built to protect them from the river's current failed to hold.

"Cabins, fences, and the dead carcasses of animals are to be seen floating down the river in great numbers," said a reporter from St. Joseph in March 1883. He predicted that the entire parish would soon be inundated as he described the "most terrific currents, the roar from which can be heard during all hours of the night." Just a few months earlier, fear had been expressed about a seven-mile-long break in the levee that had been spotted in the dense woods and low swamplands near the town.

From the very beginning, settlers in the lowlands of Louisiana along the river's banks expected the Mississippi to be a problem. When Bienville chose the site on which to establish New Orleans in 1717 or '18, his engineer, de la Tour, argued against it because of what he saw as obvious dangers of flooding. Bienville insisted on the site, and he built his town; de la Tour built his levees. Settlers for years to come would of necessity follow de la Tour's example.

Until 1882, the expensive, painstaking task of building and maintaining levees along the lower Mississippi fell to the landowners along the river. In 1882, however, the Mississippi River Commission, established by Congress in 1879, authorized the first levee work to be done by the U.S. Corps of Engineers, beginning what would be the first coordinated levee system on the lower river.

Long before the Mississippi River Commission was established, the Federal government, clearly aware of the importance of navigation on the river, turned some attention to it. Congress appropriated funds for a river survey in 1820 in hopes of finding ways to improve navigation. In 1824 the Corps of Engineers began removing snags in the river. Some interest in flood control grew after terrible floods occurred in two consecutive years, 1849 and 1850. Another survey was ordered and $50,000 appropriated to get it started in 1850. Damaging floods in 1858 and 1859, followed closely by the outbreak of the Civil War, set the already inadequate levee system back to a practically nonexistent state by the early 1870s.

Caving riverbanks captured some Federal attention, too, and the Corps of Engineers, particularly in the 1880s and 90s, devoted enormous amounts of time to the weaving and placing of willow mats and huge rocks along the vulnerable banks of the lower river. In addition to strengthening the banks, all of the work done by the Corps helped the economies of river towns and gave some steamboat companies more than one needed boost, especially in the 1890s, when business began to lag considerably on the river. In the spring of 1883 a Natchez man secured a contract to supply the Corps with 24,000 cords of willow brush for mats, for example, and at $1.50 a cord, he was pleased. Barges carried the huge rocks used for revetment work, and big steamboats carried men as well as equipment and supplies to construction sites.

Slow progress and insufficient appropriations perplexed and frustrated river people, however, who believed that with the necessary improvements in navigation, the Mississippi could be made to come alive again and compete favorably with railroads. Efforts to improve navigation on the river dwindled at about the same rate that steamboat traffic did, and many a bitter steamboatman blamed Congress for the demise of his trade. Yet, as the last golden days of steamboats slowly but inevitably drew to a close, most who witnessed the decline saw many causes. Fighting for this second chance, steamboat trade battled high and low water, snags, yellow-fever epidemics, fires, storms, tornadoes, bridges and, ultimately the most important enemy, railroads.

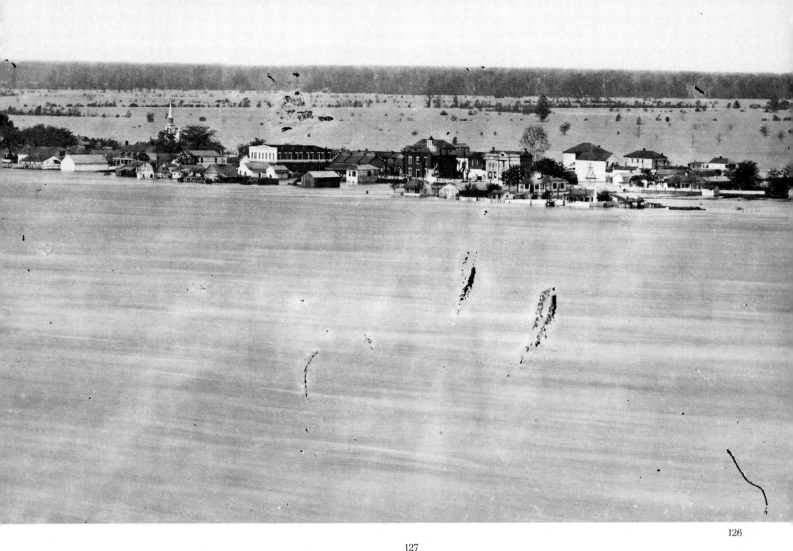

⩙ 126. River waters spread for miles across towns and into farm and forest lands in big flood years. Vidalia, Louisiana, just across the river from Natchez, lay half submerged in what is believed to have been the flood of 1892, when in June a report said that the entire parish was inundated. "Cotton two feet high in full bloom is covered with water. Corn in ear, flowers in bloom, ruined. People in great despair." The lowland of Mississippi below Natchez was covered, too, suffering six weeks of overflow. ⩙ 127. The devastation, horrible as it was, evoked curiosity, and people in small towns flocked aboard boats such as the *Charles D. Shaw* to take excursions into the flood areas. In April 1890, the *Shaw* took numerous trips to allow people to view the huge crevasse in the Lake Concordia, Louisiana, levee, where one group was said to have been "impressed with the grandeur of the sight they saw," comparing it to a miniature Niagara Falls. The *Shaw* made a special trip for women and children; fares were 50 cents for women and 25 cents for children. Meals were served, but passengers were invited to bring their own lunches. The next year, the *Shaw* repeated the trips to Lake Concordia, as again that year a huge break occurred. Promising a "royal dinner for the pleasure seekers," the steward advertised lamb, green peas, strawberries, cream, cake and puddings as a few of the foods to be served. Parents were reminded that the weather was "charming," that a lake ride would be "exhilarating," and that "delicate children are especially benefited by the river air." The clincher in the boat's pitch for passengers was, "It is hoped that this will be the last crevasse to occur in Lake Concordia and no one should fail to see it." In 1893, the *Shaw* went to the Black and Tensas Rivers to deliver supplies to flood sufferers, but not without excursionists, who "declared a great interest in the sights." The trip, it is said, was "enlivened by music, dancing, and pleasant social converse." The *Charles D. Shaw*, named for its first captain, who may be the man with the rifle over his shoulder, was built in 1883 for the Natchez and Bayou Sara trade. Shifting through the years from one trade to another, it managed to survive as a Natchez boat into the 1890s. For the last years there, it existed by taking odd jobs and by entering the excursion business. All the whistles in town blew it a farewell when it steamed out of town in

127

1896. Sold to a company in Columbus, Georgia, the boat went off to a new river, the Chattahoochee, and the new owners renamed it the *City of Columbus*. The Natchez paper reported with sadness that the *Charles D. Shaw*'s identity "has been destroyed entirely by the Queen and Crescent Navigation Company."

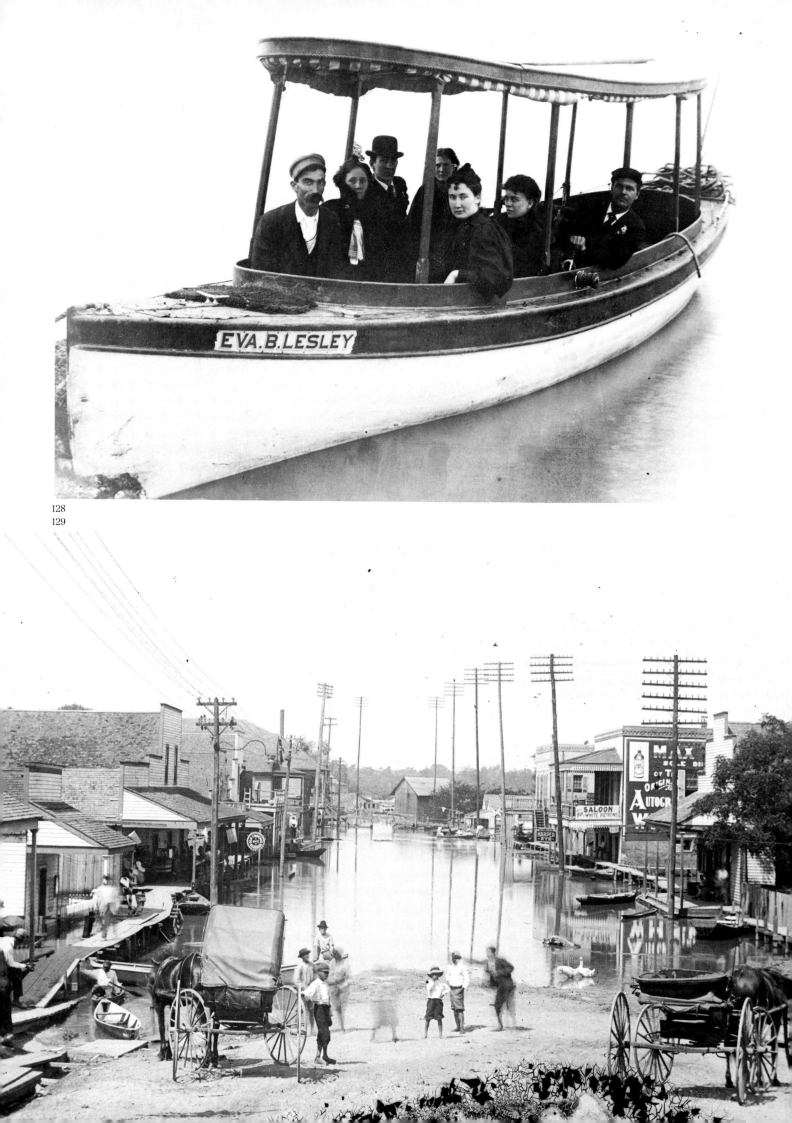

128
129

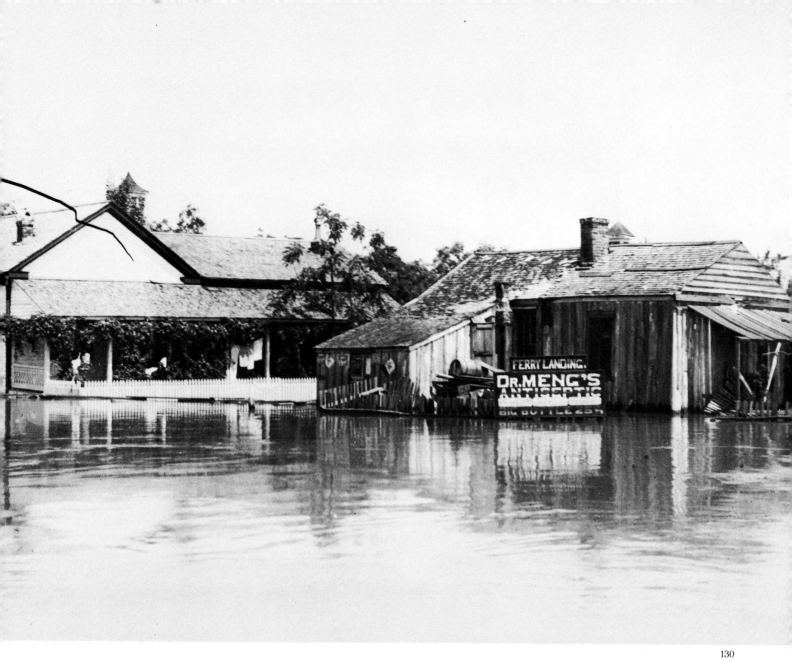

128. Passengers in smaller boats, like this launch owned by John Dale (seated in front) made pleasure trips on the river in high water as well as at other times. Pleasure boats like the *Eva B. Lesley* were often seen on the river on a Sunday afternoon. The festive striped tarpaulin was lowered in the event of rain. 129. Geese swam on Bayou Sara's main street; boats lay moored along the board walkways; and business went on as usual during this flood, also possibly in the spring of 1892. 130. High water interrupted steamboat business considerably. In many places, landings, such as this ferry landing, were impossible to use. In the 1892 high-water period, the Anchor Line announced a suspension of its boats south until the water receded since entire levee tops and landing facilities were submerged.

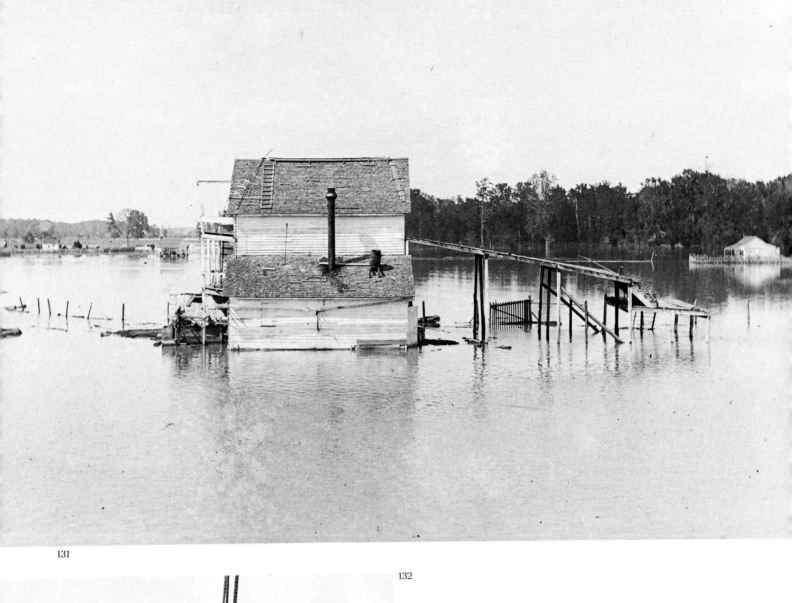

131

132

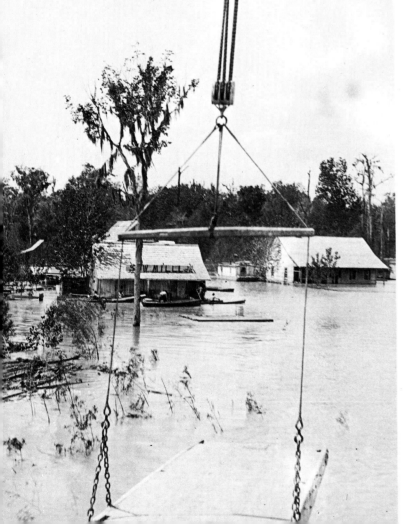

131. Local boats made many heroic rescues in flood after flood. Although many people in often-flooded areas moved out in anticipation of high water, inevitably some waited until the water invaded their houses and businesses. 132. Businesses along the Mississippi side of the river below Natchez were vulnerable, too, when they were located beneath the steep bluff, as this sawmill was. After the 1892 flood, J. B. O'Brien moved his Natchez Under-the-Hill coal company to a new foundation a few yards farther away from the river's edge in order to escape another inundation. 133. Because of their location high upon the bluff, Natchez and other towns along that section of the river enjoyed protection from rising water and offered shelter to hundreds of refugees who poured into the town during every flood. 134. Large droves of stock—cattle, horses, mules and other farm animals—were rescued by local boats and brought to higher ground. Often in the confusion of moving the stock to unfamiliar property, flood victims lost some of their animals in the wooded refuges where they were placed for temporary safekeeping.

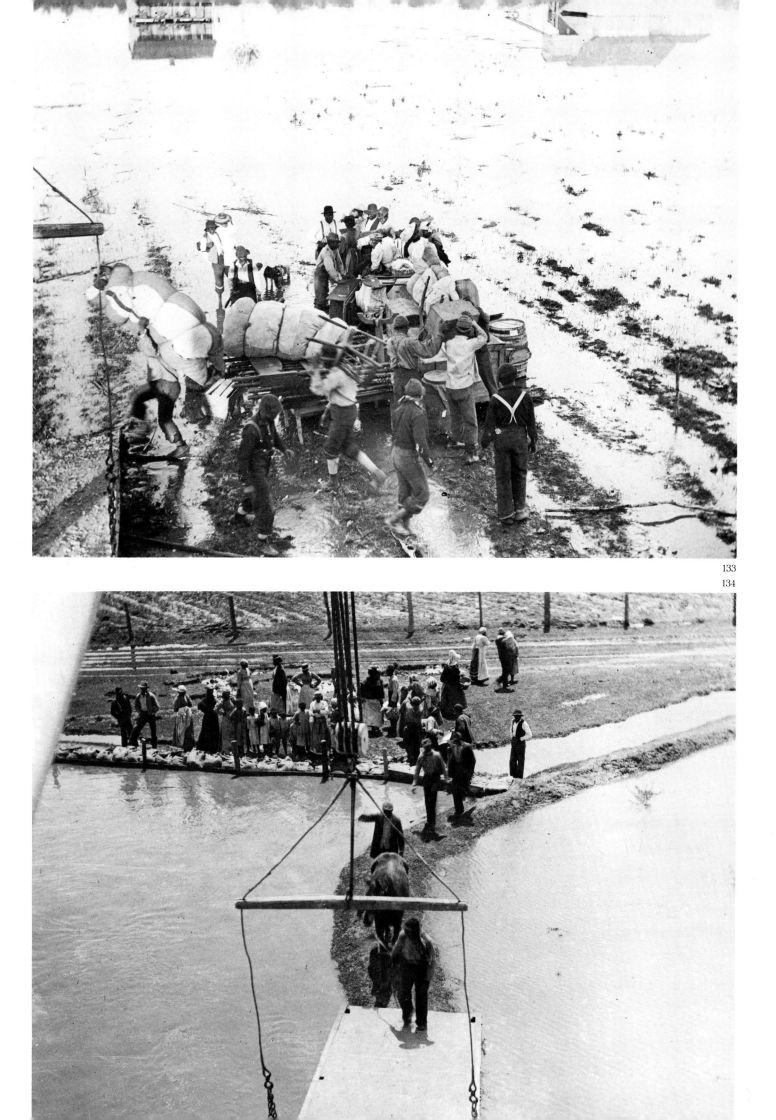

135. Perhaps a thousand refugees went to Natchez in 1897, a report said. Both black and white citizens of the town gathered to consider ways to help the virtually destitute flood victims. Most of the displaced depended upon the land for their livelihood, and sometimes the water receded too late for new crops, particularly cotton, to be planted in time. It was said that if the ground remained wet on the first of June, it was too late to raise cotton. 136. People, livestock, produce and, in season, even cotton crowded the decks of the little ferryboat *Concordia* as it crossed from Natchez to Vidalia many times a day for more than 20 years. During high water—as on the day this photograph was made—the ferry was a principal rescue boat, working long into the night if necessary to get people and animals to safe ground. This *Concordia*, the second ferry with that name, was built in 1880 and dismantled in 1903. 137. An island snaking through the encroaching water, the levee attracted people and animals waiting for help to arrive. In 1893, Concordia Parish planters lost 27,000 acres of crops.

135

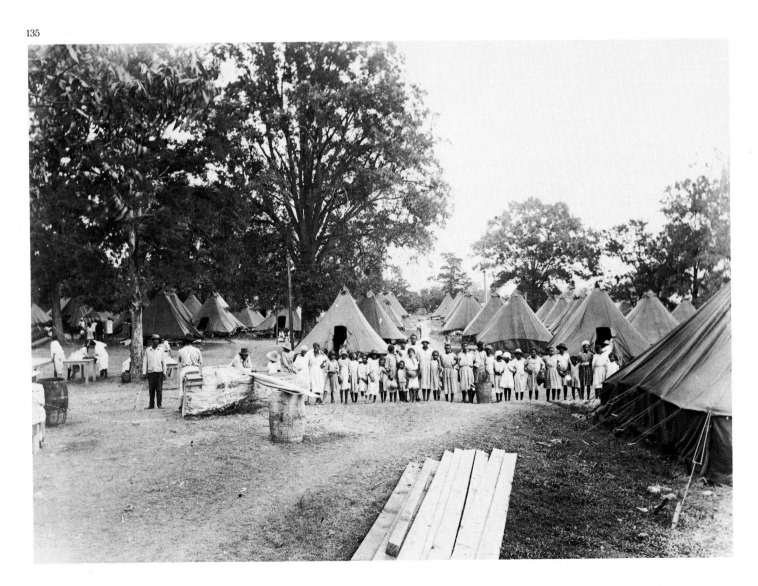

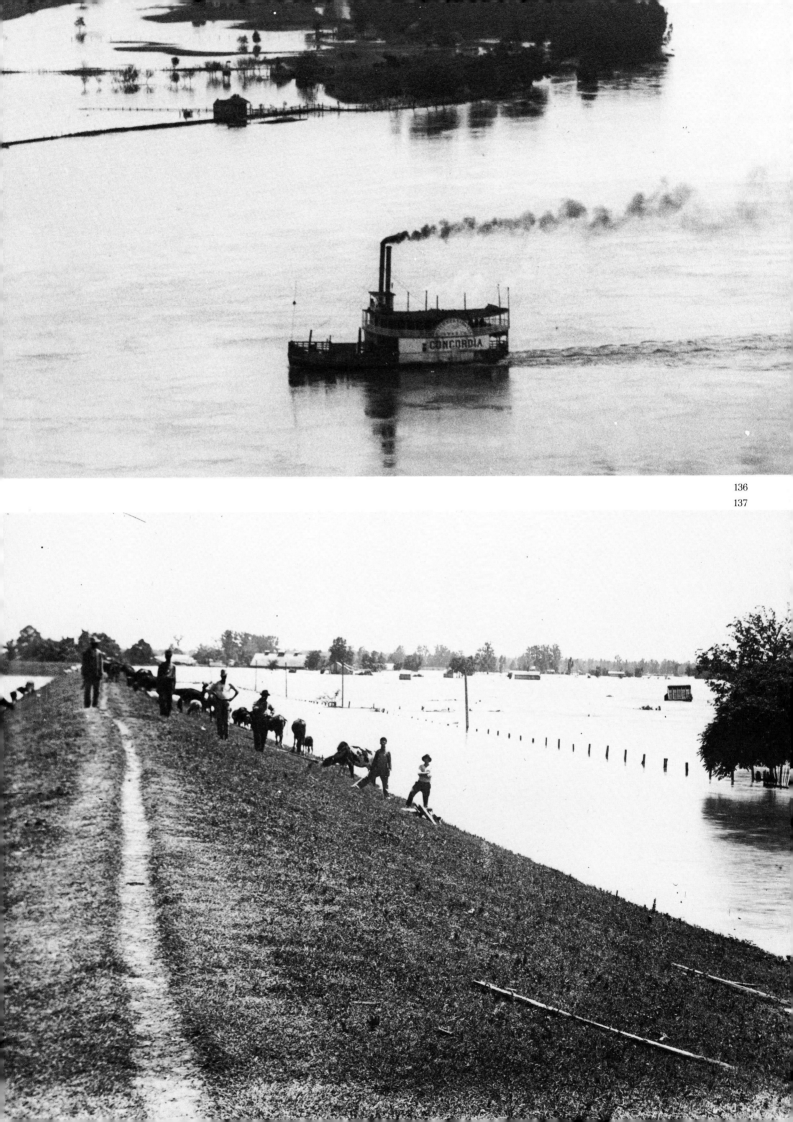

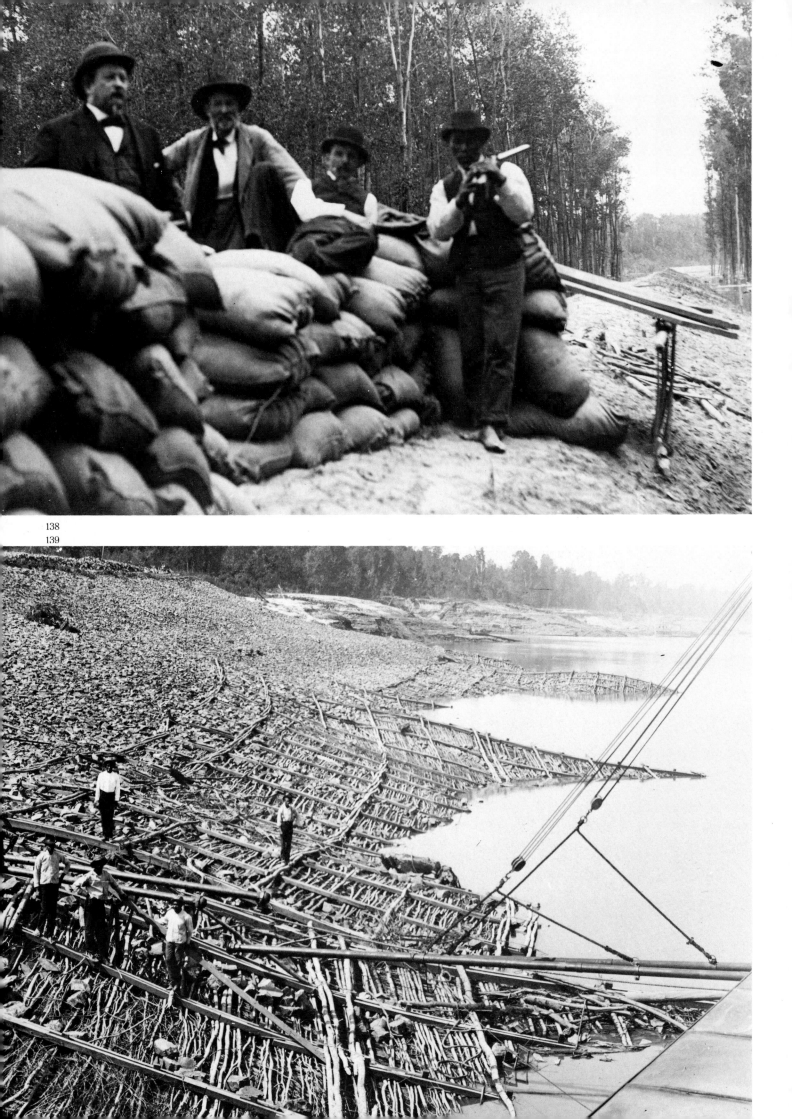

140

138. Planters sent their field workers, laborers came from the North seeking a warmer climate in the winter months, and convicts were hauled in by the hundreds on barges and steamboats. In winter months they converged on levee sites to build and repair. In the spring they came in haste to fill bags with sand or "buckshot" earth to place atop levees expected to be encroached upon by the river. The guard in this photograph may have been a trusty charged with watching convicts as they worked on the levee nearby. 139. Willow mats and huge rocks helped to stabilize caving banks along the river. They were used for levee protection, too, as described by an engineer in 1890:

> There seems to be a chance of saving a major portion of the levee by placing mattresses. I have wired for a barge load of rocks and have started a force cutting willows to fill the mattresses to protect the caving. The mattresses will extend 150 feet long and 50 feet wide, loaded with 100 tons of rocks secured in double sacks tied to the mattresses. It will be made very flexible and will be placed at each end of the breaks as soon as possible. The mattresses will rest on the river slope of the levee and extend outward from the bottom. It's expected when the caving reaches the mattresses, it will bend around the end to the opening and thus protect the earth from the action of the water.

140. Huge rocks piled upon willow branches helped to stabilize this riverbank where caving must have been a problem. Caving of the riverbanks resulted in serious loss of property, as entire buildings occasionally fell into the river. In August of 1887, when the ferry landing, along with much earth, caved into the river at a small settlement near Vicksburg, it was noted that the caving occurred "at a point where willow mats put in by the government were omitted." The observer warned that more caving would occur if something was not done.

Deluges and Delays 95

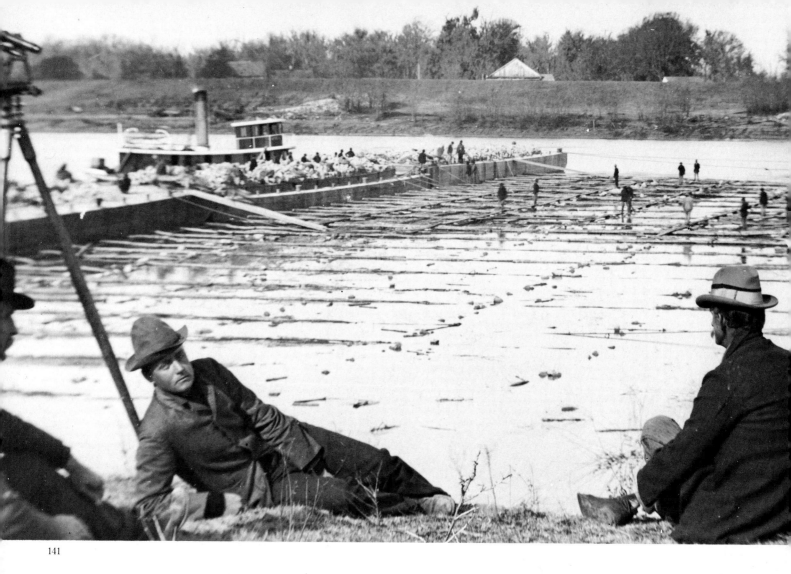

141

 141. These surveyors stopped to watch the work going on in the river. One in the early 1880s noted in his diary, after a day of working on a levee survey, that the surveyors had occasional good times along with their work:

> Arrived at St. Joseph about two o'clock; any further progress this day was "barred" by one or two saloons which seemed to cross our path, with sundry glasses with ice, etc. For the sake of getting the cool ice, we took etc. along with it, consequence was that our party surveyed round and round the rest of the evening taking several offsets all of which I suppose were duly noted in the notes. Our rodman looked through the glasses several times and getting uncertain which end of the rod was the proper one to place on the ground we thought it better to take no more observations, but all to go to bed and start fresh in the morning.

 142. Who were these men who lived and worked on the river for months at a time? They were the engineers, the surveyors and the foremen. They were the common laborers who often cut and wove the huge willow mats, put the heavy rocks in place on the banks and hammered together wooden structures used as bases for the revetment work. They were also the boat crews that helped to move workers and equipment from place to place. 143. Some of the engineers and others from the Corps worked directly off boats such as these. In addition to the laying of mats, the Corps of Engineers did substantial dredging to keep channels and harbors open.

144

145

144. The quarter boat, such as the *U.S. Gamma*, was a home that moved around on the river to provide accommodations wherever there was work to do. ࿔ 145. They were at home on a boat or on a river-bank. In that respect, the men who worked on the river were all alike, despite the wide range of economic statuses that may appear evident in photographs like this one. ࿔ 146. The little tug *Joe*, with a crew of perhaps six or seven men, pushed willow mats, log rafts or barges filled with levee-building equipment to their river destinations. ࿔ 147. Posed in front of the tug *Gen. Abbott*, these men probably worked on the little boat or on a river project in which it was then engaged.

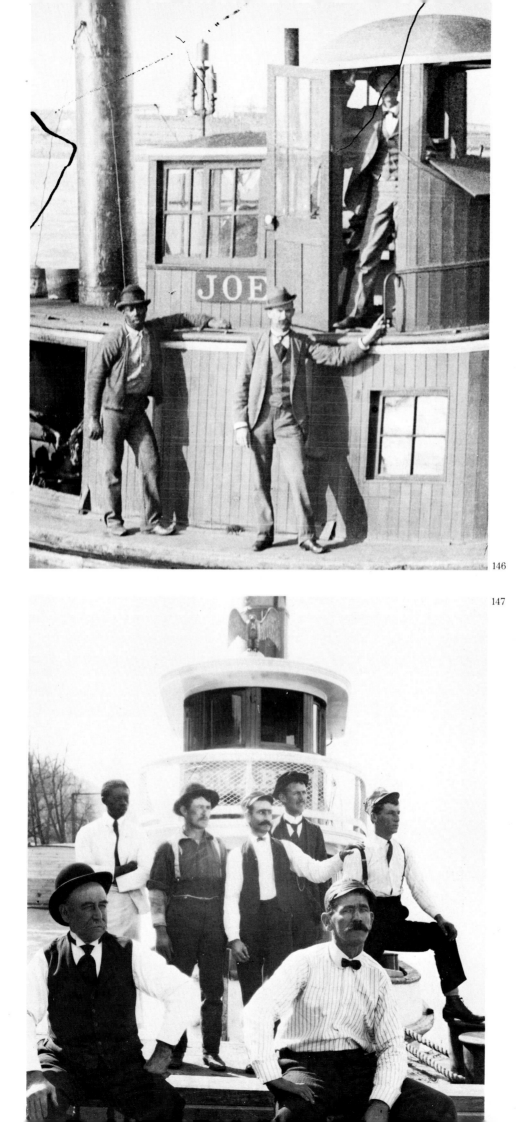

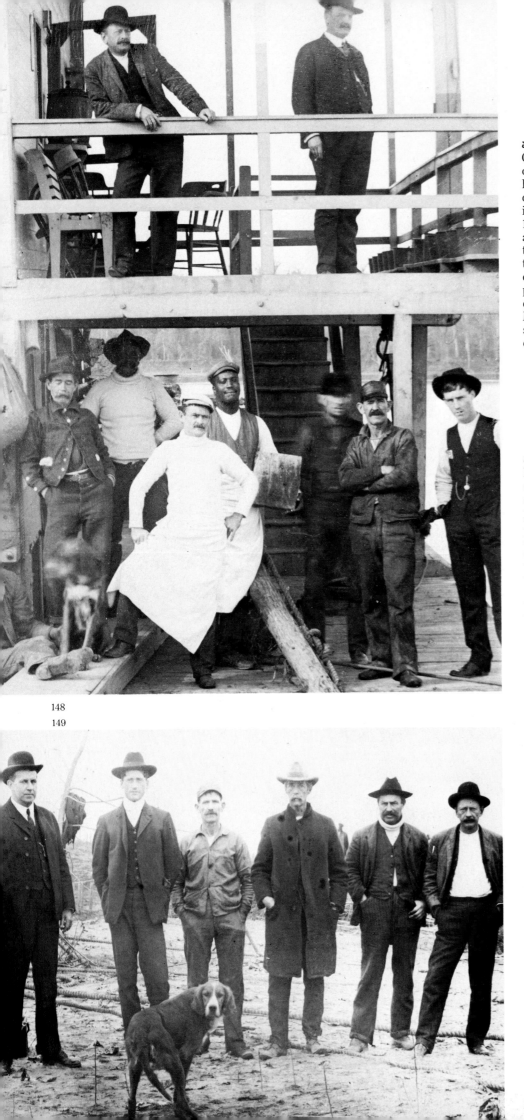

148
149

148. The cook left his kitchen on this U.S. Corps of Engineers boat in order to join the rest of the crew for the photograph. Because of the long periods of time during which the men lived on a working boat, the cook undoubtedly was an important member of the crew. 149. In 1883, when River Commission representatives and several of the engineers inspected work on the riverbank near Natchez, they declared that the "revetment work has demonstrated beyond cavil that it is possible to hold the bank and prevent it from caving," and indeed their work did prove successful. Yet that year, when the Mississippi River Commission turned down suggestions for expected improvements, the editor of the Natchez paper said:

> The country is pretty thoroughly impressed that the fight against Mississippi River improvement is made in favor of railroad interests and of the commerce of New York. The thorough improvement of the river would give the people of the West an outlet for their products far cheaper than they could possibly get eastward, and hence comes the opposition of the railroads.

150. In 1891, the U.S. Engineers were to begin making a survey of the Natchez harbor to determine ways to prevent shifting currents and caving banks. It was sourly predicted the next year that it was only a matter of time before historic Natchez Under-the-Hill caved into the river. In 1895, work on protecting the Natchez and Vidalia harbors was reported to be moving very slowly, and the statement was made that the problem with government work was that "they spend so much money, as a rule, in preparing a plant for any given work that they exhaust the allotment or appropriation before the aforesaid work is more than fairly entered upon." 151. As the years passed on toward the turn of the century, the government received the same kind of bitter criticism for not taking care of snags in the river and for not attending to the lights along it. In 1888 a steamboatman was said to have been "more interested in proper management of the snagboat and lighthouse than he is in the personality of the next president." The snagboat *Macomb* worked the lower Mississippi from 1874, the year it was built, until well into the 1900s, pulling up snags, removing drift and trees and placing buoys on dangerous protrusions in the river. Especially when the river was low, the *Macomb* might pull as many as 250 snags in a one-week period, and during that time it might cut several hundred trees. When a snag was caught by a packet rather than by the snagboat, the *Macomb* was promptly dispatched to remove the deadly nuisance before another boat was damaged by it. The first snags were removed from the Mississippi in 1824. Fourteen years later, Capt. Henry Shreve came up with the design for a steamboat built to remove snags, and his design was used throughout the ensuing history of steamboating on the river. A heavy beam supported by the twin hulls caught and pulled up the snags. If the beam failed to do the job, a steam-driven winch tore the stubborn snags from the riverbed.

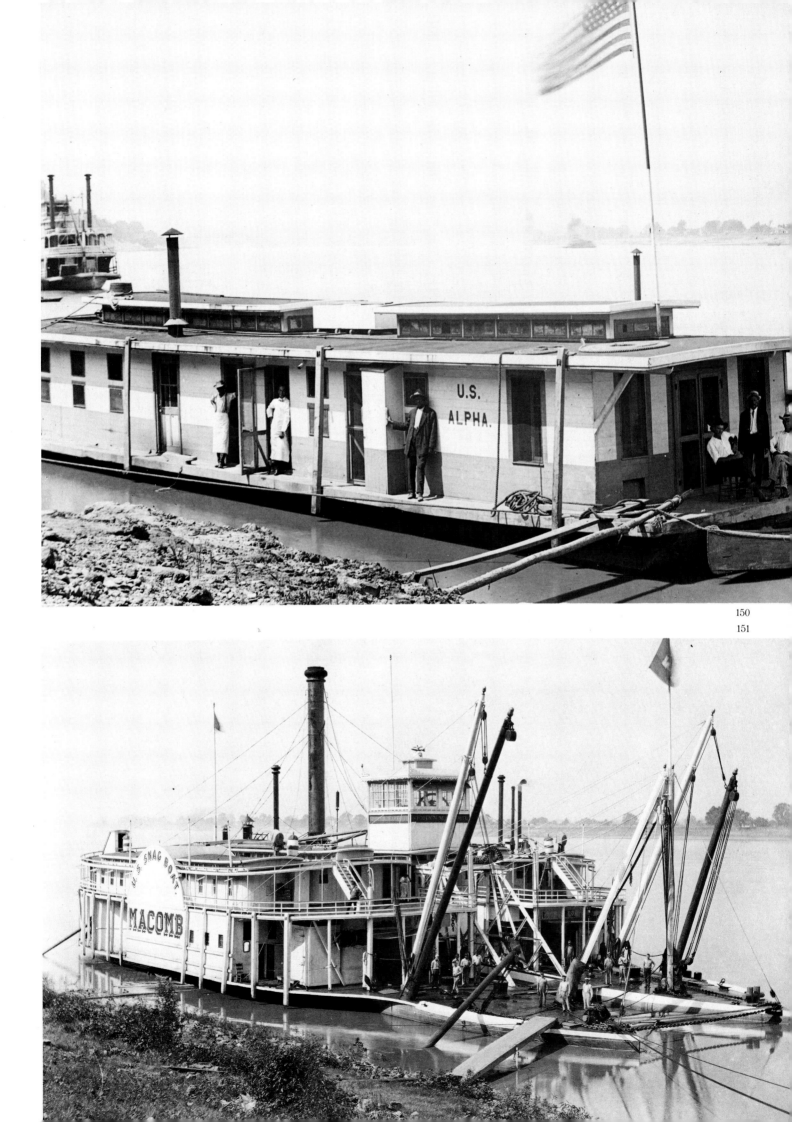

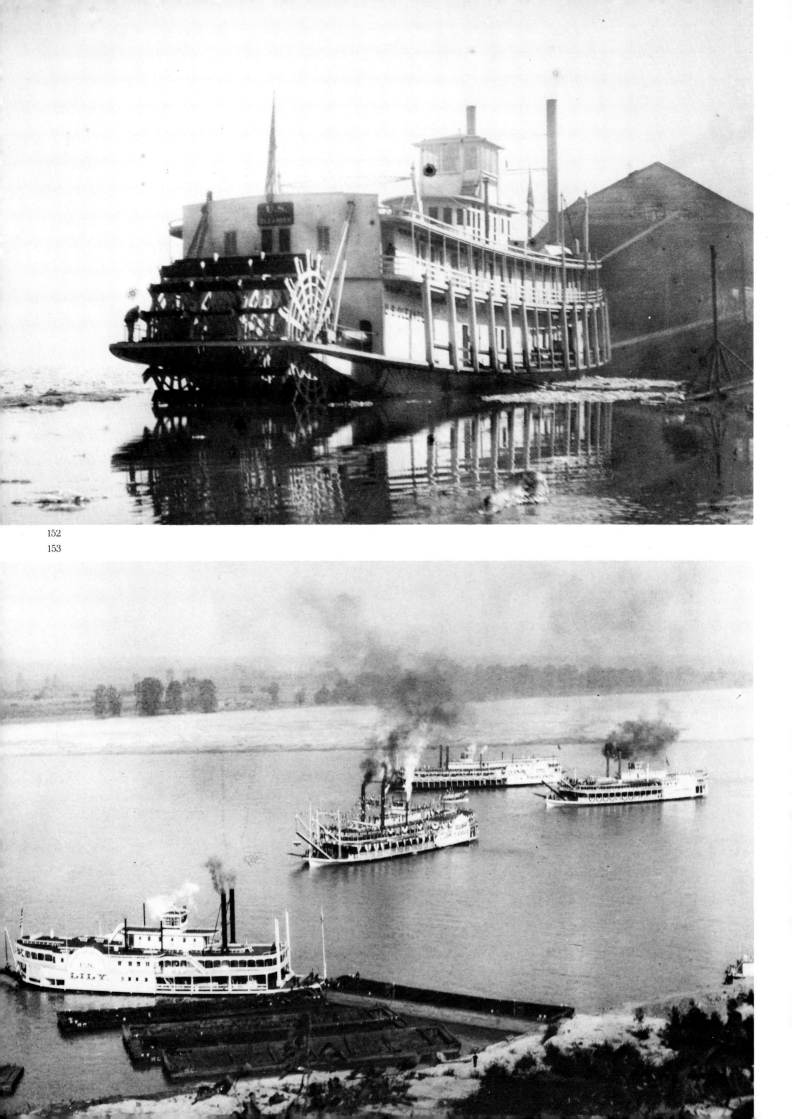

152. In the mid-1870s, around the same time that steamboats began to use electric lights, Congress authorized the first beacon lights to be placed on the river under Federal care. These were not to be the first river lights, however, as a private group of steamboaters had placed such lights on the Ohio River years before. The Federal lights led to the birth of a new kind of riverboat, the lighthouse tender. Such a boat was the *Oleander*, which served the U.S. Lighthouse Service from 1903 into the 1920s. The *Oleander* had the further distinction of bringing President Taft down the Mississippi in 1909 to New Orleans to attend a convention (see next photo). Steamboatmen welcomed the advance in safety that the government lights brought to the river. In 1882, however, when Mark Twain returned to the river after a long absence from it, he said of the lights that the government had turned the Mississippi "into a sort of two-thousand mile torchlight procession" and had "knocked the romance out of piloting, to a large extent." 153. The lighthouse tender *Lily* (affectionately known as "Tender Lily") appears to have led the way for the Presidential flotilla arriving at Natchez on October 29, 1909. President William Howard Taft and a long list of dignitaries made the journey down the river from St. Louis to New Orleans for the Lakes-to-the-Gulf Deep Waterways Convention. 154. With so many steamboats tied up at the Natchez landing on this occasion, and with the President himself traveling by steamboat down the lower Mississippi to a convention to encourage future development of the nation's waterways, was it not possible that steamboating might yet survive? The President's boat, the *Oleander*, is the third big boat from the right.

154

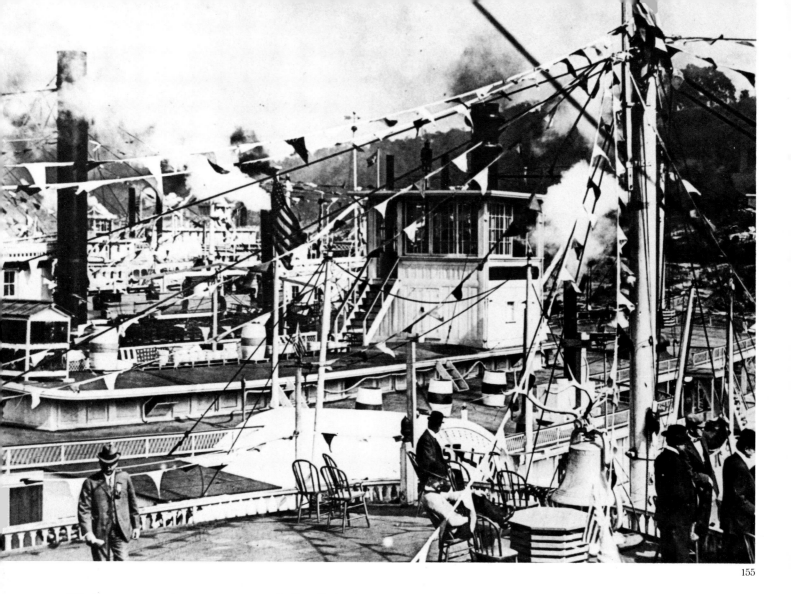

🙴 155. Governors, senators, congressmen and other dignitaries accompanied President Taft on the trip. He described the stopover at Natchez as "the most unique" one on their itinerary. 🙴 156. Twenty-five Natchez businessmen brought their automobiles to the landing and drove the special guests up Silver Street to the bluff overlooking the river, where the President and others were welcomed and gave speeches. 🙴 157. State flags adorned special boxes arranged for the visiting governors, and foreign flags decorated those for the diplomats. Five antique chairs, said to have been used by such past dignitaries as Andrew Jackson, were placed on the Presidential platform. As the party returned to the boats following the program, they received souvenir books prepared especially for the event.

157

156

Disaster and Demise

One Sunday afternoon in 1869, as the *Robert E. Lee* pulled away, a 12-year-old boy, trying to jump from the steamer to the wharfboat, fell into the river and drowned. In 1885, a whiskey barrel fell on a roustabout on the *Charles D. Shaw*; he later died of the injuries. That same year the carpenter and barkeeper on the *Ed Foster* fell, intoxicated, off the boat and drowned in the river. A passenger on the *Guiding Star* sued the boat in 1888 after he fell through the hatch of a barge it was towing. In 1896, Captain Leathers' pet parrot was blown off the *Natchez* and drowned. The next year, near the Vidalia landing, Dr. R. D. Sessions jumped from the ferry *Concordia* to save a drowning man who had fallen overboard.

Thousands of people traveled on steamboats during the late nineteenth century, and many minor accidents must have occurred. Major accidents occurred, too, but thankfully they were less frequent than in earlier steamboat days. Later boats were safer and better regulated by the government to avoid the spectacular explosions that had once blown people and boats high into the air. Fires, snags and collisions continued to pose great threats, however, and millions of dollars' worth of boats and freight were reduced to rubble. One spark could ignite a bale of cotton and send flames leaping over an entire boat, destroying it in perhaps 15 minutes. Poised beneath the muddy water like river monsters, snags ripped jagged holes in boats, and water poured into hulls faster than it could be pumped out. Boats collided in fog, storms and darkness. They grounded on sandbars and beds of ice and tore apart in tornadoes.

Problems for steamboats mounted as the end of the nineteenth century approached. High water, low water or ice interfered with the trade year after year. Disrupted schedules led to goods waiting on riverbanks for days; sometimes boats had to whistle and bypass a landing full of cargo because low water precluded any more tonnage on their decks. More business shifted to the railroads. In 1890, trains carried ten times the freight that steamboats did and by the turn of the century, 30 times more, despite unrealistic claims by river men that a revival was underway. "There's a cry for more boats on the Mississippi and Ohio rivers," one veteran river man might say; or another might claim, "No use talking about railroads killing steamboats; you can't down 'em."

The *Waterways Journal* nevertheless reported in 1892 that the steamboat business around St. Louis over the past year had been very poor, noting, "First came the low water, then the ice, and now so much high water that no boats can do any business." The report went on to say that probably no St. Louis steamboat had made a dollar in eight months. Again, in 1895, reporters lamented the low stage of the water, occurring just at the time when the big cotton carriers should begin to wheel into line. "But the railroads will profit from such a state of affairs," it was said.

River men continued to make comparisons between steamboats and railroads. For example, one huge river tow from Louisville in 1893, it was said, would have filled 75 railroad trains of 21 cars each. True or not, such comparisons did foreshadow the trend of the future—strong boats pushing barges. These boats would live on for a time, while the graceful packets would become but memories. The *Sprague* was such a boat, a huge, powerful stern-wheeler built for pushing barges—no passengers, no frills, just plenty of freight. Built in 1902, the "Big Mama," as it was called, pushed barges up and down the Mississippi for nearly 50 years.

The old passenger steamboats that had for years moved back and forth between Cincinnati and Cairo, Cairo and Memphis, St. Louis and Memphis, Memphis and Natchez and Natchez and New Orleans were, for the most part, gone as the country moved into another age in the first two decades of the twentieth century. Just as surely as the horse-and-buggy was to give way to the automobile, so the steamboat was to move aside for another chapter in Mississippi River history to begin. A few steamers survived into the mid-twentieth century—the *Tennessee Belle* to 1942, the *Betsy Ann* to 1940 and the *Senator Cordill* to 1934, to name a few—but by 1920, diesel-powered boats dominated the river.

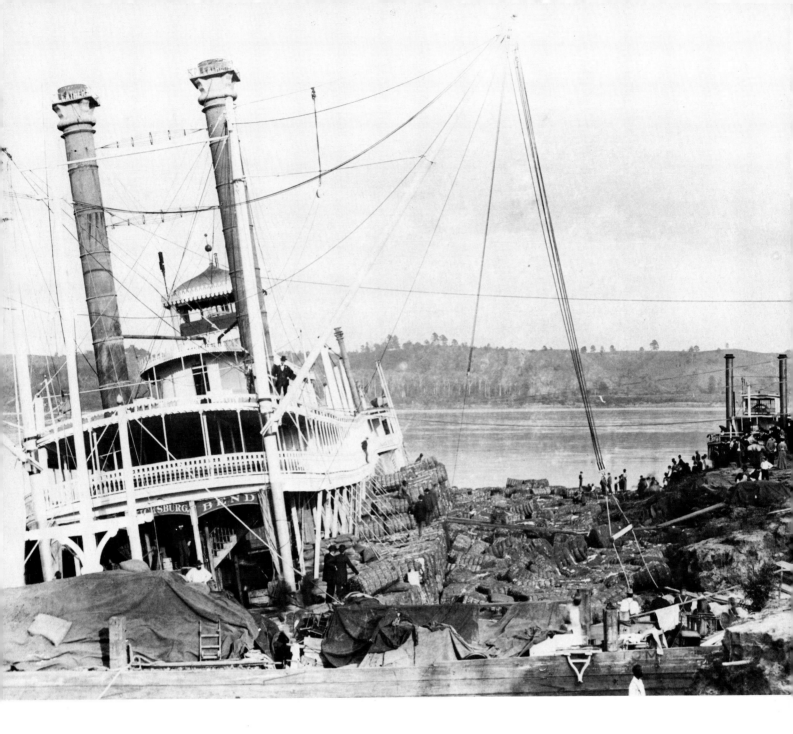

🌿 158. The *T. P. Leathers*, the third boat named for and owned by the famous captain, lay in near ruin a few miles above Natchez in the fall of 1896. Coming down the river, the boat began to fill with water. Pumps were started but could not expel the water fast enough. The crew began to throw bales of cotton and bags of cottonseed overboard to relieve the boat of some of its weight. The boat made it to the bank, the passengers disembarked and the *J. B. O'Brien*, which had heard the distress signal sounded by the big boat, brought the passengers into Natchez. The captain blamed the accident on the huge cargo of 1,700 bales of cotton, 9,000 sacks of cottonseed and a large amount of cottonseed oil, explaining that the weight of the cargo had caused the decking to open near the forward hatch, where water came into the boat. Capt. Dick Leathers had his brand-new bride with him on this trip. The boat was raised and repaired, and it continued to work up and down the lower Mississippi until 1900.

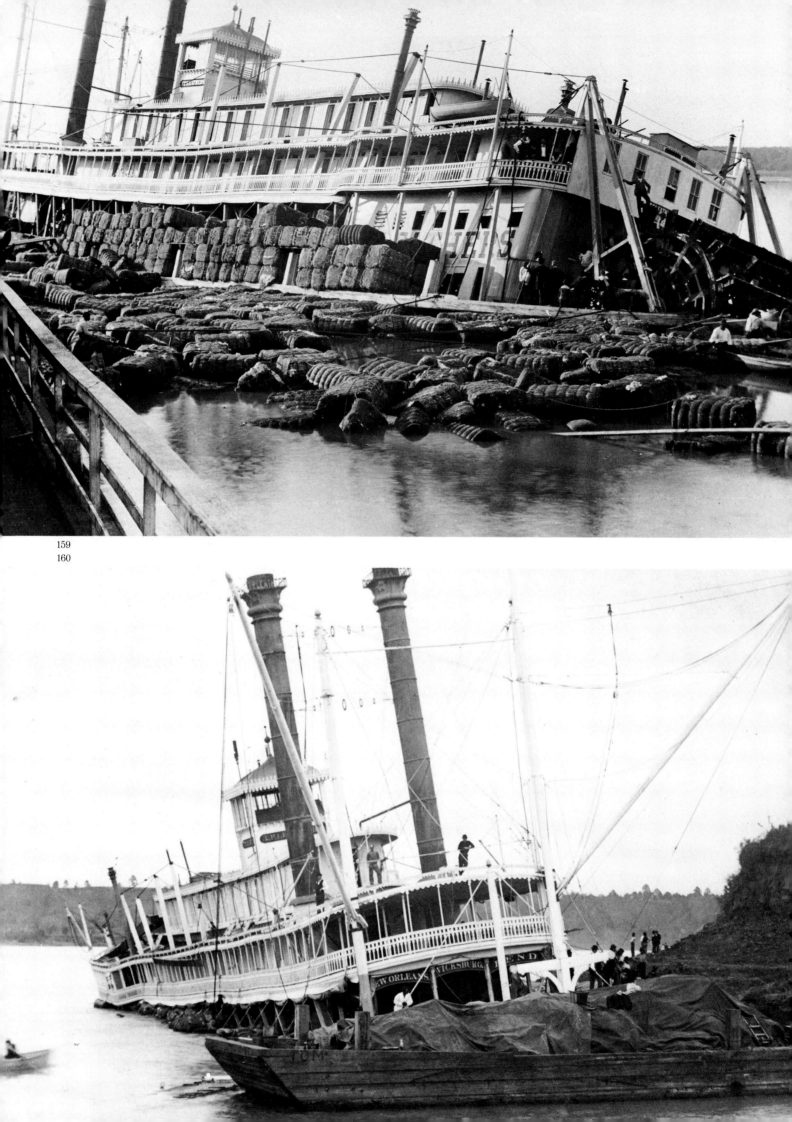

159
160

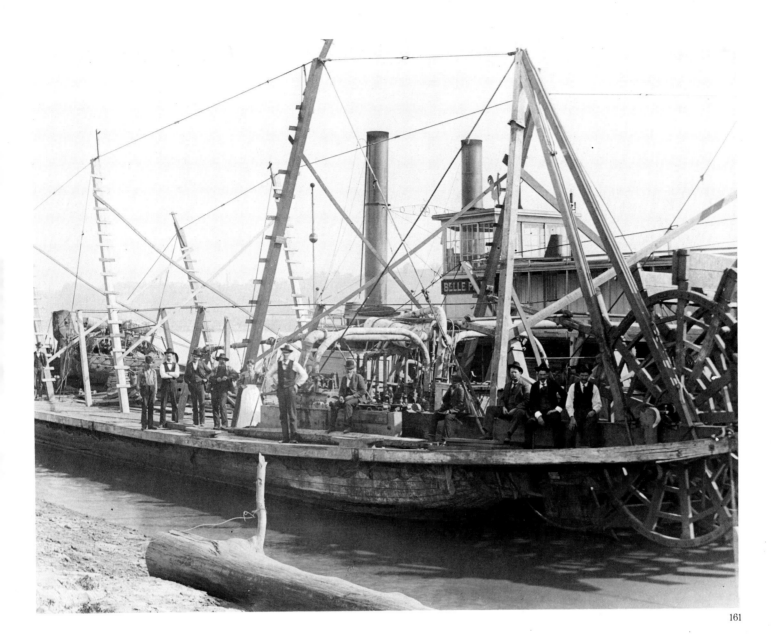

161

159. Cotton lost overboard in disasters was often retrieved and taken on to its destination. Even bales that sank were often retrievable. Many boats, like the *T. P. Leathers*, withstood accidents such as this one and were towed off to the marine docks in New Orleans, where they were recaulked, repaired, repainted and, when necessary, refurbished. This accident took place on October 22, 1896. The boat was raised on the 29th at a cost of about $12,000. By November 21, the *T. P. Leathers* was back in business, looking like a new boat with its old squared-off chimneys converted to feathered tops. 160. On the lower river, one man came again and again to the sites of wrecks such as these. His name was Al Burris, and he was a diver and a wrecker. Whether to raise a boat or scuttle it often depended on his opinion after going into the muddy water to check for certain conditions. Steamboatmen followed his advice and, as in this case; often saved their sunken boats and gave them another life. Just as Al Burris completed the raising of the *T. P. Leathers*, he was called down the river to another wreck, that of the *Lula Prince*, which for over a month others had tried unsuccessfully time and again to raise. 161. The *Lula Prince*, thought never to be seen again, had gone down in the Atchafalaya River but was raised and towed to New Orleans by the *G. W. Lyons*. The hull of the little boat was found to be sound and the machinery in pretty good condition. After some repairs at New Orleans, the remains of the boat came back to Natchez appearing as shown in this photograph. The towboat *Belle Prince* was behind it in the river. The *Lula Prince*, in tow by the *Alice Brown*, went to Madison, Indiana, and was rebuilt. It came back to Natchez in November 1897 to resume its place in the Natchez and Bayou Sara trade. The boat had been so popular that on its first trip back down the river to Bayou Sara, it is said to have received an ovation all along the river.

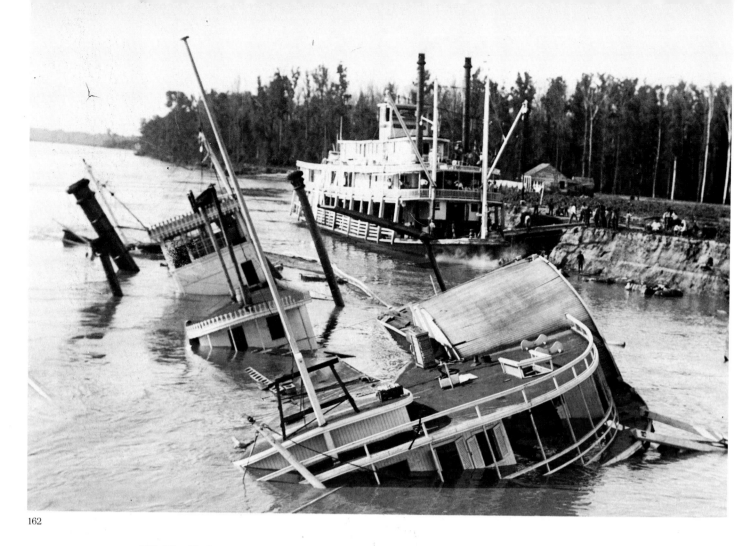

162

162. The *Chalmette* sank in the summer of 1904, probably from catching a snag. The boat was built in 1898 from the hull of the old Anchor Line boat *City of Vicksburg*, which had been damaged in the 1896 tornado at St. Louis and never repaired. 163. Divers salvaged what was usable, and wreckers usually removed the remainder of the boat. Sometimes a wrecked boat was burned to get it out of the way.

163

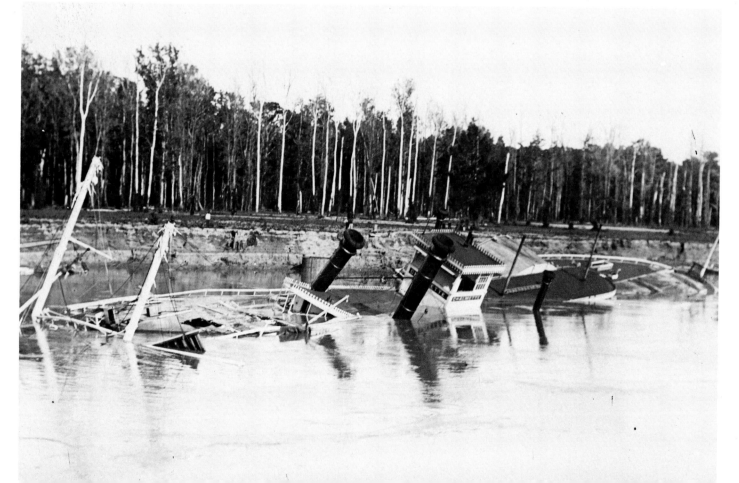

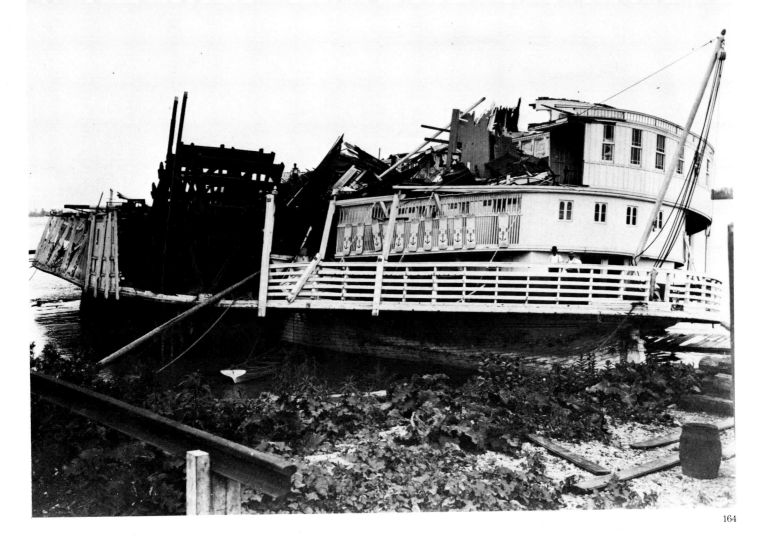

☙ 164. The *Arkansas City*, one of the Anchor Line boats caught in the tornado in St. Louis in May 1896, was a total wreck, bearing little resemblance to the once-beautiful steamboat that had served river towns on the lower Mississippi for some 14 years. ☙ 165. The beautiful *Belle Memphis*, having escaped the tornado, remained on the river for another year and a half. In late 1897, however, it caught a snag and was damaged beyond repair.

165

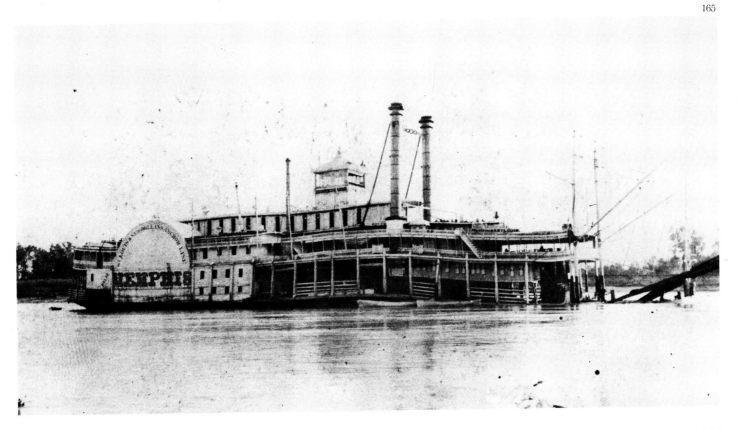

≈ 166. By the turn of the century the railroad station, rather than the river landing, had become the hub of activity in small towns like Natchez. Attracting more passengers and freight with their swiftness and their improvements in comfort and convenience, railroads appeared by then to have won the long race they had to run with steamboats through the second half of the nineteenth century.

112 *Disaster and Demise*

167. At Bayou Sara, too, the railroad station found more people and freight at its doorstep as steamboat travel and trade began to lose some of its luster in the late 1800s. 168. As the small towns of the South attempted to keep up with the rest of the country, they realized that railroads held the key. Boats, confined within the banks of the river, could not compete with the networks of railroads crisscrossing the country. Whereas events in the town had centered on boats in one era, they would in the coming era center on trains. 169. Those who once had labored at the landing loading cotton and cottonseed meal were instead loading freight onto trains by the beginning of the twentieth century.

167

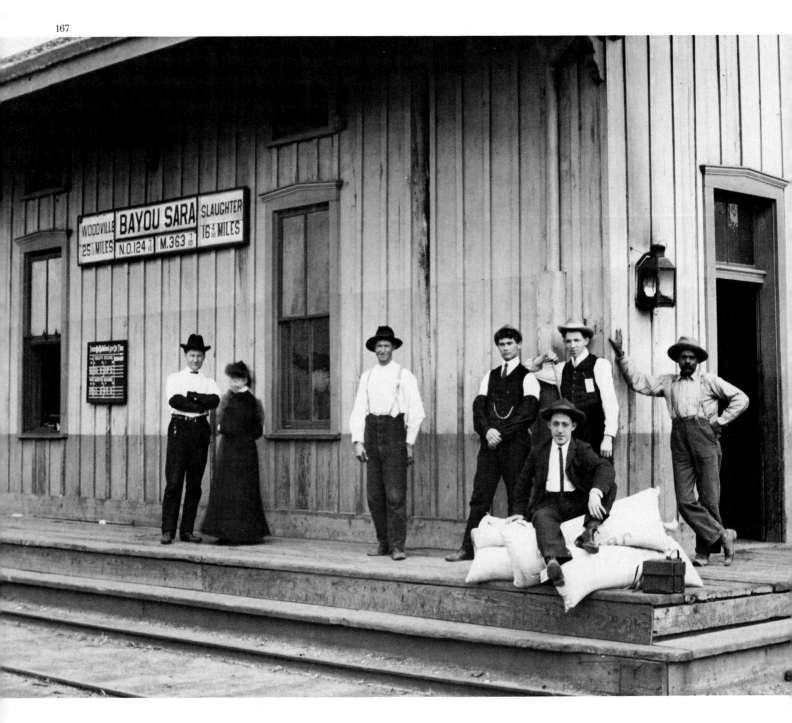

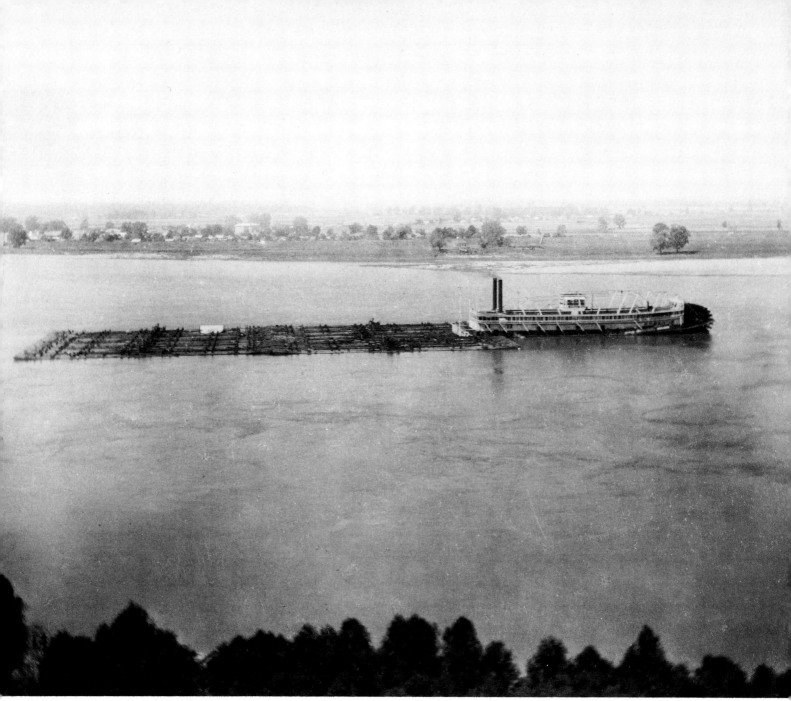

170

⟨⟨ 170. Steamboats of old were dying out, but steam pushers such as the powerful stern-wheeler *Sprague*, built in 1902, kept alive the possibility that the river might again become the nation's great passageway for trade. Said to have cost $500,000, the *Sprague* was scoffed at by old-time steamboatmen, who said that it would not be a financial success. Indeed, as the giant steel steamer came down the river on its first voyage, it encountered one problem after another. One veteran steamboatman said, "The overgrown towboat *Sprague* is a costly luxury as will be seen by a perusal of the list of changes to be made in her while she's at Pittsburgh. The wheel, 38 feet high, will have 18 inches taken off each bucket and the planking moved up. The small cylinders are cracked, had too little escape room, and will be replaced when new cylinders are made." A reporter for the Louisville *Courier-Journal* said that rivermen believed that the first trip of a steamboat foreshadowed its lifetime existence. He said, "Upon this supposition or in view of this superstition, keep your eye on the career of the new steel towboat *Sprague*. She started out with defective hogchains, ran into a show-boat, and will go on the marine docks at New Orleans." The skeptics were wrong about the *Sprague*, however, as it worked on the Mississippi River until 1948, when it was retired. As the nation approaches the end of the twentieth century, more traffic and more freight travel on the Mississippi and its tributaries than ever before in the history of the river. The glamour, romance and grandeur, however, are gone, except for the moments lovingly captured in the river towns by photographers such as Henry C. Norman.

Bibliography

Anthony, Irvin. *Paddle Wheels and Pistols*. Philadelphia: Mac-Rae-Smith Company, 1929.

Botkin, B. A. *A Treasury of Mississippi River Folklore*. New York: Bonanza Books, 1978.

Carter, Hodding. *Lower Mississippi*. New York: Farrar & Rinehart, 1942.

Claiborne, J. F. H. *Mississippi: As a Province, Territory and State*. Jackson, Miss.: Power & Barksdale, 1880.

Donovan, Fran. *River Boats of America*. New York: Thomas Y. Crowell Company, 1966.

Dorsey, Florence L. *Master of the Mississippi*. Boston: Houghton Mifflin Company, 1941.

Drago, Harry Sinclair. *The Steamboaters*. New York: Dodd, Mead & Company, 1967.

Eskew, Garnett L. *The Pageant of the Packets*. New York: Henry Holt and Company, 1929.

Flood Control, Lower Mississippi River Valley. Vicksburg, Miss.: U.S. Corps of Engineers, 1970.

Gandy, Thomas H. Miscellaneous news clippings, notes and historical excerpts. Natchez.

Glazier, Captain Willard. *Down the Great River*. Philadelphia: Hubbard Brothers, 1891.

Huber, Leonard V. *New Orleans: A Pictorial History*. New York: Crown Publishers, Inc., 1971.

Natchez *Daily Democrat*. Miscellaneous issues, 1867–1910.

Samuel, Ray; Leonard V. Huber; and Warren C. Ogden. *Tales of the Mississippi*. New York: Hastings House, 1955.

Waterways Journal. St. Louis. Miscellaneous issues, 1969–1974.

Way, Captain Frederick. *Mississippi Stern-Wheelers*. Milwaukee: Kalmbach Publishing Company, 1947.

——. *Way's Packet Directory, 1848–1983*. Athens, Ohio: Ohio University, 1983.

——, ed. *S & D. Reflector*. Marietta, Ohio. Miscellaneous issues, 1967–1984.

Wayman, Norbury L. *Life on the River*. New York: Crown Publishers, 1971.

Index

Italic numbers refer to illustrations.